LIVING WITH
ARCHITECTURE AS ART

VOLUME II

LIVING WITH ARCHITECTURE AS ART

*The Peter W. May Collection of
Architectural Drawings, Models, and Artefacts*

VOLUME II

EDITED BY
Maureen Cassidy-Geiger

AD ILISSVM

AD ILISSVM: 'By the banks of the Ilissus', where Socrates bathed his feet in Plato's
Phaedrus, 230b, remarking καλή γε ἡ καταγώγη (This is a beautiful place to settle)

Copyright © 2021
Texts copyright © the authors

All rights reserved. No part of this publication may be transmitted in any form or by any means,
electronic or mechanical, including photocopy, recording or any storage or retrieval system,
without the prior permission in writing from the copyright holder and publisher.

ISBN 978-1-912168-19-4

British Library Cataloguing in Publication Data

A catalogue record for this book is available from the British Library

Ad Ilissvm is an imprint of
Paul Holberton Publishing
89 Borough High Street
London SE1 1NL
WWW.PAULHOLBERTON.COM

Designed by Laura Parker
Printing by e-Graphic Srl, Verona

Jacket: May Collection 1990.297a (cat.12.12)
Front endpaper: May Collection 1988.135 (cat. 14.5)
Frontispiece: May Collection 1988.158 (cat. 14.3)
Catalogue opener: May Collection 2000.458a (cat. 11.3)
Back endpaper: May Collection 1987.32 (cat.11.6)

VOLUME I

ix	Foreword	PETER MAY
xiii	Acknowledgments	PETER MAY
xv	Editor's Acknowledgments	MAUREEN CASSIDY-GEIGER
1	Introduction: The Art of Architecture	MAUREEN CASSIDY-GEIGER
19	The Beaux-Arts Tradition: "Everything that is made or studied is competition, the student does not make a pencil stroke which is not the result of a competition"	BASILE BAUDEZ AND MAUREEN CASSIDY-GEIGER
47	Architectural Education and the Art of Drawing in Britain	CHARLES HIND
61	The Architectural Drawings Market, Past and Present: Architects, Collectors, Scholars, and Decorators	CHARLES HIND
77	Carpenters and Craftsmen, Architects and Collectors: A Short History of the Architectural Model	MATTHEW WELLS

The Catalogue

DRAWINGS, PAINTINGS, AND PASTEL

97	1.	Theaters, Museums, and Clubs
157	2.	Schools and Centers of Learning
195	3.	Government Buildings
235	4.	Places of Worship
255	5.	Train Stations
281	6.	Hotels and Spas
301	7.	Commerce

VOLUME II

335	8.	Private and Royal Residences, Urban and Suburban Housing
451	9.	Interiors, Interior Design and Decoration
523	10.	Construction Drawings
543	11.	Reconstruction Drawings
581	12.	Landmarks, Monuments, and Mausolea
631	13.	Landscape Design and Garden Architecture
681	14.	Cast-iron Architecture and Design
705	15.	A Plantar Archive
715	ARCHITECTURAL MODELS	
747	BOOKLETS OF DRAWINGS	

Afterwords, Concordance, and Indexes

762	Afterword I	MARK FERGUSON
767	Afterword II	BUNNY WILLIAMS
768	Concordance	
769	Indexes	
772	Photographic Credits	

CATALOGUE
VOLUME II

NOTE TO THE READER

As desired by the collector, his architectural drawings are grouped and presented not by nationality or author but by building type. Albeit an approach advanced by Nikolas Pevsner in his legendary 1970 A.W. Mellon lectures, later expanded and published in 1976 under the title *A History of Building Types*, May was instinctively drawn to collect thematically in ways that suited the architecture of his homes and gardens or appealed to his professional, cultural, or philanthropic interests.

Catalogue entries are numbered by section and provide basic information including architect and/or artist, nationality and life dates, if known. This information is followed by the Peter May Collection inventory number, comprised of a running intake number joined to the year of acquisition; these numbers also appear at the lower left of each illustrated work. For sets of drawings, the sheets are further distinguished by the addition of a lower-case letter or, when relevant, 'recto' and 'verso'. The works are titled (and in some cases subtitled) according to their function or typology and dated; media and measurements are provided. Handwritten inscriptions, marginalia and stamps are transcribed for the interested reader. Provenance is given when the dealer, gallery or auction is known; agents are not named. Many entries include comparative images that show the building or interior that is the subject of the rendering, the printed architectural assignment, comparable sheets from the same competition, design sources, or a print published after the original. Notes and captions are kept to a minimum.

8
PRIVATE AND ROYAL RESIDENCES, URBAN AND SUBURBAN HOUSING

8.1

ALPHONSE-ALEXANDRE DEFRASSE
(FRENCH, 1860–1939)

1990.291a,b: Canal façade of the Ca'd'Oro, Venice, after the restoration of 1891: preparatory sketch and finished painting, ca. 1900

Pencil, ink, watercolor

1990.291a: Finished painting. 47 × 37¼ in. (119.3 × 94.6 cm)
INSCRIBED [in watercolor] *PALAIS dit CA'DORO / VENISE / DETAIL DE LA FAÇADE SUR LE GRAND CANAL /* [architectural measurements] / [in sepia] *A Defrasse*

1990.291b: Preparatory sketch. 8½ × 6¾ in. (21.6 × 17 cm) approx.
INSCRIBED [in red] *A Defrasse*

PROVENANCE Galerie Jean-Paul Pinson, Paris

1990.291b

Ca' d'Oro, Venice, photograph early 20th century

336 PETER MAY COLLECTION II

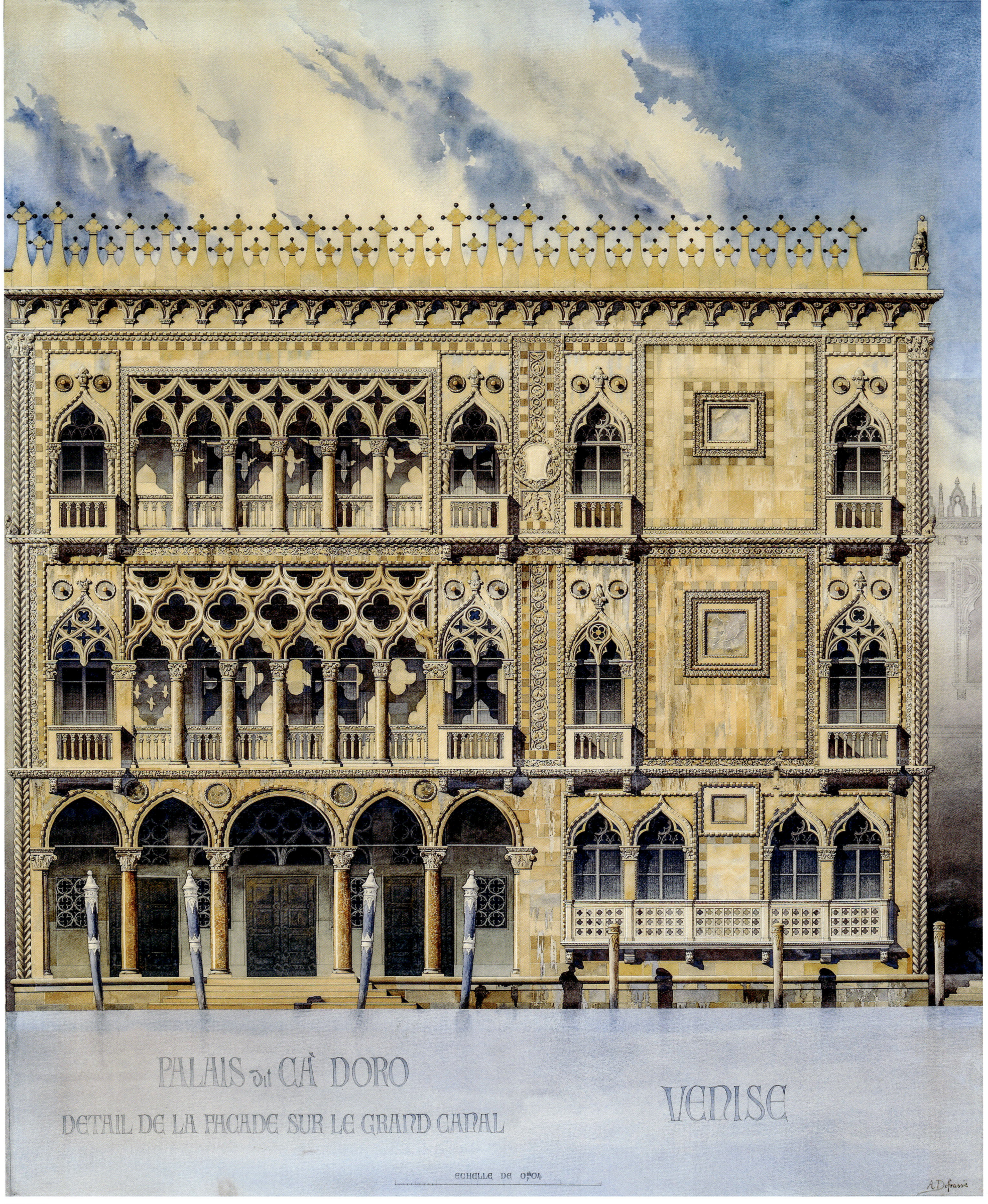

PALAIS dit CA' DORO
DETAIL DE LA FACADE SUR LE GRAND CANAL
VENISE

8.2

T. RIGAULT (FRENCH, DATES UNKNOWN)

1987.53: View of Château d'Ussé, Rigny-Usse, France, 1903

Pencil, ink, watercolor. 21 × 28 in. (53.3 × 71.1 cm)
INSCRIBED [in ink] *CHATEAU D'USSÉ CANTON D'AZAY-LE RIDEAU / T. Rigault 1903* / [in blue crayon] *Château de le Vallée de la Loire / Indre et Loire*
PROVENANCE unknown

🌹 This view was perhaps intended for publication.

Château d'Ussé, Rigny-Usse

1987.23b

8.3

ARTIST UNKNOWN

1987.23b: View of a château, 18th century

Pencil, ink, watercolor. 9 × 14½ in. (22.8 × 36.8 cm)
PROVENANCE Niall Hobhouse, London

Hôtel Monumental du Moyen-âge.

Fait par Félix Menouvrier
1869.

1987.15

8.4

FELIX MENOUVRIER
(FRENCH, DATES UNKNOWN)

1989.205: Design for a residence in the medieval style, 1869

Pencil, ink, watercolor. 21⅞ × 16⅛ in. (55.5 × 40.9 cm)
INSCRIBED [in ink] *Hotel Monumental du Moyen-Âge / Fait par Felix Menouvrier 1869*
PROVENANCE unknown

8.5

ARCHITECT UNKNOWN (FRENCH)

1987.15: Competition drawing for a château: frontal elevation, ca. 1900

Pencil, ink, watercolor. 26 × 38¼ in. (66 × 97.1 cm)
PROVENANCE unknown

RESIDENCES 341

8.6

ARCHITECT UNKNOWN (FRENCH)

1991.372: Competition drawing for a château: frontal elevation, ca. 1900

Pencil, ink, watercolor. 15½ × 21¾ in. (39.3 × 55.2 cm)
LITERATURE Sotheby's, London, sale cat. 27 April 1989, lot 672 (ill.)
PROVENANCE Sotheby's, London, 27 April 1989, lot 672

8.7

ARCHITECT UNKNOWN (FRENCH)

2000.479a,b: Two elevations for a proposed redesign of the Courtin de Torsay family estate Château de Préval, also called La Matrassière, Sarthe, France, late 19th century

Pencil, ink, watercolor. 11 × 18 in. (27.9 × 45.7 cm)

2000.479a: Entry façade
INSCRIBED [in ink] *CHÂTEAU DE PRÉVAL / Façade {Coté de l'arrivée.} / Monsieur le Comte de TORSAY.* / [architectural measurements]

2000.479b: Alternate façade
INSCRIBED [in ink] *CHÂTEAU DE PRÉVAL / Façade. Coté. / Monsieur le Comte de TORSAY.* / [architectural measurements]

PROVENANCE Galerie Daniel Greiner, Paris

🔖 The last male member of the family was Charles Courtin de Torsay (1830–1909).

Château de Préval, also called La Matrassière, Sarthe

RESIDENCES

1987.9

8.8

ARCHITECT UNKNOWN (FRENCH)

1987.9: Competition drawing for a château: frontal elevation, 1895

Pencil, ink, watercolor. 16½ × 35 in. (41.9 × 88.9 cm)
PROVENANCE unknown

1987.4

8.9

LAURENT FORTIER (FRENCH, 1867–1923)

1987.4: Competition drawing for a château: frontal elevation, 1895

Pencil, ink, watercolor. 24¾ × 37 in. (62.8 × 93.9 cm)
PROVENANCE unknown

RESIDENCES

8.10

M. FRANCQ (FRENCH, DATES UNKNOWN)

1987.5: Competition drawing for a château: frontal elevation and cross-section, 1891

Pencil, ink, watercolor. 22 × 37 in. (55.8 × 93.9 cm)
INSCRIBED [in ink] *M. FRANCQ / C. / ELEVATION PRINCIPALE / Dressé par l'architecte soussigné / Versailles le 12 Avril 1891* [indistinct signature] / [architectural measurements]
STAMPED [within circle, in blue] *ALBERT PETIT*
PROVENANCE unknown

1989.240

8.11

HERBERT S. KIMBALL
(AMERICAN, 1869–1956)

1989.240: Competition drawing for a château: frontal elevation, 1896

Pencil, ink, watercolor. 23⅜ × 39¾ in. (59.3 × 100.9 cm)
INSCRIBED [in red] *H. S. Kimball. 96.*
PROVENANCE Stubbs Books & Prints, New York

RESIDENCES 347

8.12

ARCHITECT UNKNOWN (FRENCH)

1991.383: Competition drawing
for a château: cross-section, 18th century

Pencil, ink, watercolor. 15½ × 24 in. (39.3 × 60.9 cm)
INSCRIBED [in ink] [architectural measurements]
PROVENANCE Charles Plante, London

1989.149

8.13

ARCHITECT UNKNOWN (FRENCH)

1989.149: Competition drawing for a château entrance pavilion: facade and cross-section, ca. 1900

Pencil, ink, watercolor, metallic tape. 22½ × 41 in. (57.1 × 104.1 cm)
INSCRIBED [in watercolor] *UNE ENTRÉE DE CHATEAU*
PROVENANCE unknown

RESIDENCES 349

8.14

ARCHITECT UNKNOWN (FRENCH)

1988.106a,b: Competition drawings for a château: cross-section and elevation of entrance, ca. 1860

Pencil, ink, watercolor

1988.106a: Cross-section. 18¾ × 58¼ in. (46.9 × 147.9 cm)
INSCRIBED *N* (Napoleon III?)

1988.106b: Elevation detail. 24¾ × 34⅝ in. (62.8 × 87.9 cm)

PROVENANCE Sir James Dashwood, 2nd baronet (1715–1779), given by the architect, ca. 1765; thence by descent at Kirtlington Park, Oxfordshire, to Sir George Dashwood, 6th Baronet (1851–1933); sold with the estate in 1909 to John David Melville, 12th Earl of Leven and 11th Earl of Melville (1886–1913); his brother, Archibald Leslie-Melville, 13th Earl of Leven and 12th Earl of Melville (1890–1947); sold with the estate in 1922 to Hubert Maitland Budgett (1882–1951), thence by descent to his son Richard Alan Budgett (1913–2005); sold with the estate in the late 1960s to Christopher Buxton (1929–2017); anonymous sale (but in fact by Buxton), Sotheby's, London, 28 April 1988, lot 449.

1988.106a

8.15

ARCHITECT UNKNOWN (FRENCH)

1987.58: Competition drawing for a château: partial elevation, 1866

Pencil, ink, watercolor. 17¼ × 33¼ in. (43.8 × 84.4 cm)
INSCRIBED [inside cartouches, in watercolor] *R* / [in ink] *N 7 / F1 / 23 Mai 1866 / du* [indistinct] *inspecteur* / [in pencil] [indistinct listing of words] *Medaillons / Balcon en fer*
STAMPED [within circle of leaves, in black] *ECOLES DES BEAUX ARTS*
PROVENANCE unknown

8.16

ARCHITECT UNKNOWN (FRENCH)

2000.473: Competition drawing for a château: cross-section, 19th century

Pencil, ink, watercolor. 17⅞ × 34 in. (45.6 × 86.3 cm)
PROVENANCE Alain Cambon, Paris

8.17

ARCHITECT UNKNOWN (FRENCH)

1988.120a–d: Competition drawings for a royal or diplomatic residence, 1865

Pencil, ink, watercolor

1988.120a: Frontal elevation. 32½ × 72 in. (82.5 × 182.8 cm). INSCRIBED [in black, on pediment] 1865

1988.120b: Overall plan. 39 × 28 in. (99 × 71 cm) approx. INSCRIBED [in black] 3.

1988.120c: Detailed plan. 28 × 39 in. (71 × 99 cm) approx. INSCRIBED [in red] *PLAN DU PREMIER ETAGE* / [architectural measurements]

1988.120d: Detailed plan. 25 × 39 in. (63.5 × 99 cm), whole sheet, approx.

PROVENANCE unknown

❧ Though acquired as a set, it is possible the plans belong to a different submission.

1988.120a

1988.120c

1988.120d

8.18

JEAN-CAMILLE FORMIGÉ
(FRENCH, 1845–1926)

1995.400a–e: Competition drawings for an Ambassador's Residence, 1869

Pencil, ink, watercolor

1995.400a: Frontal elevation. 27 × 59 in (68.5 × 149.8 cm)

1995.400b: Cross-section. 27 × 59 in (68.5 × 149.8 cm)

1995.400c: Plan. 39½ × 39½ in (100.3 × 100.3)
INSCRIBED [on recto, in red] COUR D'HONNEUR / Cour du Consultat / Cour des Communs / Cour du Service diplomatique / Cour de la Chancellerie / Cancellier / Aumonier / 1ʳ. Secᵗ. d'ambʳ. / Grand Salle des fêtes / Chapelle / Tribune / Salon [5×] / Chambre de parade [2×] / Chambre de maître / cour de Service / Galerie [2×] / passage de service / Grand Escalier d'honneur / Salle des Banquets / au-dessus chambre à coucher / apart. Du Consul / [on verso, in black] Projets & Concours J.C.F. E7. N⁰ 24 / E d B Arts
STAMPED [on verso, in black] ECOLE DES BEAUX ARTS

1995.400d: Plan. 62 × 57½ in (157.4 × 146 cm)
INSCRIBED [on recto, in black] PLAN du REZ-DE-CHAUSSÉE / COUR D'HONNEUR / descente à couvert / Grand Vestibule / Salle des gens / Salle des gardes / Antichambre / Salon [2×] / Grande salle à manger / Petite salle à manger / Cour du Consulat / vice-consul / Loge / entrée des Bureaux / Bureaux [6×] / Concierge principal / Cour des communs / Sellerie / Passage de Service / Cour de Service / Pass. des Cuisines / Cour du Service diplomatique / Salle d'attente [3×] / Cour de la Chancellerie / descente à couvert / Chapelle / Salle des huissiers / Burˣ Secrets [2×] / Cabinet de l'ambʳ / Salon particulier / Chambres à coucher à Entresol / [architectural measurements] / [on verso] Formige E7. No 24

1995.400e: Plan. [measurements unavailable]

PROVENANCE Alain Cambon, Paris

🍂 Submitted to the 1869 Rome Prize competition, in which Formigé came in seventh.

1995.400a

1995.400b

1995.400d

1995.400e

1988.130

8.19

LOUIS JULES ANDRÉ (FRENCH, 1819–1890), ATTRIBUTED TO

1988.130 and 1991.362: Competition drawing for a pleasure palace: elevation and cross-section, ca. 1845

Pencil, ink, watercolor

1988.130: Elevation. 31 × 111⅜ in. (78.7 × 282.8 cm)

1991.362: Cross-section. 19 ¾ × 49¼ in. (50.1 × 125.1 cm)

LITERATURE Sotheby's, Monaco, sale cat. 17 June 1988, p. 22, lots 456 (detail ill.) and 458 (ill.)
PROVENANCE Sotheby's, Monaco, 17 June 1988, lots 456 and 458; Galerie Jean-Paul Pinson, Paris

🌺 The watercolor rendering of an antique mask or 'mouth of truth' affixed to upper right of 1988.130 was perhaps the symbol used by André in blind competitions.

1991.362

29-11-08 = Un avant-corps en rotonde - Mention

1988.144a

1988.144b

8.20

EMMANUEL GEORGES BRIAULT
(FRENCH, 1887–1963)

1988.144a–d: Competition drawings for a château: elevation, cross-sections, and plan, 1908

Pencil, ink, watercolor

1988.144a: Frontal elevation detail. 19⅞ × 24 in. (50.5 × 61 cm)
INSCRIBED [in pencil] *29.11.08. Un avant-corps en rotonde. Mention.* [in blue crayon] *3*

1988.144b: Cross-section. 11¾ × 26 in. (29.2 × 66 cm)

1988.144c: Cross-section. 9¾ × 14¼ in. (24.13 × 36.2 cm)

1988.144d: Plan of Entrance. 16⅝ × 13⅜ in. (42.2 × 34 cm)
INSCRIBED *VESTIBULE* / [2×] *GALERIE* / *LE GRAND SALON*

LITERATURE Sotheby's, Monaco, sale cat. 20 Feb. 1988, p. 72, lot 437 (five drawings, 144a ill.)
PROVENANCE Sotheby's, Monaco, 20 Feb. 1988, lot 437

🔥 Awarded third place in the *concours d'émulation* of 9 January 1908 where the assignment was *Un Avant-corps en rotonde* […] *dans un hôtel ou un château* […] assigned by Professor Guadet.

Printed assignment for the *Concours d'émulation* of 9 January 1908 (May Collection)

1988.144c

1988.144d

RESIDENCES 365

1987.28

8.21

ARCHITECT: ANDREA PALLADIO
(ITALIAN, 1508–1580)
ARTIST: NADALE GRIGGIO
(ITALIAN, DATES UNKNOWN)

1987.28: Drawing of Villa Barbaro, Maser, Italy: frontal elevation, 18th century

Pencil, ink, watercolor. 19 × 26½ in. (48.2 × 67.3 cm)
INSCRIBED [in sepia] *Nadale Griggio disegno* / [in ink] [architectural measurements]
PROVENANCE unknown

Villa Barbaro, Maser, Italy

8.22

ARCHITECT: ANDREA PALLADIO
(ITALIAN, 1508–1580)
ARTIST: E. KRAH (NATIONALITY UNKNOWN)

1988.404: Drawing of Villa Almerico-Capra (Villa Rotonda), Vicenza, Italy: elevation, 1886

Pencil, ink, watercolor. 12 × 17 in. (30.4 × 43.1 cm)
INSCRIBED (in ink) *E. Krah 1886 / Villa Capra bei Pavia*
PROVENANCE Shepherd Gallery, New York

🍂 The dome and coloring are different from Palladio's design and from the villa as built, and the inscription 'near Pavia' (in another hand) is, obviously, erroneous.

Villa Almerico-Capra (Villa Rotonda), Vicenza

RESIDENCES 367

8.23

DOMENICO DEL ROSSO
(ITALIAN, DATES UNKNOWN)

1989.188: Drawing of an entrance pavilion: facade, 1743

Pencil, ink, watercolor. 12¼ × 11 in. (31.1 × 27.9 cm)
INSCRIBED [in ink] *Domenico del Rosso 1743. / Scala di Canne quattro Naple. Il presente prospetto corrispondente alla pianta Segnata con la Lettera A. / B* / [architectural measurements]
PROVENANCE unknown

8.24

ARCHITECT UNKNOWN (ITALIAN)

1987.44: Design for a palace on Strada Aragona Pignatelli in Naples: frontal elevation, 19th century

Pencil, ink, watercolor. 18¼ in × 27¼ in. (46.3 × 69.2 cm)
INSCRIBED [in ink] *Prospetto del Palazzo Signorile/ Tav. 1ª. / Strada Aragona Pignatelli*
 1. *[indistinct]*
 2. *Case limitrofe di aliena partinente*
 3. *Cancelli*
 4. *Porte laterali*
 5. *Intrada Principale*
 6. *Finestra del pianterreno*
 7. *Balconi del piano nobile*
 8. *Finestre finte che sporgano sulla volta della gran Sala*

PROVENANCE unknown

8.25

ARCHITECT UNKNOWN (ITALIAN)

1990.336: Drawing for a palace: frontal elevation and plan, 19th century

Pencil, ink, watercolor. 14⅝ × 23½ in. (37.1 × 59.6 cm)
INSCRIBED [in sepia] [architectural measurements in Bolognese and Roman feet]
LITERATURE Sotheby's, London, sale cat. 15 Nov. 1990, p. 68, lot 22
PROVENANCE Sir John Summerson; Sotheby's, London, 15 Nov. 1990, lot 22 (from a folio of drawings); Charles Plante, London

8.26

ANDRÉ DURAND (FRENCH, 1807–1867)

1990.294: View of Villa Poggio Imperiale (also Villa Medici Poggio Imperiale; Villa di Poggio Baroncelli), Florence, 1851

Pencil, ink, watercolor. 11¾ × 18 in. (29.8 × 45.7 cm)
INSCRIBED [in ink] *ANDRÉ DURAND. 1851*.
LITERATURE Sotheby's, London, sale cat. 26 April 1990, p. 118, lot 385 (ill.)
PROVENANCE Sotheby's, London, 26 April 1990, lot 385

🌶 Possibly a preparatory sketch for a plate in Durand's *La Toscane. Album pittoresque et Archéologique* (1862–63) but unused.

Villa Poggio Imperiale, Florence

8.27

JEAN-FRANÇOIS HEURTIER
(FRENCH, 1739–1822)

2000.513: Competition drawing for the reconstruction of the Château de Versailles: partial sheet of frontal elevation, 1780s

Pencil, ink, watercolor. 7¾ × 11 in. (19.6 × 27.9 cm)
PROVENANCE D. & R. Blissett, London

❧ Three further competition drawings by Heurtier, *inspecteur général des bâtiments du roi* under Louis XVI, were in the Olivier Lefuel collection, auctioned in Paris in 2008, and are now owned by the Musée national du Château de Versailles. Plans for the reconstruction were ultimately abandoned. For background, see Élisabeth Maisonnier, *Versailles. Architectures Rêvées 1660–1815* (Versailles, 2019).

Jean-François Heurtier, *Projet de façade pour le château de Versailles côté est*, 1783–87 (Château de Versailles)

372 PETER MAY COLLECTION II

1988.99

8.28

ARTIST UNKNOWN

1988.99: Aerial view of Versailles and its formal gardens, 20th century

Pencil, watercolor, gouache. 8½ × 12½ in. (21.6 × 31.8 cm) approx.
PROVENANCE unknown

Palace of Versailles and its gardens

RESIDENCES 373

8.29

JACQUES MAURICE PREVOT
(FRENCH, 1874–1950)

1991.379a–d: Competition drawings for a royal stable: ca. 1895

Pencil, ink, watercolor, metallic tape

1991.379a: Frontal elevation. 16¾ × 57¾ in. (41.9 × 146.6 cm)
INSCRIBED [in ink] *M. Prévot E*ve*. De Mrs Guadet et Paulin*

1991.379b: Plan. 20¾ × 33¾ in. (52.7 × 85.7 cm)
INSCRIBED [in ink] *M. Prévot E*ve*. De Mrs Guadet et Paulin*

1991.379c: Construction details. 35⅜ × 23¾ in. (89.8 × 59.6 cm)
INSCRIBED [in ink] *M. Prévot E*ve*. De Mrs Guadet et Paulin* / [in pencil] *pas conforme au plan* […] *pas possible* [and further indecipherable remarks]

1991.379d: Two cross-sections. (each) 16 × 13 in. (40.6 × 33 cm)
INSCRIBED [in ink] *M. Prévot E*ve*. de M*rs *Guadet et Paulin*

PROVENANCE unknown

1991.379c

1991.379d

8.30

CHARLES PERCIER (FRENCH, 1764–1838), ATTRIBUTED TO

1989.176a,b: Two plans for the private residence and gardens of Louis-Nicolas d'Avoust (also Davout) (1770–1823), Duke of Auerstädt and Prince of Eckmühl, rue St. Dominique, Paris, ca. 1810

Pencil, ink, watercolor. 39¾ × 25¾ in. (100.3 × 64.7 cm)

1989.176a: general plan of the structure on the site
INSCRIBED [in ink] *Plan General de l'hotel du Marechal Davoust A Paris / Boulevard des Invalides / Rue de Grenelle / Esplanade des Invalides / Rue St. Dominique /* [architectural measurements]

1989.176b: Floor plan
INSCRIBED [in ink] *Plan de l'hotel du Prince d'Eckmulh, a Paris / Rue St. Dominique / Rue St. Dominique / Rue des Invalides /* [architectural measurements]

PROVENANCE Stubbs Books & Prints, New York

1989.176a

Plan de l'hôtel du Prince d'Eckmuhl à Paris.

1987.87

8.31

GEORGE VERTUE (BRITISH, 1684–1756)

1987.87: View of the royal palace at Richmond, mid-18th century

Pencil, ink, watercolor 11¾ × 18 in. (29.2 × 34.9 cm)
INSCRIBED: [on recto, in ink] *George Vertue Delineavit / Royal Palace at West Sheen, called Sheen up Thames, Rebuilt by Henry 7th: and by him new Named Richmond, on Account of his having been Earl of Richmond, the Old Palace was destroyed by Fire 24 Decr: 1498.* / [on verso] *This is the Principal, at least the most pleasing View of the Old Palace at Richmond, fronting the Thames, (anciently called West Sheen, Erected by Henry 7th. On the Scite [sic] of a more Ancient Palace called Sheen upon Thames, destroyed accidentally by Fire 21 Decr. 1498, the King Hen: 7.) residing there at the time.) It was Henry 7th who changed the Name from Sheen to Richmond on Acct of his having been Earl of Richmond in Yorkshire, Some think Sheen only a Corrupt pronunciation of Shine, & so to mean Shining or full of Splendor (but the word Shoen in the German & Celtic, signifies an Oak. And tis not improbably it might have been a corruption of Shoen, & have been so called on account of its being a place where many Oaks grew, Shine is also the Old French word for an Oak) there certainly was a Palace there temp: Edward 1st: 1272, who resided there, & it was then called the Kings Manor of Sheen upon Thames, as appears by a Record (de Ordinatione Scotiae) to be seen in Tyrrels History of England, Vol. 1, p. 162, in Rymer & elsewhere, & tis highly probable Hen: 3 might begin it, & least it to his son Edw. 1. to Finish, as nothing is to be found about it before Edw. 1s. time; This Palace in Hen:7. time about 1500 was all built with Free Stone, was covered with Lead, & was 100 feet long & 40 broad, besides large & usefull Offices detached from it, The Royal Apartments which considted of three Stories covred with Lead, each containing 12. Chambers, floored Cieled [sic] & Matted, well lighted & elegantly Decorated, were built round a Court 40 feet long by 24 broad, & there were including the Chappell 14 Turretts, which were Anciently deemed a great Ornament; there were besides very many Noble buildings anexed, particularly one round Tower called the Canted Tower, containing a fine Cellar & 4 handsome Rooms one out of the other entered by a flight of Stairs containing 120 Steps, this was esteemed a grand Ornament to the Palace, also the Chapell which was three Stories high, containing a noble arched Cellar, called the Wine Cellar, with a little room on one side of it, the middle Story contained three Rooms for the Yeomen of the Wine Cellar, & two more called the Groom Porters Rooms, & over this was the Chappel it self, 96 feet long & 30 broad, & of a good height, & well lighted, also furnished with Cathedral Seats & Pews, a moveable Pulpit, & an Organ Case: The Royal Apartments contained. The Queens Closet, in which were included a variety of fair & convenient Chambers, The Princes Closet Do. The Wardrob wich had very numerous apartments; In addition to these there were the Fryars, Privie Kitchin [sic], Liverie Kitchin where the Provision was Dressed, Larders, Poultryhouse, Woodyard, Plummerie, Armorie, Bakers house, Keepers house, Clock house, Conduit house, Privie Garden of 3 rood 12 perch, a fine Ewe Tree in y Centre, Privie Orchard, Great Orchard, & Dove house. This whole Palace contains 10 Acres one rood & a Perch, ... Tho' the most Pleasing Front is towards the Thames, yet there is no good or handsome Entrance that way, whereas from a Drawing I have seen of the Back Front, which was towards Richmond Green, there was a Regular Entrance*

by a large Olde Gait [sic] *way, The Palace of Richmond was then, as now, bounded on the North by Richmond Green, which contains about 20 Acres, & was anciently adorned with 113 Stately Urnes, with the River Thames on the Southwest, with the Fryery on the South, & with a way or Path leading from Richmond Green into the said Fryers on th'East, … Kew Green which is in the Manor of Richmond, contains also about 20 Acres, … Mr. Vertue copied this Drawing from a very large Picture Printed by Rubens and W. W. Holler made an Etching of the same Palace about 1630 in which he has Introduced the Royal Family of Charles the first as just Landing from a Royal Barge … The Society of Antiquarys London have also Engraved a Print of this same Palace, exactly the size of this Drawing & so like it that one would think it copied from it, only in their Print there are Swans coming towards the Palace in the water, & no boats, they have als* [sic] *engraved the back from which is opposite Richmond Green.*

LITERATURE Timothy and Jane Lingard, *Capital Buildings: An Exhibition of Architectural Designs and Topographical Views of London* (London, 1987), p. 12, cat. 1
PROVENANCE Gallery Lingard, London

❦ The Old Palace was largely destroyed in 1649.

W. Holler, *Richmond*, etching, 1638

RESIDENCES

8.32

JEFFRY WYATVILLE (1766–1840) AND
MICHAEL GANDY (BRITISH, 1778–1862)

1999.415a,b: Two views of Windsor Castle for publication, ca. 1840

Pencil, ink, watercolor

1999.415a: Military Knight's Tower. 11 ¾ × 16 ½ in. (29.8 × 41.9 cm)
INSCRIBED [in pencil] *Mich. Gandy Del – 33 years with the late Sir Jeffry Wyatville. / View of the Military Knight's Tower / Tower by J.C.* [indistinct] */ View of King Henry the Third's Tower Showing the Architect's Office and Middle-Ward Ramparts and Winchester Tower in the distance*

1999.415b: Upper Ward Tower. 12 × 17 ½ (30.4 × 44.4 cm)
INSCRIBED [in pencil] *Gandy / size of plate / size of plate / Hawkins / NE View of the Upper Ward – showing King John's Tower – State Entrance – St. George's Hall – Kitchen – Gateway – Visitors Entrance / with Brunswick Tower in the distance*

LITERATURE Sotheby's, London, sale cat. 27 April 1989, p. 168, lots 697, 698 (ills.); Sotheby's, London, sale cat. 26 April 1990, p. 120, lot 389 (ill.)

PROVENANCE (both) Sotheby's, London, 27 April 1989, lots 697, 698; (1999.415a) Sotheby's, London, 26 April 1990, lot 389; Charles Plante, London

See Michael Gandy and Benjamin Baud, *Architectural Illustrations of Windsor Castle* (London, R.A. Sprigg, 1842), for two of 40 lithographs (XXXIII and XXXIV).

Gandy and Baud, *Architectural Illustrations of Windsor Castle* (1842), Plates XXXIII and XXXIV

8.33

JEAN-BAPTISTE FOURTUNÉ DE FOURNIER (FRENCH, 1798–1864)

1988.131a,b: Two interiors of the Tuileries Palace during the reign of Napoleon III, 1855–56

Pencil, watercolor

1988.131a: Salle des Gardes du Corps (guardroom).
14⅞ × 18⁷⁄₁₆ in. (37.8 × 46.8 cm)
INSCRIBED [in black] *F. de Fournier 1856*

1988.131b: Grand Cabinet du Roi (king's room).
15 × 18¹⁵⁄₁₆ in. (38.1 × 48 cm)
INSCRIBED [in black] *F. De Fournier / d'Ajaccio / 1855.*

PROVENANCE Shepherd Gallery, New York

🙵 Watercolors of royal interiors were in vogue at the courts of Europe from the mid-19th century onward and were sometimes published. Napoleon III commissioned paintings of several state rooms in the Tuileries Palace from Fournier and some were exhibited at the Salon. Some of the interiors were also photographed in around 1865 before the devastating fire of 1871 destroyed the palace. Other watercolors from the series are in French museums.

Cabinet du Roi, Tuileries Palace, ca. 1865

8.34 (1)

ARTIST UNKNOWN

1989.178a–k: Eleven views of the village of Sagan, formerly Prussia, today Żagań, Poland, ca. 1850

Colored lithographs and gouaches mounted and labeled on paper

1989.178a: Sagan from the Sorauer side. 10⅜ × 14⅞ in. (26.3 × 37.7 cm)
INSCRIBED [on mount, in ink] *Stadt Sagan von der Sorauer Seite*

1989.178b: View of Sagan and the Sorauer bridge. 8⅞ × 13½ in. (22.5 × 34.2 cm)
INSCRIBED [on mount, in ink] *Die Sorauer Brücke*

1989.178c: The old quarter of Sagan. 7¾ × 12½ in. (19.6 × 31.7 cm)
INSCRIBED [on mount, in ink] *Alte Ring[strasse]*

1989.178d: The village center. 6 × 10¼ in. (15.2 × 26 cm)
INSCRIBED [on mount, in ink] *Altere Ring[strasse]*.

1989.178e: View of Sagan and the foot bridge. 4⅞ × 7⅛ in. (12.3 × 18.1 cm)
INSCRIBED [on mount, in ink] *Die laufe Brücke*.

1989.178f,g: Two views of the Evangelical Church. 7¼ × 8 in. (18.4 × 20.3 cm) and 3 × 6⅛ in. (10.1 × 15.5 cm)
INSCRIBED [on mount, in ink] *Evangelische Kirche*.

1989.178h–k: Four views, of the Willmann factory, Augustinian gate, 'Bergel' church and Sorauer bridge.
INSCRIBED [on mount, in ink] *Willmanns Fabrick. / Augustinisches Tor. / Bergel Kirche / Vorauer Brücke*.

1989.178a

1989.178b

1989.178c

Alter Ring

1989.178d

Neuer Ring

1989.178e

Die lange Brücke

Evangelische Kirche.

1989.178h-k

8.34 (II)

ARTIST UNKNOWN

1989.179–80 and 1989.183–87: Views of the Castle and Estate of Royal Duchy of Sagan, ca. 1850–55

Gouache

1989.179: Small sculpture gallery. 8 × 9⅜ in. (20.3 × 23.8 cm)
INSCRIBED [on mount, in ink] *Kleine Sculptur Gallerie*

1989.180: Entry hall. 8⅝ × 8⅝ in. (21.9 × 21.9 cm)
INSCRIBED [on mount, in ink] *Treppen Halle*

1989.183: Marble sculpture gallery. 9 × 12½ in. (22.8 × 31.7 cm)
INSCRIBED [on mount, in ink] *Marmorsculpturen Gallerie im Herzoglichen Schloss zu Sagan*

1989.184: So-called Lobkowitz corridor. 8 × 9½ in. (20.3 × 24.1 cm)
INSCRIBED [on mount, in ink] *Lobkowitzer Treppen Halle im Herzoglichen Schloss zu Sagan*

1989.185: Concert hall. 6⅞ × 11⅜ in. (17.4 × 28.8 cm)
INSCRIBED [on mount, in ink] *Konzert-Saal im Herzogl. Schlosse zu Sagan*

386 PETER MAY COLLECTION II

1989.183

1989.184

1989.185

1989.186: Orangerie and Dutch garden. 8⅝ × 13⅛ in. (21.9 × 33.3 cm)
INSCRIBED [on mount, in ink] *Orangeriehaus und Holländische Garten im Herzogl. Park zu Sagan*

1989.187: Fishing pavilion on the canal. 8¼ × 10⅜ in. (20.9 × 26.3 cm)
INSCRIBED [on mount, in ink] *Angelhaus am Canal im Herzoglichen Park zu Sagan*

LITERATURE Sotheby's, Monaco, sale cat. 4 March 1989, p. 6, lot 1 (ill.); p. 16, lot 22 (ill.); p. 19, lot 28; p. 28, lot 53 (ill.); p. 33, lots 59 and 60 (ill.); p. 36, lot 65 (ill.); p. 37, lot 67
PROVENANCE Talleyrand Library, Château de Valençay; Sotheby's, Monaco, 4 March 1989, lots 1, 22, 28, 53, 59, 60, 65, 67

❦ From a pair of albums with dozens of views commissioned by Dorothea (1793–1862), Duchess of Talleyrand-Périgord, daughter of Peter von Biron (1724–1800), last Duke of Courland, who purchased the Duchy of Sagan from the Lobkowitz family. Dorothea was an avid collector and patron and completely refurbished the interiors of the castle around 1850 according to prevailing tastes, documenting the results in watercolors by an anonymous artist. The albums were broken up and sold in 74 lots. Whether she commissioned or sponsored the lithographs of the village is unknown. In 1855, she opened the palace to visitors and published a catalogue of the paintings and sculpture.

1989.186

1989.187

Orangerie, Castle and Estate of Royal Duchy of Sagan

388 PETER MAY COLLECTION II

8.35

C. BOVET (FRENCH?)

1989.181, 182: Two views of the palace of Günthersdorf, now Zatorie, Poland, 1843

Gouache

1989.181: View of the palace from the garden.
$11\frac{3}{8} \times 15\frac{1}{2}$ in. (28.8 × 39.3 cm)
INSCRIBED [in ink] *C. Bovet 1843 / Günthersdorff Garten Seite*

1989.182: View of the palace from the courtyard.
$11\frac{1}{4} \times 15\frac{3}{8}$ in. (28.5 × 39 cm)
INSCRIBED [in ink] *C. Bovet. 1843. / Günthersdorff Hof Seite.*

LITERATURE Sotheby's, Monaco, sale cat. 4 March 1989, pp. 20–21, lots 34 (ill.) and 35 (ill.)

PROVENANCE Talleyrand library, Château de Valençay: Sotheby's, Monaco, 4 March 1989, lots 34 and 35

🌺 Built in 1842–43 by Dorothea von Biron, Duchess of Talleyrand-Périgord, who commissioned these views which were bound with the paintings of her estate in Sagan (8.34 (ii)) and dispersed at the same sale.

1989.181

1989.182

Palace of Günthersdorf, now Zatorie, Poland

1987.96

8.36

KENNETH STEEL (BRITISH, DATES UNKNOWN)

1987.96: View of St. James's Palace, London, ca. 1930

Pencil, watercolor, ink. 11½ × 13¾ in. (29.2 × 34.9 cm)
INSCRIBED [in ink] *Kenneth Steel*
LITERATURE Timothy and Jane Lingard, *Capital Buildings: An Exhibition of Architectural Designs and Topographical Views of London* (London, 1987), pp. 10 and 33, cat. 40
PROVENANCE Gallery Lingard, London

St James's Palace, London

8.37

JAMES PLUCKNETT & CO.
(BRITISH, CA. 1860–1908)

1990.303b: View of the reception room, Royal Pavilion, Brighton, UK, probably 1896

Pencil, watercolor, ink. 12½ × 20½ in. (31.8 × 52.1 cm) approx.
INSCRIBED [in pencil] *The Reception Room, Royal Pavilion, Brighton / Sussex / James Plucknett*
LITERATURE Sotheby's, London, sale cat. 26 April 1990, p. 142, lot 456
PROVENANCE Sotheby's, London, 26 April 1990, lot 456

❧ Apparently a scheme for decorating rooms at the Royal Pavilion in anticipation of a visit by Edward VII, either as Edward, Prince of Wales in 1896 or as King in 1908, 1909 or 1910.

BUCKINGHAM PALACE.
REMODELLING OF FRONT. SIR ASTON WEBB, R.A.
 ARCHITECT.

1987.88

8.38

ASTON WEBB (BRITISH, 1849–1930)
AND THOMAS RAFFLES DAVISON
(BRITISH, 1853–1937)

1987.88: Presentation drawing for
remodeling Buckingham Palace, ca. 1912

Pencil, ink. 9¼ × 22 in. (23.5 × 55.9 cm)
INSCRIBED [in ink] *BUCKINGHAM PALACE. REMODELLING OF FRONT. SIR ASTON WEBB, RA. ARCHITECT. / original DRAWN BY T. RAFFLES DAVISON* / [underneath matt] *presented to William Lucas by Artist's daugher 1938*
LITERATURE Sotheby's, London, sale cat. 24 sept. 1987, p. 33, lot 180 (ill.); Timothy and Jane Lingard, *Capital Buildings: An Exhibition of Architectural Designs and Topographical Views of London* (London, 1987), pp. 38–39, cat. 51
PROVENANCE Sotheby's, London, 24 Sept. 1987, lot 180; Gallery Lingard, London

Buckingham Palace, London

392 PETER MAY COLLECTION

1990.299

8.39

WILLIAM HAYWARD BRAKSPEAR
(BRITISH, 1819–1898)

1990.299: Drawing for a royal residence:
frontal elevation, ca. 1840

Pencil, ink, watercolor. 14 3/4 × 27 1/4 in. (37.4 × 69.2 cm)
EXHIBITED Royal Academy, London, 1843 (#1321)
LITERATURE *The exhibition of the Royal Academy of Arts: MDCCCXLIII: the seventy-fifth*, London: Royal Academy of Arts 1843, p. 49, no. 1321; Sotheby's, London, sale cat. 26 April 1990, p. 136, lot 440
PROVENANCE Sotheby's, London, 26 April 1990, lot 440

8.40

CYRIL ARTHUR FAREY
(BRITISH, 1888–1954)

2000.466, 467: Two views of Hampton Court Palace, 1908

Pencil, watercolor

2000.466: Perspective. 12¾ × 9⅛ in. (31.7 × 23.1 cm)
INSCRIBED [in watercolor] *Cyril A. Farey. Hampton. Court. Palace. Oct. 1908*

2000.467: Elevation. 12⅝ × 18¾ in. (32 × 46.9 cm)

LITERATURE *Thumbnotes & Masterpieces by Cyril Farey (1888–1954): Architectural Sketches and Watercolours between 1900 and 1925* (Gallery Lingard, London, 1996), p. 23, cat. 8
PROVENANCE Gallery Lingard, London

2000.466

Hampton Court Palace, UK

RESIDENCES 395

2000.514a

2000.514b

8.41

WILLIAM ATKINSON (BRITISH, d. 1839)

2000.514a,b: Presentation drawings for Statham Lodge, Cheshire, UK, for the Fox family, 1815

Pencil, ink, watercolor. Both 12¼ × 18⅜ in. (31.1 × 46.6 cm)

2000.514a: Frontal elevation
INSCRIBED [in ink] *A. / Entrance Front of Statham Lodge / W. Atkinson 1815*

2000.514b: South-west elevation
INSCRIBED [in ink] *A. / South West Elevation / W. Atkinson 1815*

PROVENANCE D. & R. Blissett, London

8.42

HENRY BAILEY (BRITISH, 1817–1894)

1999.417: Drawing for a neoclassical villa, frontal elevation, 1837

Pencil, watercolor. 21 × 26 in. (53.3 × 66 cm)
INSCRIBED [according to invoice] *Bailey 1837*
PROVENANCE Charles Plante, London

8.43

THOMAS CUBITT (BRITISH, 1788–1855), ATTRIBUTED TO

1989.211a,b: Two drawings for a country house: elevations and plans, before 1855

Pencil, ink, watercolor. 14 × 10 in. (35.5 × 25.4 cm)

1989.211a: Rear elevation and main floor plan
INSCRIBED [in ink] [2×] *Terrace / Hall Lighted by glass in Panels & door / Stove / Staircase / Back Stairs / Buffetier / [2×] Lobby / Study / W.C. / [2×] Store Closet / Conservatory / Drawing Room / ante Room / Dining Room / Housekeepers Room / Passage from offices / Butlers Room / Plate Closet*

1989.211b: Frontal elevation and upper floor plan
INSCRIBED [in ink] *Best Stairs / Back Stairs / [2×] Dressing Room / Lobby / W.C. / [4×] Bed Room*

LITERATURE Sotheby's, London, sale cat. 27 April 1989, p. 155, lot 647 (ill.)
PROVENANCE Sotheby's, London, 27 April 1989, lot 647 (from a portfolio of 16 drawings)

1989.211a

1989.211b

8.44

ALBERT WIELAND (GERMAN, DATES UNKNOWN)

2000.430–433: Competition drawings for a villa: elevations, plan, profile, 1889

Pencil, ink, watercolor

2000.430: Elevation and profile. 24¾ × 18⅛ in. (62.8 × 46 cm)
INSCRIBED [in ink] *Blatt N°. 7 / Classe 1. Fassaden: Streifen zum Entwurf eine freistehenden Wohnhauses* / *Buxtehude den 5.3. 89.* / *gesehen Kessler Architekt. Alb. Wieland H.B. No. 96.* / [architectural measurements]

2000.431: Frontal elevation. 17¾ × 24⅜ in. (45 × 61.9 cm)
INSCRIBED [in ink] *Blatt N°. 5. Classe 1. Vorder-Fassade zum Entwurf eines freistehenden Wohnhauses* / *Technikum Buxtehude den 28.2. 89.* / *ges. Kessler Architekt* / *Entw. u. gez. V. Alb. Wieland. H. B. No 96.* / [architectural measurements]

2000.432: Side elevation. 18⅛ × 24⅜ in. (46 × 61.9 cm)
INSCRIBED [in ink] *Blatt 6. Seiten-Fassade zum Entwurf eines freistehenden Wohnhauses / Class 1.* / [on weathervane] *1889* / [on plaque on façade] *Anno 1889* / *Technikum Buxtehude den 28.2.89* / *gesehen Kessler Architekt.* / *Entw. u. gez. Alb. Wieland. H. B. No 96.* / [architectural measurements]

2000. 433: Elevation and partial plan. 24⅜ × 18⅛ in. (61.9 × 46 cm)
INSCRIBED [in ink] *Blatt 20. Classe 2. Façade. Ionische-Ordnung.* / *Buxtehude den 28.2.88* / *attestirt Kessler* / *Albert Wieland* / [architectural measurements]

LITERATURE *Nineteenth Century European Architectural Drawings* (Shepherd Gallery, New York, 1994; unpaginated), cat. nos. 50–53

PROVENANCE Shepherd Gallery, New York

🌶 Wieland was presumably a student at the Baugewerkschule (Technical School for Building), Buxtehude, near Hamburg, Germany, founded in 1875. This assignment was overseen by architecture professor Kessler.

8.45

WILLIAM WARMAN (BRITISH, 1881–1977)

1987.67: Drawings for a country seat: two elevations, two plans and perspective, early 20th century

Pencil, ink, watercolor. 23 3/4 × 18 in. (23.5 × 45.7 cm)
INSCRIBED [in ink] *W. WARMAN* / [cipher] *WW* / *DESIGN FOR A COUNTRY SEAT* / [numbered ground floor plan] *1. DINING RM.* / *2. SITTING HALL* / *3. DRAWING RM.* / *4. MAIN STAIRCASE* / *5. MORNING RM* / *6. LIBRARY* / *7. STUDY* / *8. BILLIARD RM.* / *9. PALM COURT* / *10. GARAGE* / *11. SERVANTS ENT.* / *12. SERVANTS HALL* / *13. SCULLERY* / *14. KITCHEN* / *15. BUTLERS P.* / *16. STORE* / *17. LARDER* / *18. LAV & W.C.* / *19. STORE* / *20. LAV & W.C.* / *21. COAL & WOOD* / *22. SERVANTS W.C.* / *23. MAIN ENT.* / *24. GARDEN ENT.* / [numbered upper floor plan] *1. BEDROOM* / *2. DRESSING RM* / *3. BEDROOM* / *4. DRESSING RM* / *5. BEDROOM* / *6. MAIN STAIRCASE* / *7. BEDROOM.* / *8. BEDROOM.* / *9. BEDROOM* / *10. SCHOOL RM* / *11. BEDROOM* / *12. BEDROOM* / *13. NURSERY* / *14. SERVANT'S STAIRS* / *15. BEDROOM* / *16. SERVANTS BATH* / *17. BEDROOM* / *18. LAV & W.C.* / *19. BATHROOM* / *20. SEAT* / *21. SEAT* / *22. STORE & H.M. SINK* / *23. LAV & W.C.* / *ff LINEN CUPB.*
LITERATURE *Greeks and Goths: An Exhibition of Architectural Drawings in Revival Styles 1800–1930* (Gallery Lingard, London, 1987), pp. 38 and 40, cat. 42
PROVENANCE Gallery Lingard, London

8.46

ARCHITECT UNKNOWN (FRENCH)

1989.189a,b: Competition drawings for a villa: frontal elevations, ca. 1900

Pencil, ink, watercolor

1989.189a: Frontal elevation. 7 1/8 × 9 5/8 in. (18.1 × 24.4 cm)

1989.189b: Frontal elevation. 11 × 15 3/4 in. (27.9 × 40 cm)

PROVENANCE unknown

1987.67

1989.189a

1989.189b

8.47

ROBERT ADAM (BRITISH, 1728–1792)

1988.110: Presention drawing for a gate for the 4th Duke of Manchester for Kimbolton Castle, Huntingdonshire, UK, 1764

Pencil, watercolor. 23¾ × 36 in. (59.6 × 91.4 cm)
INSCRIBED [in ink] *Elevation & Plan of a Gateway for His Grace The Duke of Manchester at Kimbolton Castle in Huntingden Shire / R. Adam Architect 1764* / [architectural measurements]
LITERATURE Charles Hind, 'Collecting: Architectural Drawings', in *Sotheby's Preview*, March/April 1989, p. 6; Sotheby's, London, sale cat. 28 April 1988, p. 450, lot 449 (ill.)
PROVENANCE By descent in the Dashwood family to Sir George Dashwood, 6th Baronet; Mrs. H. R. Budgett; private collection; Sotheby's, London, 28 April 1988, lot 449

A preparatory drawing of 1764 is in Sir John Soane's Museum (vol. 51, no. 89).

Robert Adam, Preparatory drawing for Kimbolton Gate design, 1764 (Sir John Soane's Museum)

8.48

JOHN TASKER (BRITISH, 1738–1815)

1990.334: Design for a gate with lodges: elevation and plan, late 18th century

Pencil, ink, watercolor. 8¼ × 12¼ in. (20.9 × 31.1 cm)
INSCRIBED [in ink] *Jn Tasker Archt*
LITERATURE Sotheby's, London, sale cat. 15 Nov. 1990, pp. 26–27, lot 22 (ill.)
PROVENANCE Sir John Summerson collection; Sotheby's, London, 15 Nov. 1990, lot 22 (17 drawings by various hands); Charles Plante, London

8.49

ELIE BERTEAU (FRENCH, 1864–1906),
ATTRIBUTED TO

1989.168: Competition drawing for a villa: frontal elevation, 1880s

Pencil, ink, watercolor. 12½ × 17 in (31.7 × 43.1 cm)
PROVENANCE unknown

8.50

ARCHITECT UNKNOWN (FRENCH)

2000.480: Competition drawing for a villa: frontal elevation, ca. 1900

Pencil, ink, watercolor. 10 × 16 ¾ in. (25.4 × 42.5 cm)
PROVENANCE Daniel Greiner, Paris

8.51

EDOUARD JEAN MARIE HOSTEIN
(FRENCH, 1804–1889)

1987.55: View of Villa Dupuy de Lôme, 1877

Pencil, watercolor. 18½ × 23 ¾ in. (46.9 × 60.3 cm)
INSCRIBED [in watercolor] *Villa Dupuy de Lôme. près de La Valette (Var.) Environs de Toulon. Edouard Hostein 1877*
PROVENANCE unknown

8.52

J. DE BIEVRE (BELGIAN, DATES UNKNOWN)

2000.442: Competition designs for a villa: elevation, partial plan and portico, early 20th century

Pencil, ink, watercolor. 22¾ × 35¾ in. (57.1 × 90.1 cm)
INSCRIBED [in ink] *HOTEL DE VOGUE / PLAN / PORTIQUE / J. DE BIEVRE / 702 tome XIX / 862 / tomes I et II /* [in pencil] *148/150*
PROVENANCE Shepherd Gallery, New York

1990.258a

1990.258b

8.53

LOUIS PERIN (FRENCH, 1871–1938)

1990.258a,b: Competition drawings for a château with two roof variations, 1890s

Pencil, ink, watercolor. (Each) 19⅛ × 12⅝ in. (48.5 × 32 cm); overleaf 6½ × 12⅝ in. (16.5 × 32 cm)
STAMPED [*Louis PERIN Architecte Diplome par le Gouvernement Eleve des Ecoles PARIS*
PROVENANCE unknown

8.54

JACQUES JEAN CLERGET
(FRENCH, 1808–1877)

1991.356: Competition drawing for a villa: elevation and two plans, ca. 1830

Pencil, ink, watercolor. 23¾ × 16 in. (59.6 × 40.6 cm)
INSCRIBED [in ink] *Maison de Campagne / Plan / Rez de Chaussée / Travail / Cuisine / Vestibule / Salle a manger / Salon / 1ᵉʳ Etage / Chambre / [3×] Ch. à coucher / Balcon / Clerget (1ᵉʳᵉ. Année) /* [architectural measurements]
STAMPED [in red] *Ecole Centrale des Arts et Manufactures*
PROVENANCE unknown

8.55

G. HUGON (FRENCH, DATES UNKNOWN)

1987.60: Presentation drawing for a residence for M. Vallière, Boulevard Garnot, Dijon, France, early 20th century

Pencil, ink, watercolor. 22 × 34½ in. (55.8 × 87.6 cm)
INSCRIBED [in ink] *G. Hugon / HÔTEL DE MR. VALLIÈRE / Boulevard Garnot. DIJON*
PROVENANCE unknown

8.56

L. CUINAT (FRENCH, DATES UNKNOWN)

1990.309a–i: Competition drawings for a villa in Bois le Roi, France: elevations, cross-sections, plans, late 19th–early 20th century

Pencil, ink, watercolor

1990.309a: Side elevation and cross-section. 23 × 35¾ in. (58.4 × 90.1 cm) approx.
INSCRIBED [in ink] *VILLA A BOIS LE ROI / [3×] PLANCHERS EN POUTRES DECIMENT ARMÉ / L. CUINAT /* [architectural measurements]

1990.309b: Frontal elevation. 16 × 25 in. (40.6 × 63.5 cm)
INSCRIBED [in ink] *L. CUINAT /* [architectural measurements]

1990.309c: Two plans. 25 × 29 in. (63.5 × 73.7 cm) approx.
INSCRIBED [in ink] *VILLA A BOIS LE ROI / REZ DE CHAUSSÉE / SALLE A MANGER / SALON / VESTIBULE / BUREAU / W.C. / CUISINE / 1ER ETAGE / [4×] CHAMBRE / TOILETTE / W.C. / BAINS /* [architectural measurements]

1990.309d: Rear elevation. 13 × 14¼ in. (27.9 × 33 cm)

1990.309e, f: Side elevations. 13 × 11 in. (33 × 27.9 cm)

1990.309g: Cross-section. 11¾ × 14 in. (29.2 × 29.2 cm)
INSCRIBED [in red] [architectural measurements]

1990.309h: Plan. 11¾ × 11¾ in. (29.2 × 29.2 cm)
INSCRIBED [in ink] *VESTIBULE / DEBARRAS / CUISINE / W.C. / SALLE A MANGER / BUREAU /* [in red] [architectural measurements]

1990.309i: plan. 11¾ × 11¾ in. (29.2 × 29.2 cm)
INSCRIBED [in ink] *ANTICHAMBRE / CHAMBRE / BAINS / CHAMBRE / CHAMBRE / BALCON / BALCON / L. CUINAT ARCHITECTE /* [in red] [architectural measurements]

PROVENANCE unknown

VILLA À BOIS LE ROI

ECHELLE 0,02 P.M.

L. CUINAT

ECHELLE 0,02 P.M.

L. CUINAT

1990.309d

1990.309e 1990.309f

VILLA A BOIS LE ROI

REZ DE CHAUSSÉE

1ᴇʀ ÉTAGE

L. CUINAT ARCHITECTE

8.57

L. CUINAT (FRENCH, DATES UNKNOWN)

1987.54a–e: Competition drawings for a villa: elevations, plan, and cross-section, late 19th–early 20th century

Pencil, ink, watercolor, metallic tape

1987.54a: Frontal elevation. $19\frac{1}{4} \times 25\frac{1}{4}$ in. (48.9 × 64.1 cm)
INSCRIBED [in ink] *FAÇADE PRINCIPALE / L. CUINAT ARCHE.* / [architectural measurements]

1987.54b: Rear elevation. $19\frac{1}{4} \times 25\frac{1}{4}$ in. (48.9 × 64.1 cm)
INSCRIBED [in ink] *FAÇADE POSTERIEURE / L. CUINAT ARCHE.* / [architectural measurements]

1987.54c: Side elevation. $25\frac{3}{8} \times 19\frac{1}{4}$ in. (64.4 × 48.9 cm)
INSCRIBED [in ink] *FAÇADE LATERALE / L. CUINAT ARCHE.* / [architectural measurements]

1987.54d: Plan for ground floor. $19\frac{1}{4} \times 25\frac{5}{8}$ in. (48.9 × 65 cm)
INSCRIBED [in ink] *PLAN DU 1ER ÉTAGE / TOILETTE / [5×] CHAMBRE / BALCON / [3×] TOILETTE / SERVICE / PENDERIE / BAINS / DÉGAGEMENT / L. CUINAT ARCHE.* / [architectural measurements]

1987.54e: Cross-section. $16\frac{1}{4} \times 16\frac{5}{8}$ in. (41.2 × 42.2 cm)
INSCRIBED [in ink] *L. CUINAT ARCHT* / [architectural measurements]

PROVENANCE unknown

1987.54a

1987.54b

FAÇADE LATÉRALE

ECHELLE 0,02 Pr MÈTRE — L. CUINAT ARCHᵉ

1987.54c

ECHELLE 0,02 Pr MÈTRE — L. CUINAT ARCHᵉ

1987.54e

PLAN DU 1ᵉʳ ÉTAGE

Chambre — Chambre — Chambre — Balcon
Toilette
Bains — Dégagement — Toilette — Service
Chambre — Penderie — Chambre — Toilette

ECHELLE 0,02 Pr MÈTRE — L. CUINAT ARCHᵉ

1987.54d

8.58

R. VIDELOU (FRENCH, DATES UNKNOWN)

1990.286a,b: Competition drawings for two cottages: elevations, 1933, 1935

Pencil, ink, watercolor

1990.286a: 19 × 15 ¾ in. (48.2 × 40 cm)
INSCRIBED [in ink] *R. Videlou 22 Novembre 1933*

1990.286b: 14 ¾ × 20 ¼ in. (37.4 × 51.4 cm)
INSCRIBED [in ink] *R. Videlou 30/8/35*

PROVENANCE unknown

1990.286a

1990.286b

8.59

ARCHITECT UNKNOWN (FRENCH)

1990.319a–d: Competition drawings for a farmhouse and barn: elevations, plans and cross-section, early 20th century

Pencil, ink, watercolor

1990.319a: South elevation. 13 × 37 in. (33 × 93.9 cm)
INSCRIBED [in ink] *Batiment annexe / Façade Sud /* [architectural measurements]

1990.319b: North elevation. 11¾ × 37¼ in. (29.8 × 94.6 cm)
INSCRIBED [in ink] *Batiment annexe Façade Nord /* [architectural measurements]

1990.319c: Former condition and plans. 24¾ × 38¾ in. (62.8 × 97.7 cm)
INSCRIBED [in ink] *Maison d'Habitation / Etat Ancien / Façade / Coupe / Rez de Chaussée / ENTRÉE / SALON / SALLE à MANGER / CUISINE / Etage /* [2×] *CHAMBRE / TOILETTE / CHAMBRE DE DOMESTIQUE / Sous Sole / CAVE / SERRE-PLEIN /* [in red and black] [architectural measurements]

1990.319d: East elevation. 12¼ × 34¾ in. (31.1 × 87.6 cm)
INSCRIBED [in ink] *Façade Est /* [architectural measurements]

PROVENANCE unknown

NORTH - ELEVATION

SOUTH - ELEVATION

WEST ELEVATION

EAST ELEVATION

1987.81

8.60

JEFFREY WYATVILLE (BRITISH, 1766–1840), ATTRIBUTED TO

1999.420a–d: Presentation drawings for a Gothic-style cottage, early 19th century

Pencil, ink, watercolor. 6½ × 20½ in. (16.5 × 52 cm)

 1999.420a: INSCRIBED [in ink and watercolor] *NORTH – ELEVATION*

 1999.420b: INSCRIBED [in ink and watercolor] *SOUTH – ELEVATION*

 1999.420c: INSCRIBED [in ink and watercolor] *WEST – ELEVATION*

 1999.420d: INSCRIBED [in ink and watercolor] *EAST – ELEVATION*

LITERATURE *Antiques Trade Gazette*, 13 Nov. 1999, p. 87 (ill.)
PROVENANCE D. & R. Blissett, London

🦊 Formerly attributed to John Nash (1752–1835); reattributed to Wyatville by Charles Hind.

8.61

SAMUEL WILLIAM TRACY (BRITISH, DATES UNKNOWN)

1987.81: View of a country house, 1855

Pencil, ink, watercolor. 13½ × 19¼ in. (34.2 × 48.9 cm)
INSCRIBED [in ink] *S.W.Tracy. MIBA. 1855*
LITERATURE Sotheby's, London, sale cat. 22 May 1986, p. 109, lot 323 [ill. mislabeled as lot 325]
PROVENANCE Sotheby's, London, 22 May 1986, lot 323

RESIDENCES 421

8.62

ARCHITECT UNKNOWN (BRITISH)

1987.40: View of a country house, mid- to late 19th century

Pencil, ink, watercolor. 26 × 39 ¾ in. (66 × 100.9 cm)
PROVENANCE unknown

8.63

DAVID BRANDON (BRITISH, 1813–1897)

1991.373: View of Colesborne House, Gloucestershire, UK

Pencil, watercolor. 24¾ × 38¾ in. (62.2 × 97.7 cm)
EXHIBITED [according to Sotheby's] *Exhibition of the Art Treasures of the United Kingdom*, Manchester, 1857 [not located in publications accompanying exhibition]
LITERATURE Sotheby's, London, sale cat. 11 April 1991, pp. 112–13, lot 102 (ill.)
PROVENANCE Sotheby's, London, 11 April 1991, lot 102

❦ Commissioned by J. N. Elwes in 1851, completed in 1855 and demolished in 1958.

Colesborne House, Gloucestershire, UK

RESIDENCES 423

8.64

ARCHITECT UNKNOWN (BRITISH)

1987.73a,b: Two views of a country house, ca. 1900

Pencil, watercolor. 21 × 30 in. (53.3 × 76.2 cm)
PROVENANCE Gallery Lingard, London

1987.73a

1987.73b

8.65

ARCHITECT: EDWARD GUY DAWBER
(BRITISH, 1861–1938)
ARTIST: JOHN DEAN MONROE HARVEY
(BRITISH, 1895–1978)

1987.68: Presentation drawing for 'Berry Leas', Elton, Huntingdonshire (now Cambridgeshire), UK

Pencil, watercolor. 18¾ × 27 in. (46.9 × 65.5 cm)
INSCRIBED [beneath mount] *Reduce height of window over bay/dormers/roof pitch/take over bay* / [architectural measurements] / [on mount] *BERRY LEAS, ELTON, HUNTINGDONSHIRE. E. GUY DAWBER, A.R.A. 18 MADDOX STREET LONDON / J.D.M. HARVEY. DELT.*

EXHIBITED Royal Academy, London, 1929, no. 1258; *British Empire Trade Exh.*, Buenos Aires, 1931, no. 2
LITERATURE Sotheby's, London, sale cat. 22 May 1986, p. 118, lot 348; *Trad Jazz & Mod / An Exhibition of European Architectural Drawings of the 1920s and 1930s* (Gallery Lingard, London, 1986), p. 21
PROVENANCE Sotheby's, London, 22 May 1986, p. 118, lot 348; Gallery Lingard, London

🌺 Built in around 1929 and still standing, unaltered

Portrait of Edward Guy Dawber by William Orpen, 1930 (RIBA Collections, London)

RESIDENCES

2000.462

8.66

ARCHITECTS: WILLIAM FREDERICK
UNSWORTH (BRITISH, 1876–1912)
AND HENRY INIGO TRIGGS
(BRITISH, 1876–1923)
ARTIST: CYRIL ARTHUR FAREY
(BRITISH, 1888–1954)

2000.462–2000.464: Presentation drawings for three country houses, 1921–30

Pencil, ink, watercolor, gouache

2000.462: Perspective and plan of a house at Hartfield by Unsworth & Triggs, 1921. 9 × 14¾ in. (22.8 × 37.4 cm)
INSCRIBED [in watercolor] *CYRIL A. FAREY DEL. 1921* / [in pencil and watercolor] *HOUSE AT HATFIELD Unsworth and Triggs. Architects* / [plan labeled with letters]

2000.463: Elevation and two plans for a house called Rake Holt at East Liss near Petersfield, 1930. 16 × 26¾ in. (40.6 × 67.3 cm)

INSCRIBED [in ink and watercolor] *RAKE HOLT / EAST LISS NEAR PETERSFIELD / Ground Floor Plan* [labeled with letters] / *First Floor Plan* [labeled with letters] / *Basement.* [labeled with letters] / [on applied paper label, in ink] *Cyril. A. Farey. Delt.* / [on applied paper label, in ink] *Unsworth & Goulder Architects.* / [architectural measurements]

2000.464: Presentation drawing for a house at Puttenham, Surrey, 1923. 13¾ × 20¾ in. (37.9 × 52 cm)
INSCRIBED [underneath mount] *CYRIL A. FAREY DEL. 1923.* / [on mount] *Cyril A. Farey: Delt. HOUSE AT PUTENHAM. SURREY. Unsworth & Triggs. Architects*

LITERATURE *Thumbnotes & Masterpieces by Cyril Farey (1888–1954) / Architectural Sketches and Watercolors between 1900 and 1925* (Gallery Lingard, London, 1996, pp. 18 and 39, cat. 115 (ill.) –118
PROVENANCE Gallery Lingard, London

🌺 Unsworth & Triggs was the architectural firm of William Frederick Unsworth and Henry Inigo Triggs. Rake Holt house was illustrated in *Architect and Building News*, 148, 13 November 1936, p. 206.

RAKE HOLT
EAST LISS NEAR PETERSFIELD

12

FACADE PRINCIPALE

COUPE C.D.

SOUS-SOLS REZ-DE-CHAUSSEE 1ᵉʳ ETAGE COMBLES

COUPE A.B.

Projet d'un

Pavillon de chasse

8.67

J. DE BIEVRE (BELGIAN, DATES UNKNOWN)

2000.448: Competition drawings for a hunting lodge: elevations, plans, cross-sections and perspective

Pencil, ink, watercolor. 24¼ × 35⅜ in. (61.6 × 89.8 cm)
INSCRIBED [in ink] *Projet d'un Pavillon de chasse* / 12 / *FAÇADE PRINCIPALE* / *COUPE A.B.* / *COUPE C.D.* / *SOUS-SOLS* / *CHARBON* / *BUISINE* / *CAVE-BOIS* / *CAVE-VINS* / *PROVISIONS* / *OUTILS* / *REZ-DE-CHAUSSEE* / *GRANDE SALLE* / *HALL* / *TERRASSE* / *TERRASSE COUVERTE* / *OFFICE* / *CHENIL* / *VESTIAIRE* / *LAVATORY* / [2×] *W.C.* / 1ᴱᴿ *ETAGE* / [3×] *CHAMBRE* / [3×] *TOILETTE* / *COMBLES* / *MANSARDES* / [in blue crayon] 28.3 / 4
STAMPED [circular, in red ink] *ACADÉMIE ROYALE DES BEAUX-ARTS ET ÉCOLE DES ARTS DECORATIFS*
PROVENANCE Martin du Louvre Gallery, Paris

8.68

C. LIBERTON (BELGIAN, DATES UNKNOWN)

2000.451: Competition drawings for a villa: frontal elevation, profile and plan, 1915

Pencil, ink, watercolor. 27¾ × 20¾ in. (69.9 × 52.1 cm)
INSCRIBED *Etude d'une Villa* / *Façade principale* / [within three circles] 17 / *C. Liberton 1915* / [architectural measurements]
PROVENANCE Martin du Louvre Gallery, Paris

2000.451

RESIDENCES 429

8.69

JUEL ESMER (DANISH, DATES UNKNOWN)

1989.196a–h: Competition drawings for an artist's house, 1906

Pencil, ink, watercolor. 21¼ × 35¾ in. (53.9 × 80 cm)

1989.196a: Frontal elevation
INSCRIBED [in ink] · FAMILIEBOLIG · FOR · EN · MALER · / Juel Esmer Januar 1906 / [architectural measurements]

1989.196b: Perspective
INSCRIBED [in ink] Familiebolig for en Maler / Bygningen I Perspektiv fer fra nordost / Juel Esmer Januar: 1906 / [architectural measurements]

1989.196c: Rear elevation
INSCRIBED [in ink] · FAMILIEBOLIG · FOR · EN · MALER · / Bygningen i Perspektiv set fra nordøst / Juel Esmer Januar 1906 / [architectural measurements]

1989.196d: Perspective
INSCRIBED [in ink] Familiebolig for en Maler / Parti set fra Haven / Juel Esmer Januar: 1906

1989.196e: Side elevation
INSCRIBED [in ink] · FAMILIEBOLIG · FOR · EN · MALER · / Juel Esmer Januar 1906 / [in red pencil] No 8 / [in blue pencil] Pr 2 / [architectural measurements]

1989.196f: Cross-section
INSCRIBED [in ink] · FAMILIEBOLIG · FOR · EN · MALER · / Juel Esmer Januar 1906 / [architectural measurements]

1989.196g: Cross-section
INSCRIBED [in ink] · FAMILIEBOLIG · FOR · EN · MALER · / Juel Esmer Januar 1906 / [architectural measurements]

1989.196h: Two plans
INSCRIBED [in ink] · FAMILIEBOLIG · FOR · EN · MALER · / Plan af 1ste Sal. / Toilet / Tjener / Rum for Model / Atelier / Søn / Badeværelse / VC / Herrenes paaklædning / Fruens paaklædning / Herrens og Fruens Soveværelse / Datters paaklædning / Datter / Dagligstue / Værelse / Gæstev. / Skabværelse / Billard / Husjomfru / Kammerjomfru / Plan af Stueetagen. / Anretning Elevator / Spisestue / Toilet [×2] / Forstue / Rum for Model / Atelier / Atelier / Bibliotek / Venteværelse / Malerens Arbejdsværelse / Entré / Havestue / Salon [×2] / Rekvisiter / Værelse for tjeneste [?] / Væksthus / Juel Esmer Januar 1906 / [architectural measurements]

LITERATURE Sotheby's, London, sale cat. 27 April 1989, p. 172, lot 706
PROVENANCE Sotheby's, London, 27 April 1989, lot 706

1989.196a

1989.196b

1989.196c

1990.291d

1989.196e

1989.196f

1989.196g

1989.196h

8.70

HANS RASMUSSEN (DANISH?, DATES UNKNOWN)

1989.159a,b: Competition drawings for two hexagonal houses: elevations, plans, cross-section, 1931

Pencil, ink, watercolor. 26 3/4 × 40 in. (67.9 × 101.6 cm)

1989.159a: Frontal elevation and plans.
INSCRIBED [in ink] *UNE MAISON HEXAGONALE ESSAI* / *N°. 41* / *SURFACE BATI 172,38 M LES MURS DU HEXAGONE SONT 7 % PLUS COURTS ENVIRON QUE CEUX DU CARRE – L'ETENDUE DES PIECES EST PLUS GRANDE – AUX ANGLES EST CREE UN AMENAGEMENT MODERNE ET TRES COMPLET* / *L'HEXAGONE REALISE UNE INSOLATION COMPLETE DE TOUTES LES PIECES CELLES DONNANT AU N-OUEST ET N-EST RECOIVENT LE SOLEIL SOUT L'ANGLE DE 89° AU SOLSTICE D'ETE ET 31° EN HIVER SUR LE 48° DE LATITUDE* / *A GAUCHE* / *MAISON FAMILIALE COMPOSEE DE 3 CHAMBRES AVEC LEURS BAINS ET UNE CHAMBRE DE BONNE* / *Vestibule* / *W.C.* / *Chambre de bonne* / *Office* / *monte plat* / *Salle a manger* / [3×] *Chambre* / [3×] *Bains* / *Hall-Salon* / *A DROITE* / *DEMEURE DE LUXE: 3 PIECES DE RECEPTION – CHA. AVEC CABINET D'HABILLAGE – BAINS – CH. BONNE* / *Vestibule* / *W.C.* / *Chambre de bonne* / *Office* / *monte plat* / *Salle a Manger* / *Vaisselle* / *Salon* / *Livres* / *Chambre* / *Habits* / *Cabinet d'habillage* / *Linge* / *Bains* / *LE MEME SOUS-SOL POUR TOUTES LES DEUX MAISON AU MILIEU* / *Vestibule du Sous-sol* / *Cuisine* / *monte plat* / *Terre-plein* / *Lavanderie* / *Chaufferie* / *W.C.* / *Cave* / [compass] / *Paris mai 1931* / *Hans Rasmussen architecte*

1989.159b: Rear elevation, cross-section and garden plan.
INSCRIBED [in ink] *UNE MAISON HEXAGONALE ESSAI* / *COUPE TRANSVERSALE PAR L'AXE NORD-SUD* / *FAÇADE POSTERIEURE DONNANT AU MIDI* / *PLAN DU JARDIN* – [architectural measurements] / *Paris mai 1931 Hans Rasmussen architecte*

PROVENANCE Fischer-Keiner, Paris

N° 42

UNE MAISON HEXAGONALE ESSAI

FACADE POSTERIEURE DONNANT AU MIDI

COUPE TRANSVERSALE PAR L'AXE NORD-SUD

ECHELLE 0.02 PAR METRE

POTAGER OU PELOUSE

POTAGER OU PELOUSE

PLAN DU JARDIN = ECHELLE 0.01 PAR METRE

Paris mai 1931
Hans P. Rasmussen
architecte

8.71

EDWARD BROWN
(BRITISH, DATES UNKNOWN)

1987.95: Drawing for attached housing for Chestnut Avenue, Forest Gate, Spitalfields, London: elevation, 1875

Pencil, ink, watercolor. 15 × 48 in. (38.1 × 121.9 cm)
INSCRIBED [in ink] *EDWARD BROWN. SURVEYOR. 25 CHURCH STREET SPITALFIELDS.* / [in red and black] *Elevation of 21 Cottages situate in Chestnut Avenue Forest Gate Essex The Property of the Spitalfields Investment Society. Erected. 1875.*
LITERATURE *Capital Buildings: An Exhibition of Architectural Designs and Topographical Views of London* (Gallery Lingard, London, 1987), p. 12, cat. 12
PROVENANCE Gallery Lingard, London

8.72

ARCHITECT: BASIL CHAMPNEYS
(BRITISH, 1842–1935)
ARTIST: R.W. GODDARD (BRITISH, DATES UNKNOWN)

1990.283: Drawing of St. Bride's Vicarage, Fleet Street, London: elevation, 1886

Pencil, in, watercolor. 18½ × 16 in. (46.9 × 40.6 cm)
INSCRIBED [in sepia] *ST BRIDE'S VICARAGE. FLEET STREET. BASIL CHAMPNEYS ARCHT 19 BUCKINGHAM STREET STRAND W.C.* / *R.W. GODDARD. DEL*
PROVENANCE unknown

❧ Perhaps prepared for publication in *The Building News*, 27 August 1886.

434 PETER MAY COLLECTION II

'St. Bride's Vicarage', *The Building News*, 27 August 1886

St. Bride's Vicarage, Fleet Street, London

RESIDENCES 435

Abbaye S.^te Geneviève

Lucarne sur la Cour

8.73

ARCHITECT UNKNOWN (FRENCH)

1987.30: Composite study of an exterior window of the Abbey of Sainte Geneviève, Paris, ca. 1900

Pencil, ink, watercolor. 39¼ × 26¾ in. (99.6 × 67.9 cm)
INSCRIBED [in ink and watercolor] *Abbaye Ste. Geneviève / Lucarne sur la Cour*
PROVENANCE unknown

8.74

ARCHITECT UNKNOWN (FRENCH)

1989.151: Competition drawing for a palace entrance: elevation, plan, cross-section, ca. 1900

Pencil, ink, watercolor. 25 × 40 in. (63.5 × 101.6 cm)
INSCRIBED [in watercolor] *UNE LOGE*
PROVENANCE unknown

RESIDENCES 437

8.75

EUGÈNE LUCIEN BOURDAIN (b. 1873)

1988.133, 1990.275: Composite studies of a building in the 5th arrondissement, Paris, ca. 1900

Pencil, ink, watercolor, metallic tape

1988.133: Close-up composite details. 39 × 26¼ in. (99 × 66.6 cm)
INSCRIBED [in watercolor] *DÉTAILS AU 5ème / E. BOURDAIN*
PROVENANCE unknown

1990.275: Frontal elevation, profile, cross-section and plan. 50 × 30¾ in. (127 × 78.1 cm)
INSCRIBED [in ink] *E. BOURDAIN El. De MM. Lequeux et Dufour.*
PROVENANCE Stubbs Books & Prints, New York

1998.133

1990.275

E. BOURDAIN
El. de MM. Lequeux et Dupont

8.76

ARCHITECT UNKNOWN (FRENCH)

1990.273: Composite study of a château, ca. 1900

Pencil, ink, watercolor. 37¼ × 25 in. (94.6 × 63.5 cm)
PROVENANCE unknown

1987.6

1987.12

8.77

PAUL MARTIN (FRENCH, DATES UNKNOWN)

1987.6 and 1987.12: Drawings for rental buildings with apartments and shops in Moulins, France: frontal elevations, 1891–92

Pencil, ink, watercolor

1987.6: Frontal elevation. 25 × 18¼ in. (63.5 × 46.3 cm)
INSCRIBED [in ink] *Projet de Maison à Loyer / Moulins, 15 Mai 1892 Paul Martin*

1987.12: Frontal elevation. 20½ × 15¾ in. (52 × 40 cm)
INSCRIBED [in ink] *PROJET DE MAÏSON A LOYER – FAÇADE PRINCIPALE* / [over door] *18* / [left of doorway] *DRAPERIE SOIERIES LAINAGES A. VABRE. / IMPRESSION P. JOUVET & Cº RELIURE / LIBRAIRIE D'ART / Paul Martin inv. Moulins le 1 Juin 1891*

PROVENANCE unknown

RESIDENCES 441

8.78

EMILE WILLAEY (FRENCH, DATES UNKNOWN)

1989.155: Drawing for 21 Avenue de Paris, Vincennes: frontal elevation, 1904

Pencil, ink, watercolor. 25½ × 18⅛ in. (64.7 × 46 cm)
INSCRIBED [in sepia] *Rue de Paris / DRESSE PAR L'ARCHITECTE SOUSIGNE / VINCENNES LE 20 JUIN 1904 Eme Willaey*
PROVENANCE unknown

8.79

ARCHITECT UNKNOWN (FRENCH)

1990.271 and 1990.272: Drawings for apartment buildings in Paris: frontal elevations, ca. 1900

Pencil, ink, watercolor

1990.271: 120 Boulevard de Sébastopol. 14¼ × 8⅝ in. (36 × 22 cm)
INSCRIBED [in ink] *PROPRIÉTÉ / 120 Bould de SÉBASTOPOL 120 / ÉLÉVATION PRINCIPALE*

1990.272: 39 rue Neuve des Mathurins. 15½ × 10 in. (39.4 × 25.4 cm) approx.
INSCRIBED [in ink] *PROPRIÉTÉ RUE NEUVE DES MATHURINS _39_ ELÉVATION*

PROVENANCE unknown

❧ These were probably prepared for publication in an architectural journal.

1989.155

442 PETER MAY COLLECTION II

PROPRIÉTÉ

120 Boult de Sébastopol 120

Élévation Principale

PROPRIÉTÉ

Rue Neuve des Mathurins _39_

_ Élévation _

1991.375a

1991.375b

8.80

ADOLF LANG (HUNGARIAN, 1848–1913)
AND ANTAL STEINHARD
(HUNGARIAN, 1856–1928)

1991.375a,b: Drawings for the New York apartment building, Budapest, Hungary: elevation and cross-section, 1891

Pencil, ink, watercolor

 1991.375a. Elevation. 23 × 40 in. (58.4 × 101.6 cm)
 INSCRIBED [2× on façade, in watercolor] *NEW YORK*

 1991.375b. Cross-section. 24 × 32 in. (61 × 81.28 cm)

PROVENANCE Stubbs Books & Prints, New York

8.81

PROSPER ETIENNE BOBIN
(FRENCH, 1844–1923)

1989.197 (Bobin archive): drawing of an entry

Pencil, ink. $9\frac{1}{2} \times 11$ in (24.1 × 28 cm)
LITERATURE Sotheby's, London, sale cat. 27 April 1989, p. 156, lot 653
PROVENANCE Sotheby's, London, 27 April 1989, lot 653

1989.197

2000.452

2000.453

8.82

A. R. JANSSENZ (BELGIAN, DATES UNKNOWN)

2000.452–2000.455: Drawings for town houses in Brussels, Belgium: frontal elevations and profiles, 1911–16

Pencil, ink, watercolor

2000.452: Rue de la Monnaie, 2, Brussels. 19⅝ × 11¾ in. (49.8 × 29.8 cm)
INSCRIBED [in ink] *Maison rue de la monnaie nº. 2. / – Façade. – / – Coupe. – / 24 – IV – 1911 / AR Janssenz / Ernst Van* [indistinct] / [architectural measurements]

2000.453: Rue de la Monnaie, 14, Brussels. 18⅛ × 11¾ in. (46 × 29.8 cm)
INSCRIBED [in ink] *Maison rue de la monnaie nº. 14. / – Façade – / – Coupe. – / 12 – IV – 1911 / AR Janssenz. / Ernst Van* [indistinct] / [architectural measurements]

2000.454: Rue Haute Soleil, 1. Brussels. 17⅜ × 17⅜ in. (44.1 × 44.1 cm)
INSCRIBED [in ink] *Nº. 1 A 3 / – Maisons rue haute soleil. – Nº. 1 A. 3 / – Plan – / – Coupe – / 15 – IV – 1911. / AR Janssenz. /* [architectural measurements]

2000.455: Façade and section of the Van Der Meersch residence, rue Jan Breydel, Ghent. 17¾ × 18¾ in. (45.1 × 47 cm)
INSCRIBED [in ink] *PROPRIETE – DES – M^{LLES} – VAN – DERMEERSCH. / RUE – JEAN – BREYDEL – A – GAND. / FAÇADE – PRINCIPALE. / – Avant-projet de restauration dressé par l'architecte soussigne – Gant, le 14 août 1916 – / AR Janssenz. /* [architectural measurements]

PROVENANCE Martin du Louvre Gallery, Paris

2000.454

2000.455

RESIDENCES 447

8.83

CAMILLE GARDELLE
(FRENCH, 1866–1947)

1988.124, 1988.125: Drawings for two private residences in Montevideo, Uruguay: elevations and provile, 1916–18

Pencil, ink, watercolor

1988.124: Frontal elevation and two profiles of the A. Heber Jackson residence, 1918. 39¾ × 25¾ in. (100.3 × 64.7 cm)
INSCRIBED [in watercolor and ink] *PALACIO A. HEBER JACKSON* / [in ink] *Montevideo Marzo 15. 1918.* / *El Arquitecto Camilo Gardelle* / [architectural measurements]

1988.125: Frontal elevation of the Francisco Piria residence, 1916. 25 × 38 in. (63.5 × 96.5 cm)
INSCRIBED [in watercolor and ink] *PALACIO PIRIA FRENTE CALLE IBICUY* / [in ink] *Camille Gardelle Arch. Mayo, 27 1916.*

PROVENANCE Guinevere Antiques, London

🍂 The Jackson residence is now home to two museums while the Piria property houses the Supreme Court.

Palacio Jackson, Montevideo

1998.124

448 PETER MAY COLLECTION II

PALACIO PIRIA FRENTE CALLE IBICUY

Palacio Piria, on the former Calle Ibicuy, now Los Derechos Humanos, Montevideo

RESIDENCES 449

9
INTERIORS, INTERIOR DESIGN AND DECORATION

9.1

JULES HARDOUIN-MANSART
(FRENCH, 1646–1708)

1989.172a,b: Two preliminary designs for the marble paving of the Dôme des Invalides, Paris, 1691–98

Pencil, ink, watercolor

1989.172a: Detail of central paving. 32⅜ × 23 in. (82.2 × 58.4 cm)
INSCRIBED [recto, in ink]
A. Il y aura 4. chiffres courones.
B. " " 4 chiffres en outre sans couronne.
C. " " 8 Fleurons Entiers
D. " " 16 demyes fleurons
E. " " 16 roses Entieres.
F. " " 96 demyes fleurons dans le plat bande du dosme / [verso, in ink] bon / Dessein du pavé de marbre du dosme de l'Église des Invalides réglé par M. Mansart en avril 1691 sur lequel est marqué la quantité de chacun ornement qui se doit faire, reçu le 12 juillet 1698

1989.172b: Detail of central and radial paving. 27¼ × 22¼ in. (69.2 × 56.5 cm)
INSCRIBED [recto, in ink] Je prie M. Baufran [sic] de mettre les huit fleurons sur ce plan dans les endroits marqués 3 autres de ce qui il est me fera plaisir à Versailles le 3e. mars 1691 / [verso, in ink] bon / Dessein du pavé de marbre des chapelles de l'Église des Invalides, réglé par M. Mansart en avril 1691, reçu le 12 juillet 1698

LITERATURE Sophie Mouquin, *Versailles en ses marbres* (Paris, 2018), p. 251, figs. 261, 262
PROVENANCE unknown

🌺 These two drawings were both approved ("*bon*") by Édouard Colbert (1628–1699), Marquis de Villacerf, royal buildings inspector to Louis XIV, 1691–99. The marble floor was not completed until around 1709 due to wartime interruptions, which yielded related drawings by other hands in the Bibliotheque nationale de France. A full plan after Mansart's original design was engraved by Gêrard Jean-Baptiste I Scotin (1671–1716) and published in 1711. The pattern of the marble paving in the Invalides today dates from a renovation of 1840 when Napoleon's tomb was erected inside the sanctuary.

1989.172a verso

1989.172b verso

Dôme des Invalides, Paris

Present floor, Dôme des Invalides

Mansart workshop, Pencil and watercolour design for the Invalides paving, ca. 1698 (Bibliothèque nationale de France)

Plan of the paving published by Gêrard Jean-Baptiste I Scotin after Jules Mansart (1711)

452 PETER MAY COLLECTION II

A	4	chiffres couronés
B	4	chiffres en ovalle sans couronne
C	8	fleurons Enbos
D	16	demys fleurons
E	16	roses Enbas
F	96	demys fleurons dans la plat-fonde du dosme

1 Hyena 2 chiffres couronné
2 4 chiffres sans couronne
8 8 fleur de lys
4 1 rose

Je prie M. Chaufan d'omettre les trois
fleurons par chapiteau dans les endroits
marqués 3 bâton de règne y fait
et me fera plaisir Mansart

A Versailles 9.e novembre
1691

9.2

ARCHITECT UNKNOWN
(FRENCH)

2000.481: Ceiling and other designs, 19th century

Pencil, ink, watercolor. 12 × 8¾ in. (30.4 × 22.2 cm)
PROVENANCE unknown

INTERIORS 455

9.3

GEORGE RICHARDSON (BRITISH, 1736–1817), ATTRIBUTED TO

2000.423: Design for a ceiling, late 18th century

Pencil, ink, watercolor, gouache. 12 × 15⅞ in. (30.4 × 40.3 cm)
LITERATURE Peter Fuhring, *Design into Art / Drawings for Architecture and Ornament / The Lodewijk Houthakker Collection* (London, 1989), no. 417
PROVENANCE Lodewijk Houthakker Collection

🌹 Although this is an original gouache on paper, Howard Coutts, in his review of Fuhring's publication for *Master Drawings*, vol. 29, no. 2, Summer 1991, supposed that it might instead be a handcolored engraving of the Baths of Titus after Nicolas Ponce (pp. 197–98 and note 16).

456 PETER MAY COLLECTION II

9.4

ARCHITECT UNKNOWN

2000.445: Design for a ceiling, ca. 1800

Pencil, ink, watercolor. 12⅝ × 14⅛ in. (32 × 35.8 cm)
LITERATURE *Dessins du XVIe au XIXe Siècle* (Galerie Daniel Greiner, Paris, 1997), pp. 34–35, cat. 67 (ill.)
PROVENANCE Galerie Daniel Greiner, Paris

INTERIORS

9.5

ROBERT ADAM (BRITISH, 1728–1792)

1991.389–390: Presentation drawings for mantelpieces for the Circular Room at Moccas Court, Herefordshire, UK, 1781

Ink, watercolor. 13 × 18½ in. (33 × 46 cm)

1991.389
INSCRIBED [in ink] *Design of a Chimney Piece for the Eating room at Moccas. Adelphi / 26ᵉ. Sepʳ. 1781. /* [architectural measurements]

1991.390
INSCRIBED [in ink] *Design of a Chimney Piece for the Circular Drawing room at Moccas. Adelphi / 26ᵉ. Sepʳ. 1781. /* [architectural measurements]

LITERATURE Sotheby's, London, sale cat. 14 Nov. 1991, pp. 38-39, lots 43 and 44 (ill.)
PROVENANCE Sotheby's, London, 14 Nov. 1991, lots 43 and 44

❧ From a commission by Sir George Amyand Cornewall, the mantelpiece was not executed to these designs. Most of Adam's designs for this house are in the Sir John Soane Museum, including five mantelpiece designs, two of them preliminary to these finished drawings.

Moccas Park, elevation showing the colonnaded Circular Room, SM Adam vol. 34/47

Moccas Park, plan showing the location of the Circular Room, SM Adam vol. 34/49

Moccas Park, interior elevation of the Circular Room showing the fireplace, SM Adam vol. 34/52

Design of a Chimney Piece for the Eating room at Moccas.

Scale of Feet

Adelphi
26 Sep.r 1781.

Design of a Chimney Piece for the Circular Drawing room at Moccas.

Scale of Feet

Adelphi
26 Sep.r 1781.

9.6

ARCHITECT UNKNOWN (FRENCH)

1990.323a–l : Design proposals for the interiors of the Château de Syam, Syam, France, ca. 1820

Pencil, ink, watercolor

1990.323a: Designs for the walls and ceilings of the three-story center hall. 32 × 24 in. (81.2 × 60.9 cm)
INSCRIBED [in ink] *CHATEAU DE SYAM DECORATION DU HALL /PLAFON 1^E ETAGE / PLAFOND 1^R ETAGE / PLAFOND REZ DE CHAUSEE / no. 3 - A* / [architectural measurements] / [in pencil] *Commande*

1990.323b: Designs for the billiard room and lower library. $19\frac{1}{2} × 24\frac{1}{2}$ in. (49.5 × 62.2 cm)
INSCRIBED [in ink] *CHATEAU DE SYAM / DECORATION BILLARD ET BIBLIOTHEQUE* / [architectural measurements] / [in pencil] *Commande*

1990.323c: Design for the ceiling of the center hall. $19\frac{5}{8} × 32\frac{7}{8}$ in. (49.8 × 83.5 cm)
INSCRIBED [in ink] *HALL / PLAFOND III^E ETAGE* / [architectural measurements] / [in pencil] *Commande*

1990.323d: Design for the ceiling of the upper library. $18\frac{7}{8} × 8\frac{1}{2}$ in. (47.9 × 21.5 cm)
INSCRIBED [in ink] *PLAFOND* / [in pencil] [architectural measurements]

1990.323e: Design for a niche with ceramic stove. $13\frac{1}{2} × 9$ in. (80 × 22.8 cm)
INSCRIBED [in ink] *DECORATION D'UNE NICHE / No 3 J* / [in pencil] *FOND DE LA NIC* [indistinct] / [architectural measurements]

1990.323f: Design for a niche with ceramic stove. $13\frac{1}{2} × 9$ in. (80 × 22.8 cm)
INSCRIBED [in ink] *DECORATION D'UNE NICHE* / [in pencil] [indistinct] / [architectural measurements]

1990.323g-l: Designs for pairs of doors. $13\frac{1}{2} × 9$ in. (80 × 22.8 cm)
INSCRIBED [in ink and pencil] [architectural measurements]

🍂 The house was built for foundry owner Jean-Emmanuel Jobez (1775–1828) in around 1818–28 as a Jura-mountain homage to the Villa Rotonda and was owned by his descendants until 2001. The architect of the house and its interiors has not yet been established, though men named Champonnois l'aîné and Alfred Schacre are variously cited. The largely preserved interiors include some painted walls, ceilings and woodwork that do correspond to these designs, notably to ones marked "commande", that is, approved and ordered. Most striking is the clear indication of high-style *papiers peints* from the Psyche series introduced by Dufour & Cie, Paris, in 1815 after designs by Merry-Joseph Blondel (1781–1853) and Louis Lafitte (1770–1828); the house boasts altogether six sheets from this famous series. A drawing for a ceiling may have been preliminary to that in the upper library. The two niche designs seem to indicate now lost alcoves for ceramic stoves in the bedrooms; one stove pipe has survived. The drawings for the doors presented the client with alternatives for painted neoclassical motifs.

Château de Syam, exterior

View of three-story circular center hall, Château de Syam

CHATEAU DE SYAM.
DECORATION DU HALL
ECHELLE DE 0.05 P.M

PLAFOND IIᵉ ÉTAGE

PLAFOND Iʳ ÉTAGE

PLAFOND REZ DE CHAUSSÉE

CHATEAU DE SYAM

DÉCORATION BILLARD ET BIBLIOTHÈQUE

ECHELLE DE 0M 10e P.M

Bookcase in ground floor library off the billiard room, Château de Syam

View of wall with Dufour wallpaper in the ground floor library, Château de Syam

Dome ceiling above three-story center hall, Château de Syam

INTERIORS 463

PLAFOND

1990.323d

Detail of ceiling of top floor library, Château de Syam

Ceramic stove pipe from a bedroom niche, Château de Syam

DÉCORATION D'UNE NICHE

DÉCORATION D'UNE NICHE

1990.323g 1990.323h 1990.323i

1990.323j 1990.323k 1990.323l

Double door with original painted decoration, Château de Syam

1990.323k

INTERIORS 467

9.7

ARCHITECT UNKNOWN (ITALIAN)

1999.419: Interior elevation, ca. 1800

Pencil, ink, watercolor, gouache. 19⅛ × 25¾ in. (48.5 × 65.4 cm)
INSCRIBED [in ink] *Piedi di Parigi* / [architectural measurements]
PROVENANCE Marc Dessauce, New York

9.8

ARCHITECT UNKNOWN

1990.314: Interior view, 19th century

Pencil, ink, watercolor, metallic tape. 20 × 13¼ in. (50.8 × 33.6 cm)
PROVENANCE unknown

9.9

ARCHITECT UNKNOWN (ITALIAN?)

2000.484: Painted ceiling,
late 18th–19th century

Pencil, ink, watercolor. 16½ × 33½ in. (41.9 × 85 cm)
INSCRIBED [in ink] *Villa Magnani*
LITERATURE *Dessins du XVIe Siècle* (Galerie Daniel Greiner, Paris, 1997)
PROVENANCE Galerie Daniel Greiner, Paris

🍒 Possibly a now lost ceiling in Villa Magnani, Mamiano, Italy.

9.10

JEAN-BAPTISTE DEDEBAN (FRENCH, 1781–1850), ATTRIBUTED TO

2000.482a,b: Two designs for wall panels, ca. 1800

Pencil, ink, watercolor, gouache. Both 10⅞ × 5½ in. (27.6 × 13.9 cm)
LITERATURE *Dessins du XVIe Siècle* (Galerie Daniel Greiner, Paris, 1997), pp. 32 and 35 (ill.)
PROVENANCE Galerie Daniel Greiner, Paris

2000.484

2000.482a
2000.482b

9.11

ARCHITECT UNKNOWN

1987.38: Design for a wall panel, 18th/19th century

Pencil, ink, watercolor, gouache. 22 × 5¾ in. (55.8 × 14.6 cm)
PROVENANCE unknown

9.12

LOUIS SAINT-ANGE DESMAISON
(FRENCH, 1780–1853)

1989.192a,b: Two designs for mirror frames or mirrored mounts for wall sconces, early 19th century

Pencil, ink, watercolor. Both 6¼ × 5⅜ in. (15.8 × 8.4 cm)
INSCRIBED [in ink] *L.S.*
PROVENANCE unknown

1989.192a

1989.192b

1989.167

9.13

ARCHITECT UNKNOWN

1989.167: Interior elevation, 19th century?

Pencil, ink, watercolor, gouache. 7⅜ × 16 in. (18.7 × 40.6 cm)
INSCRIBED [in watercolor] *CAROLO IIII ET AELOISE CATOLICORUM OPTIMISQUE YSPANYARUM REX Q. YNGRATITUDYNI LATIN QUE TESTIMONIUM ARQUE P. VALENT*
PROVENANCE unknown

9.14

HANS PESCHEL (AUSTRIAN, DATES UNKNOWN) AND FRANZ WILHELM LADEWIG (AUSTRIAN, DATES UNKNOWN)

2000.444: Designs for the walls and ceiling of a room in the Berndorf School, Berndorf, Austria, 1909

Pencil, ink, watercolor, gouache. 15½ × 10⅜ in. (39.3 × 35 cm)
INSCRIBED [in pencil] *Einverstanden 4.VI.1909 Hans Peschel Architect* [indistinct]
STAMPED [in purple] *WILH. LADEWIG / k.u.k. Hof-Decorationenmaler / Anstreicher u. Vergolder / Wien, IV, Theresienstrasse 31*
PROVENANCE Galerie Martin du Louvre, Paris

Interior of the School, Berndorf

1994.397

9.15

G. MUNNINGS (BRITISH,
DATES UNKNOWN)

1994.397: Design for the ceiling of the
Marble Hall, Buckingham Palace, London:
detail, 1852

Pencil, watercolor, gilding. 8¾ × 13¼ in. (22.2 × 33.6 cm)
INSCRIBED [in pencil] *G. Munnings 1852*
LITERATURE Christopher Wood, *People and Places* (Shepherd Gallery, 1992), cat. 48
PROVENANCE Shepherd Gallery, New York

❦ An element of the restoration of the palace undertaken by Queen Victoria and Prince Albert and completed in 1853.

George Housman Thomas, *Queen Victoria and Prince Albert inspecting wounded Grenadier Guardsmen at Buckingham Palace, 20 Feb. 1855* (British Royal Collection)

INTERIORS 477

1989.235a

1989.235b

9.16

ARCHITECT UNKNOWN (FRENCH)

1989.235a,b: Imagined interior elevations of the Chapel at Versailles: two designs from a student assignment, 19th century

Pencil, ink, watercolor. 20½ × 14 in. (52 × 35.5 cm)
PROVENANCE unknown

Jacques-François Blondel, Cross-section of the Chapel at Versailles, from the north, 1756

9.17

PIETRO LUCCHI (ITALIAN, DATES UNKNOWN)

1990.347: Elevation and ceiling of a church interior, ca. 1900

Pencil, ink, watercolor. 9 × 14 in. (22.8 × 35.5 cm)
INSCRIBED [in ink] *Pietro Lucchi Dis.*
PROVENANCE unknown

🍎 Another small study by the artist of the interior of Chiesa della Pietà, Fermo, Italy, was sold at Christie's, London, on 1 May 2012, lot 331.

Pietro Lucchi, *Interior of the Chiesa della Pietà, Fermo, Italy*, ca. 1900

INTERIORS 479

1990.327a

9.18

ARCHITECT UNKNOWN (FRENCH)

1990.327a–d: Four interior elevations
for a French royal residence, 19th century

Pencil, ink, watercolor, gilding

 1990.327a, d: 9½ × 14 in. (24.1 × 35.5 cm)

 1990.327b, c: 9½ × 18 in. (24.1 × 45.7 cm)
 INSCRIBED [in gilding, above doors, interlaced] *LL*
 [for King Louis]

PROVENANCE unknown

1990.327b

1990.327d

1990.327c

9.19

EMILE DUFAY-LAMY (FRENCH, 1868–1953)

1989.160: Interior elevations of the billiard room, Vaux-le -Vicomte, ca. 1875–77

Pencil, ink, watercolor. 8 × 30 in. (20.3 × 76.2 cm)
INSCRIBED [in ink, on mat] *a mes bons amis Dessus. Souvenir affectieux.*
PROVENANCE unknown

❧ The new billiard room for the famous 17th-century château, owned from 1875 by Alfred Sommier (1835–1908), was designed by the office of the fashionable revivalist Gabriel Hippolyte Destailleurs (1822–1893).

9.20

P. PICCARDO (NATIONALITY UNKNOWN)

1988.145: Interior elevations for a Louis XVI revival-style room, 19th–20th century

Pencil, ink, watercolor. 6¾ × 37¾ in. (17.1 × 95.8 cm)
INSCRIBED [on recto, in pencil] *sur le hall* / [on verso, in ink] *Salon LXVI par P Piccardo / Salon Louis XVI P. Piccardo*
PROVENANCE unknown

Monsieur Otto Beit
à Londres
Boudoir

A. TARDIF,
Architecte - Décorateur

9.21

ALFRED TARDIF (FRENCH, DATES UNKNOWN)

1989.153a–c: Three interior elevations for the boudoir of the home of Sir Otto Beit (1865–1930), London, early 20th century

Pencil, ink, watercolor. 16 × 20 in. (40.6 × 50.8 cm)

1989.153a: Elevation
INSCRIBED [in pencil] *Monsieur Otto Beit à Londres. Boudoir*
STAMPED [in black] *A. TARDIF. Architecte – Décorateur*

1989.153b: Elevation
INSCRIBED [in pen] *Projet A / Non*

1989.153c: Elevation
INSCRIBED [in ink] *Faudra-t-il poser les appliques dans ces 2 panneaux?* / [in pencil] *Monsieur Otto Beit à Londres. Boudoir*

PROVENANCE unknown

🌸 Beit's home from around 1906 until his death was 49 Belgrave Square, now the residence of the Argentine ambassador to Britain.

1988.153b

1988.153c

INTERIORS 485

1990.328

1990.320

9.22

ARCHITECT UNKNOWN

1990.328: Interior elevation, ca. 1900

Pencil, ink, watercolor. 7 × 15 in. (17.7 × 38.1 cm)
PROVENANCE unknown

9.23

ARCHITECT UNKNOWN

1990.320: Interior elevation, ca. 1900

Pencil, ink, watercolor. 6½ × 12½ in. (16.5 × 31.7 cm)
PROVENANCE unknown

9.24

ARCHITECT UNKNOWN

2000.436: Interior elevation: detail of window treatment, mid-19th century

Pencil, ink, watercolor, gouache. 14¾ × 10½ in. (37.4 × 26.6 cm)
PROVENANCE Shepherd Gallery, New York

9.25

ALEXANDRE-FREDERIC COGEZ
(FRENCH, d. 1896), ATTRIBUTED TO

1989.177: Interior elevation: detail,
late 19th century

Pencil, ink, watercolor. 13¼ × 10 in. (33.6 × 25.4 cm)
PROVENANCE Shepherd Gallery, New York

1987.16

9.26

GEORGE REMON
(FRENCH, DATES UNKNOWN)

1987.16: Interior elevation, ca. 1895

Pencil, ink, watercolor, gouache. 19 × 24½ in.
(48.2 × 62.2 cm)
INSCRIBED [in watercolor] *AURORA*; [on original mount, in ink] *à notre ami Charvet / Souvenir de Collaboration / Georges Remon / Eugene Maraud / 1895*
PROVENANCE unknown

❧ Possibly for publication, as Rémon provided similar designs for books of interior design in the art nouveau style.

Georges Rémon, *Intérieurs modernes* (Paris, 1900), pl. 22

INTERIORS 489

1990.346

9.27

ARCHITECT UNKNOWN

1990.346: Interior elevation, ca. 1900

Pencil, ink, watercolor, gouache. 10½ × 14¼ in. (26.6 × 36.2 cm)
PROVENANCE unknown

9.28

ARCHITECT UNKNOWN (FRENCH)

1988.134: Interior elevation, 19th century

Pencil, ink, watercolor. 13⅜ × 14⅞ in. (33.9 × 37.7 cm)
INSCRIBED [in watercolor, cipher] *R.F.* [République française]
PROVENANCE unknown

1988.134

9.29

ARCHITECT UNKNOWN (FRENCH)

1987.31: Competition drawing for a state bedroom: elevations, ceiling and flooring plans, profiles, late 19th century

Pencil, ink, watercolor, metallic tape. 26½ × 41 in. (67.3 × 104.1 cm)
INSCRIBED [in ink] *UNE CHAMBRE D'APPARAT*
PROVENANCE unknown

UNE CHAMBRE D'APPARAT

1990.251b

9.30

ARCHITECT UNKNOWN (FRENCH)

1990.251a,b: Designs for a state bedroom: cross-section and ceiling, late 19th century

Pencil, ink, watercolor

1990.251a: Ceiling. 21 × 15½ in. (53.3 × 39.3 cm)

1990.251b: Cross-section. 16¾ × 18⅛ in. (42.5 × 46 cm)

PROVENANCE unknown

9.31

ARTIST UNKNOWN

1990.254: Perspective of a bedroom, 19th century

Pencil, ink, watercolor, gouache. 11 × 12⅜ in. (27.9 × 31.4 cm)
PROVENANCE unknown

9.32

CHARLES-ANTOINE CAMBON
(FRENCH, 1802–1875)

2000.483: Stage set interior, mid-19th century

Pencil, ink, watercolor, gouache. 10¼ × 13½ in. (26 × 34.2 cm)
PROVENANCE Galerie Daniel Greiner, Paris

1990.254

2000.483

9.33

ARTIST UNKNOWN

1989.170: View of a sitting room, 19th century

Watercolor. 8⅞ × 11½ in. (22.5 × 29.2 cm)
PROVENANCE unknown

9.34

HENRI VAN SEBEN
(BELGIAN, 1825–1913)

1988.113: View of a sitting room, 1852

Watercolor, gouache. 15⅛ × 18½ in. (38.4 × 46.9 cm)
INSCRIBED [in gouache] *HvSeben. f 52*
PROVENANCE unknown

INTERIORS

9.35

ARTIST UNKNOWN (BRITISH)

1990.292: View of a bank interior, mid-19th century

Pencil, watercolor. 6 × 8¼ in. (15.2 × 82.9 cm)
LITERATURE Sotheby's, London, sale cat. 26 April 1990, p. 114, lot 374 (ill.)
PROVENANCE Sotheby's, London, 26 April 1990, lot 374

9.36

ELLEN S. BICKERSTAFFE
(BRITISH, DATES UNKNOWN)

1990.293: View of the interior of the artist's father's medical office in Liverpool, UK, mid-19th century

Pencil, watercolor. 8 × 11½ in. (20.3 × 29.2 cm)
INSCRIBED [on verso] *Consulting Room 2 Rodney Street, Liverpool, Right side entrance Hall facing Rodney Street, original painted by Ellen S Bickerstaffe, 2ⁿᵈ daughter of Robert Bickerstaffe, FRCS*
LITERATURE Sotheby's, London, sale cat. 26 April 1990, p. 115, lot 380 (ill.)
PROVENANCE Sotheby's, London, 26 April 1990, lot 380

1990.292

1990.293

9.37

ARTIST UNKNOWN

1987.82: View of an interior, ca. 1900

Oil on canvas. 24 × 20 in. (60.9 × 50.8 cm)
PROVENANCE Fine Art Society, London

1987.82

INTERIORS 499

1999.409

9.38

O. KOROVINE (RUSSIAN, DATES UNKNOWN)

1999.409: View of an interior, 1928

Watercolor, ink. 14 × 24 in. (35.5 × 60.9 cm)
INSCRIBED [in ink] *O Korovine 1928*.
PROVENANCE unknown

9.39

EMMANUEL AUGUSTE MASSÉ
(FRENCH, 1818–1881)

1999.418: View of an interior, 1879

Pencil, ink, watercolor, gouache. 5¾ × 8½ in.
(14.6 × 21.5 cm)
INSCRIBED [on recto, in gouache] ƎVE / [on verso, on paper label, in ink] *Madame* [indistinct] *Cesson / son ami respectueux et devoté Massé 9^{bre} 1879* / [on verso, on paper label, in ink] *Amicial souvenir à Monsieur le D^{teur} Marguiles de ce sous-* [indistinct] *signé E. Massé / 8^{bre} 95* [indistinct signature]
PROVENANCE unknown

9.40

ALBERT PROCTER (BRITISH, 1864–1909)

2000.519: View of an interior, 1887

Watercolor, gouache. 19½ × 15 in. (49.5 × 38.1 cm)
INSCRIBED [in brown watercolor] *Albert Procter. 87*.
PROVENANCE unknown

1987.64

9.41

PAUL THOMAS (BRITISH, d. 1961)

1987.64: View of an interior, mid-20th century

Pastel on paper. 25½ × 21 in. (64.8 × 53.3 cm) approx.
PROVENANCE unknown

1987.65a

1987.65b

9.42

EMILE OCTAVE DENIS VICTOR
GUILLONNET (FRENCH, 1872–1967)

1987.65a,b: Two views of a room, 1960 and 1961

Oil on canvas. 21¾ × 18¼ in. (55.3 × 46.4 cm)

1987.65a
INSCRIBED [in black] *EODV Guillonnet 60*

1987.65b
INSCRIBED [in black] *EODV Guillonnet 61*

PROVENANCE Garrick Stephenson, New York

9.43

MAURICE LOBRE (FRENCH, 1862–1951)

1989.171: View of an interior with royal collector's items, mid-20th century

Oil on canvas. 28½ × 23¾ in. (72.4 × 60.3 cm)
PROVENANCE unknown

🌸 Likely staged in a private collector's residence, on account of the depiction of three noteworthy historical items – the pianoforte on the right, the jardinière on the left and the ivory lute on the sofa. The pianoforte is by Erard Frères and may be the example sold from the Château de Fontainebleau in the 19th century. The jardinière is evidently by Jacob Frères and may be the one offered in the sale of the 'Succession de Madame S.' at Artcurial, Paris, on 9 Oct. 2013, lot 9. The white ivory lute would seem to be identical with that made by Edmond Saunier (b. 1730) for Queen Marie-Antoinette (1755–1793), which was sold by Maison de Ventes Richard, Villefranche, on 15 June 2019, lot 301. Another painting by the artist of the same room and pianoforte but otherwise different musical instruments and decorative arts exists, perhaps executed for the same collector.

Interior with Musical Instruments by Maurice Lobre (private collection)

Pianoforte by Erard Frères

Jardinière by Jacob Frères

Lute by Erard Frères

506 PETER MAY COLLECTION II

1989.171

9.44

PAUL FRANCOIS MARIE URTIN
(FRENCH, 1872–1962)

1987.39: View of the interior of Musée Carnavalet, Paris, 1929

Oil on canvas. 21¾ × 18 in. (55.2 × 45.7 cm)
PROVENANCE unknown

❧ Although an archival photograph of this distinctive room with its freestanding two-tiered glass display cabinet has not been located, it was recorded from a different angle by Walter Gay (1856–1937) at around the same time.

1987.39

Walter Gay, *Interior (Musée Carnavalet, Paris)*, ca. 1912
(The Fine Arts Museums of San Francisco)

9.45

ARTIST UNKNOWN

1989.154: View of a private interior, ca. 1900

Oil on panel. 12½ × 16 in. (31.7 × 40.6 cm)
PROVENANCE unknown

9.46

ARTIST UNKNOWN

1990.252: View of a sitting room, 20th century

Pencil, watercolor, gouache. 12½ × 18⅜ in. (31.7 × 46.6 cm)
PROVENANCE unknown

9.47

ARTIST UNKNOWN

1988.142: View of a sitting room, early 20th century

Pencil, ink, watercolor, gouache. 10½ × 17½ in. (26.6 × 44.4 cm)
PROVENANCE unknown

9.48

ARTIST UNKNOWN

1990.278: View through a window, 20th century

Pencil, watercolor. 11½ × 8½ in. (29.2 × 21.5 cm) approx.
PROVENANCE unknown

9.49

CLAUDE BOUSSIN (FRENCH, DATES UNKNOWN)

1987.34–37, 1989.190, 1989.206–08: interior designs, ca. 1928

Pencil, ink, watercolor, gouache

1987.34: Entry foyer. 11¼ × 13¼ in. (28.5 × 33.6 cm)

1987.35: Interior elevation. 16¾ × 19 in. (42.5 × 48.2 cm)

1987.36: Interior elevation. 17 × 19 in. (43.1 × 48.2 cm)
INSCRIBED [in pencil] *CL. BOUSSIN DÉCORATEUR*

1987.37: Dining room for M. Vivaux, Lardy, Essonne, France. 17 × 19 in. (43.1 × 48.2 cm)
INSCRIBED [in pencil] *SALLE A MANGER DE MONSIEUR VIVAUX A LARDY / CL. BOUSSIN A^TE DÉCORATEUR*

1989.190: Library for M. Spicq. 11 × 15 in. (27.9 × 38.1 cm)
INSCRIBED [in ink] *CL. BOUSSIN A^TE DECORATEUR / BUREAU DE BIBLIOTHEQUE DE MR. SPICQ*

1989.206: Bedroom, 9 × 11¼ in. (22.8 × 28.5 cm)
INSCRIBED [in pencil] *6/10.28 CL. Boussin*

1989.207: Interior elevation. 7½ × 11⅛ in. (19 × 28.2 cm)

1989.208: Interior elevation. 7½ × 8⅜ in. (19.3 × 21.2 cm)
INSCRIBED [in pencil] *Cl. Boussin*

PROVENANCE unknown

🌹 The wallpaper depicted by Boussin, after designs by Hubert Robert, has not been identified.

1987.34

1987.35

1987.36

1989.206

1989.208

1989.207

9.50

LINKE & CIE, PARIS
(FRENCH, ca. 1920–59)

1988.109a,b: Presentation drawings for two interiors for Maharaja Gaekwad (1863–1939) of the state of Baroda (within present-day Gujurat), India, 1927

Pencil, ink, watercolor

1988.109a: A library. 19 × 26 in. (48.2 × 66 cm)
INSCRIBED [in ink] *Projets de Library pour son Altesse le Maharajah Geakwer [sic] of Baroda / par LINKE & Cie / PARIS / 26 Place Vendôme / 170 Faubourg St. Antoine / Decembre 1927*

1988.109b: A reading room. 17½ × 19¼ in. (44.4 × 48.9 cm)
INSCRIBED [in ink] *Projets de Reading Room pour son Altesse le Maharajah Geakwer [sic] of Baroda / par LINKE & Cie / PARIS / 26 Place Vendôme / 170 Faubourg St. Antoine / Decembre 1927*

PROVENANCE unknown

🐾 Linke & Cie was founded after the First World War by Jean Bieder, foreman to furniture-maker Francois Linke (1855–1946), and closed its doors in 1959.

1988.109b

1988.109a

516 PETER MAY COLLECTION II

9.51

PHILIPPE FEREIRA D'ARANJO PINHO
(FRENCH, b. 1841)

1990.261a,b: Presentation drawings for a dining room for Dr. Simon, Buenos Aires, Argentina, ca. 1900

Pencil, ink, watercolor. $18\frac{1}{2} \times 22\frac{1}{2}$ in. (46.9 × 57.1 cm)

1990.261a: Cross-section and elevation.
INSCRIBED [in ink] *SALLE A MANGER DU DOCTEUR SIMON A BUENOS-AYRES / Philippe PINHO. Architecte a Paris*

1990.261b: Ceiling
INSCRIBED [in ink] *SALLE A MANGER DU DOCTEUR SIMON A BUENOS-AYRES / Philippe PINHO. Architecte a Paris*

PROVENANCE unknown

1990.345

9.52

ARCHITECT UNKNOWN

1990.345: View of a planted interior courtyard, ca. 1900

Pencil, watercolor. 9¼ × 13½ in. (23.5 × 34.2 cm)
PROVENANCE unknown

9.53

ARCHITECT UNKNOWN (FRENCH)

1990.280: Godeboeuf competition drawing for an elevator cabin: elevation, 1890

Pencil, ink, watercolor. 38 × 23¾ in. (96.5 × 60.3 cm)
PROVENANCE unknown

🌹 The Godeboeuf prize was a two-part, two-week design competition established in 1880 by the sister of architect Eugène Godeboeuf (1815–1879) and its assignments were construction elements and new technologies, such as this elevator cabin assigned in 1890 (see Baudez/Cassidy-Geiger essay, pp. 30–31). Another submission is illustrated in Anne Jacques et al., *Les Dessins d'Architecture de l'Ecole des Beaux Arts* (1987), p. 91.

9.54

CHARLES EDWARD GEORGES
(BRITISH, 1869–1970)

1988.141h: Design for a stained glass window illustrating the opening verse from Edmund Spenser's 1590–96 *The Faerie Queene*, ca. 1888–90

Pencil, ink, watercolor. 21 × 14¾ in. (53.3 × 37.4 cm)
INSCRIBED [in watercolor] *A Gentle Knight was pricking on the Plaine Yclad in mighty armes of silver Shield / His angry steed did chide his foaming bit As much disdaining to the curbe to yield.* / [in pencil] *Stained Glass* / [4×] *Chas. E. Georges*
PROVENANCE unknown

9.55

UNKNOWN (BRITISH)

1987.42: View of a great hall, late 19th century

Pencil, ink, watercolor. 21¾ × 18 in. (55.2 × 45.7 cm)
PROVENANCE unknown

VUE INTERIEURE. ECH: 10% BASE.

CHAPITEAU

DETAIL A.B GRANDEUR d' EXECUTION.

10
CONSTRUCTION DRAWINGS

10.1

JACQUES MAURICE PREVOT
(FRENCH, 1874–1950), JEAN HEBRARD
(FRENCH, b. 1878) AND PIERRE FERRET
(FRENCH, 1877–1949)

1991.368a–o: Diploma drawings for a country house: elevations, floor plans, cross-sections, construction plans, 1900

Pencil, ink, watercolor, metallic tape. 19 × 32½ in. (48.2 × 82.5 cm)

1991.368a–k: by Jacques Maurice Prévot

1991.368a: Main façade elevation
INSCRIBED [in red watercolor] *UNE MAISON DE CAMPAGNE / FAÇADE SUR COUR /* [in black ink] *M. Prévot / E*ve*. de MM. Gaudet et Paulin /* [architectural measurements]

1991.368b: Garden facade elevation
INSCRIBED [in red watercolor] *UNE MAISON DE CAMPAGNE / FAÇADE SUR JARDIN /* [in black ink] *M. Prévot /* [architectural measurements]

1991.368c: Lateral façade elevation
INSCRIBED [in red watercolor] *UNE MAISON DE CAMPAGNE / FAÇADE LATERALE /* [architectural measurements] / [in black ink] *M. Prévot / E*ve*. de MM. Gaudet et Paulin*

1991.368d: Estate plan
INSCRIBED [in red watercolor] *UNE MAISON DE CAMPAGNE / PLAN GENERAL. A.L. /* [in black ink] *VESTIBULE / SALON / SALLE A MANGER / BUREAU / SALLE DE BILLARD / CUISINE / OFFICE / COUR D'HONNEUR / ENTRÉE DU JARDIN / ECURIES / COUR BASSE / TERRASSE /* [architectural measurements] / [in sepia] *M. Prévot / E*ve*. de MM. Gaudet et Paulin*

1991.368e: Transverse cross-section
INSCRIBED [in red watercolor] *UNE MAISON DE CAMPAGNE / COUPE TRANSVERSALE /* [architectural measurements] / [in sepia] *M. Prévot / Eve. De MM. Gaudet et Paulin*

1991.368f: Longitudinal cross-section
INSCRIBED [in red watercolor] *UNE MAISON DE CAMPAGNE / COUPE LONGITUDINALE /* [in sepia] *M. Prévot / Eve. De MM. Gaudet et Paulin /* [in black ink] [architectural measurements]

1991.368g: Ground floor plan
INSCRIBED [in red watercolor] *UNE MAISON DE CAMPAGNE / PLAN DU REZ DE CHAUSSEE /* [in black ink] *GRANDE COUR D'HONNEUR / ENTRÉE DU JARDIN / VESTIBULE / BUREAU / W.C. / LAVABO / BILLARD / GRAND SALON / SALLE A MANGER / OFFICE / COUR DE SERVICE / CUISINE / PORTIQUE /* [in sepia] *M. Prévot /* [in red and black] [architectural measurements]

1991.368h: First floor plan
INSCRIBED [in red watercolor] *UNE MAISON DE CAMPAGNE / PLAN DU 1*ER *ETAGE /* [in black] *VESTIBULE / ANTICHAMBRE / GALERIE / SALLE DE BAINS / CHAMBRE / LAVABO / W.C. / CHAMBRE / TOILETTE / DEBARRAS /* [2×] *CHAMBRE / TOILETTE /* [in red and black] [architectural measurements]

1991.368i: Second floor plan
INSCRIBED [in red] *UNE MAISON DE CAMPAGNE / PLAN DU II*EME *ETAGE /* [in black ink] *ATELIER / BOUDOIR / DOMESTIQUE / W.C. / TOILET* [sic] / [4×] *CHAMBRE / TOILETTE / CHAMBRE / DOMESTIQUE /* [in sepia] *M. Prévot /* [in red and black] [architectural measurements]

1991.368j: Cellar plan
INSCRIBED [in red watercolor] *UNE MAISON DE CAMPAGNE / PLAN DU SOU-SOL /* [in black] *ENTRÉE DE SERVICE / DEPOT / CALORIPÈRE POSSE / CHARBON / SALLE DE REDOS / CAVE A BOIS / CAVE A VINS / CAVE A VINS FINS / DEPOT / CHAUFFAGE / LEGENDE. / A. CHAUDIÈRE B. CONDUIT DE FUMÉE. C. TREMIE DE CHARGEMENT. D. REGULATEUR DE PRESSION. E. ROBINET DE VIDANGE. FFF. PRISES D'AIR FRAIS. GGGG. BATTERIES. H APPAREIL DE SURETÉ. K. SUFFLET D'ALARME. /* [thin red line] *VAPEUR /* [thin black line] *EAU DE CONDENSATION. /* [thick red line] *AIR CHAUD. /* [thick sepia line] *AIR FROID.* [sepia ink] *M. Prévot /* [in red and black] [architectural measurements and other notations]

1991.368k: Construction plan for flooring
INSCRIBED [in red watercolor] *UNE MAISON DE CAMPAGNE / PLANCHER REZ-DE-CHAUSEE / PLANCHER DES ETAGES /* [in black] *PLAN DE LA CHARPENTE / PLAN D'UN PLANCHER / POUTRES DU FLANCHER DU SALON A / POUTRE D'EGALE RESISTANCE / ASSEMBLAGES DES POUTRES ET SOLIVES DU VESTIBULE. B. /* [in red and black] [architectural measurements and other notations]

1991.368l and 368o: by Jean Hébrard

1991.368l: Framing plans
INSCRIBED [in red watercolor] *UNE MAISON DE CAMPAGNE / CHARPENTE PORTIQUE SUR LE JARDIN / ELEVATION / COUPE SUR A.B. / COUPE SUR C.D. / DETAIL D'UN ANGLE / PLAN AU 1*ER *ETAGE / PLAN SUR G.H. / PLAN SUR E.F.* [in black] *Jean Hébrard / E*le*. de M*r*. Scellier de Gisors /* [in red and black] [architectural measurements and other notations]

1991.368o: Masonry plans
INSCRIBED [in red watercolor] *UNE MAISON DE CAMPAGNE / DETAIL DE MAÇONNERIE* [in black] *Jean Hébrard / El. de M*r*. Scellier de Gisors /* [architectural measurements and other notations]

1991.368m and 368n: by Pierre Ferret

1991.368m: Carpentry plans
INSCRIBED [in red watercolor] *UNE MAISON DE CAMPAGNE /* [in black ink] *MENUISERIE PORTES EXT*RES *DU SALON / ELEVATION / PORTE FERMÉE / PORTE OUVERTE / PLANS / COUPE A. / COUPE SUR A.B. / COUPE SUR C.D. / COUPE SUR E.F. / DETAILS D'ASSEMBLAGES / GRANDEUR D'EXECUTION / COUPE SUR I.J. / COUPE SUR G.H. / Pierre Ferret E*l*. de Mr. PASCAL /* [in red and black] [architectural measurements and other notations]

1991.368n: Woodworking plans
INSCRIBED [in red watercolor] *UNE MAISON DE CAMPAGNE / MENUISERIE /* [in red and black] *COUPE SUR A.B. / COUPE SUR C.D. / COUPE SUR E.F. / COUPE SUR G.H. / COUPE SUR M.N. / PORTE D'ACCÈS DE L'APPARTEMENT DU IIe ETAGE / PORTE D'ACCÈS DES SERVICES /* [in black] *Pierre Ferret E*l*. de Mr. PASCAL /* [in red and black] [architectural measurements and other notations]

PROVENANCE unknown

🔖 The three men, who were in the same class at the École, evidently participated in the same *Maison de Campagne* assignment and their signed construction drawings were mixed together when sold.

UNE MAISON DE CAMPAGNE

FAÇADE SUR COUR

1991.368a

UNE MAISON DE CAMPAGNE

FAÇADE SUR JARDIN

1991.368b

VNE MAISON DE CAMPAGNE

FAÇADE LATERALE

VNE MAISON DE CAMPAGNE

COVPE LONGITVDINALE

VNE MAISON DE CAMPAGNE

PLAN GENERAL A L'
Echelle 0.005 p.m.

1991.368d

VNE MAISON DE CAMPAGNE

COVPE TRANSVERSALE
Echelle de 0.02 p Meter

1991.368e

1991.368g

1991.368h

1991.368i

1991.368j

1991.368k

1991.368l

1991.368m

1991.368n

1991.368o

10.2

ARCHITECT UNKNOWN
(GERMAN OR AUSTRIAN)

1991.366: Drawing of a country house: frontal façade, two plans, construction details, ca. 1900

Pencil, ink, watercolor on tracing paper. 17¼ × 11¾ in. (43.8 × 29.8 cm)
INSCRIBED [in black ink] *Taf: XVIII / Parterre-Stock / In den Hof fuhrend / Treppenhaus Vorplatz / Schlaf-Zimmer / Schlaf-Z[immer] / [2×] Neben Zimmer / Eingang / Bedienten Z[immer] / Comod: / [2×] Terrasse / Treppe in den Garten / Erster-Stock / Treppenhaus Vorplatz / Grosser Salon / [2×] Neben Z.[immer] / Salon / Kabinet / Fremden Z[immer] / Com[ode] / [3×] Balkon / Fenster des I Stocks uber dem Balkon / Backstein-Teppich / Hauptgesims / Fensterbank vom obern Stock / Balkon-Brüstung / an dem Fenster d. I Stocks /* [architectural measurements]
PROVENANCE Shepherd Gallery, New York

🌸 Given the plate ("Tafel") number on the upper right, this was either a preparatory design for a publication or, more likely, a tracing.

10.3

SIR JOHN SOANE (BRITISH, 1753–1837) AND C.J. RICHARDSON (BRITISH, 1806–1871)

2003.524a,b: Two-sided construction drawings for a lodge or cottage: elevations, floor plans, and construction plans, ca. 1811

Pencil, ink, watercolor. 14½ × 11½ in. (36.8 × 29.2 cm)

2003.524a recto: Elevation and cross-section
INSCRIBED [in sepia] *Elevation of the South East Front A. / a tin Gutter to be fixed / finished stucco / Section showing the Framing to Attic – Entrance front / Scanthings [sic] to framing of Attic Story – The back not to be cut out of the openings till the building is quite settled / [architectural measurements and other notations]* / [in pencil] *C. Richardson*

2003.524a verso: Plan
INSCRIBED [in sepia] *South East Front A / (This set not perfect N^{os}. 3, 4, 5 executed) / Porch to separate drawing / Drawing Room / [2×] Bed Room / Lobby / Eating Room / Water Closet / North West Front of House / [architectural measurements and other notations]*

2003.524b recto: Elevation and cross-section
INSCRIBED [in sepia] *Elevation of the South West Front B. / Scanthings [sic] for Roofs of Attic Story / Section of the framing for the attic South West Front / [architectural measurements and other notations]* / [in pencil] *C. Richardson / Rich Coll*
STAMPED [in red] [abstract design]

2003.524b verso: Elevation and plan
INSCRIBED [in sepia] *Elevation of the North West Side of House – C / finished stucco / Plan of the Attic Story N^o 2 / [architectural measurements and other notations]*

PROVENANCE Sir Albert Richardson; Charles Plante, London, and Florian Papp, New York

2003.524a recto

2003.524a verso

2003.524b recto

2003.524b verso

10.4

ALBERT WIELAND (GERMAN, DATES UNKNOWN)

1994.398: Competition drawing for a barn for sheep: elevation and construction details, 1888

Pencil, ink, watercolor. 18 × 24¼ in. (45.7 × 61.6 cm)
INSCRIBED [in ink] – *Entwurf eines Schafstalles* – / *Quer-Ansicht* / *Blatt Nº. 15.* / *Classe 2.* / *Detail der Stallthür* / *Schicht a.* / *Schicht b.* / *Kreuzkamm.* / *Detail der Hängewerke.* / *Buxtehude den 17 Januar 1888.* / *gesehen Kessler* / *Albert Wieland* / [architectural measurements]
PROVENANCE Shepherd Gallery, New York

1989.245

1989.246

10.5

R. DE CLERCK (BELGIAN,
DATES UNKNOWN)

1989.245, 1989.246 and 2000.425, 2000.427: Second year competition drawings for a chapel with a tower: elevation, cross-section, plan, profile, and construction details, ca. 1900

Pencil, ink, watercolor. 27½ × 19⅞ in. (69.8 × 50.4 cm)

1989.245: Elevation details and profile
INSCRIBED [in black ink] *CONCOURS de 2ᵐᵉ. ANNEE – ETUDE D'UNE CHAPELLE AVEC TOUR-ANCRAGE / TRAVEE VUE INTERIEURE / FACE / PROFIL* / [three interlocking circles] / [architectural measurements] / [on verso] *De Clerck*

1989.246: Elevation, cross-section and construction details
INSCRIBED [in black] *VUE EXTERIEURE. TRAVEE / CONCOURS de 2ᵐᵉ. ANNEE / ETUDE D'UNE CHAPELLE AVEC TOUR. / PLAN / COUPE / DETAIL A* / [three interlocking circles] / [architectural measurements] / [on verso] *De Clerck*

2000.425: Elevation and construction details
INSCRIBED [in black ink] *CONCOURS de 2ᵐᵉ. ANNEE – ETUDE D'UNE CHAPELLE AVEC TOUR-PORTE D'ENTRÉE / DETAILS de la PORTE D'ENTRÉE / CHAPITEAU / VUE INTERIEURE – / DETAIL AB / GRANDEUR d'EXECUTION /* [three interlocking circles] / [architectural measurements]

2000.427: Elevation and construction details
INSCRIBED [in ink] *CONCOURS de 2ᵐᵉ ANNEE – ETUDE D'UNE CHAPELLE AVEC TOUR-PORTE D'ENTRÉE – / ELEVATION – / COUPE – / PLAN –* / [three interlocking circles]

1989.243: Third year competition drawings for a doctor's residence in the country: elevation, cross-section and construction details, ca. 1900

Pencil, ink, watercolor. 27½ × 19⅞ in. (69.8 × 50.4 cm)
INSCRIBED [in black ink] *CONCOURS de 3ᵐᵉ ANNÉE – Projet d'HABITATION pour DOCTEUR de CAMPAGNE / PORTE d'ENTRÉE / DÉTAILS – / Détail: A. / Détail: B / Détail: C / Détail: D / ÉLÉVATION / PLAN / COUPE /* [architectural measurements] / [in red watercolor, cipher] *ESL* [École de Saint Luc] / [on verso] *De Clerck*

2000.426: Third year competition drawings for a vaulted ceiling: cross-section and construction and plan details, ca. 1900

Pencil, ink, watercolor. 27½ × 19⅞ in. (69.8 × 50.4 cm)
INSCRIBED [in ink] *CONCOURS de 3ᵐᵉ ANNEE – ETUDE d'une VOUTE à LIERNE sur BASE RECTANGULAIRE – / COUPE: AB / COUPE: CD / PLAN /* [architectural measurements] / [in red watercolor, cipher] *ESL* [École de Saint Luc]
PROVENANCE Shepherd Gallery, New York

CONSTRUCTION DRAWINGS 535

2000.245

Concours de 2ᵐᵉ Année
Étude d'une Chapelle avec Tour
Porte d'Entrée — Détails de la Porte d'Entrée

Vue Intérieure. — Éch = 10 ‰
Chapiteau
Base. Grandeur d'Exécution
Détail A.B — Grandeur d'Exécution

2000.247

Concours de 2ᵐᵉ Année
Étude d'une Chapelle avec Tour
Porte d'Entrée

Élévation — Coupe
Plan
Éch = 10 ‰

1989.243

2000.246

10.6

CHARLES ULYSSE GOUREAU
(FRENCH, 1846–1932)

1989.217a,b: Construction drawings for spiral staircases: elevations, cross-sections, plans, 1870

Pencil, ink. 20½ × 13⅝ in. (52 × 34.6 cm)

1989.217a: Construction details
INSCRIBED [in ink] *Escalier a limons pleins sur un plan circulaire / G. Ulysse Paris le 1ᵉ Mars 1870* / [architectural measurements]

1989.217b: Construction details
INSCRIBED [in ink] *Goureau Ulysse Paris le 22 Fevrier 1870* / [architectural measurements]

PROVENANCE Galerie Acteon, Paris

Paris le 22 Février 1670

10.7

ARCHITECT UNKNOWN (FRENCH)

1991.363b: Competition drawing for a public swimming pool: cross-section, ca. 1900

Pencil, ink, watercolor. 23½ × 53 in. (59.6 × 134.6 cm)
PROVENANCE unknown

11
RECONSTRUCTION DRAWINGS

11.1

CHARLES-JEROME CHIPIEZ
(FRENCH, 1835–1901)

2000.421: Reconstruction drawing
of the Temple of Jerusalem, 1888

Pencil, ink, watercolor. 25⅝ × 38⅞ in. (65 × 98.7 cm)
INSCRIBED [in ink] *Charles Chipiez. 1888.*
PROVENANCE Major Anthony Everett, Wiltshire;
D. & R. Blissett, UK

Chipiez worked with archaeologist Georges Perrot (1832–1914) to achieve his theoretical and highly influential reconstructions of the Temple of Jerusalem, destroyed in AD 70, which illustrated their *Histoire de l'art dans l'Antiquité*, first published in Paris in 1887. This rendering was displayed at the Exposition Universelle in Paris in 1889 and a portion of its original mat survives, indicating it was titled, as in the publication, *Vue laterale du Temple et de L'enciente du Parvis des Pretres*.

Fragment of original mat

Histoire de l'art dans l'Antiquité, 1887, vol. IV, pl. V

11.2

YVES VIEULET (FRENCH, b. 1920)

1990.266: Reconstruction drawing of the Temple of Vesta, Rome: elevation and plan, mid-20th century

Pencil, ink, watercolor. 27¼ × 20¼ in. (69.2 × 51.4 cm)
INSCRIBED [in ink] *TEMPLE DE VESTA A ROME / VIEULET / DIVI · HERCULIC · AVG*
PROVENANCE unknown

Temple of Vesta, Rome

RECONSTRUCTION DRAWINGS 545

11.3

JULES FORMIGÉ (FRENCH, 1879–1960)

2000.458a–d: Reconstruction drawings of the Roman theater in Arles, France: elevations and plans, 1914

Pencil, ink, watercolor

2000.458a: Reconstruction of original facade, plan and various details. 26⅝ × 39¾ in. (67.6 × 100.9 cm) INSCRIBED [in watercolor] *ARLES THEATRE ROMAIN / FAÇADE ET PLAN DU POSTSCENIUM ETAT ACTUEL / ARCATURES AVEGLES AU XXE / PEINTURES DU PORTIQUE AU XE / CORBEAU DU VELUM AU XXE – FACE ET PLAN / CORNICHE SUPERIEURE AU XE – FRAGMENT AVEC RETOUR / FAÇADE DU POSTSCENIUM RESTIVEE / Les largeurs sont données par le plan. La hauteur du portique et celle des arcatures aveugles reglent avec la façade conservée au Sud; les parties supérieurs avec la decoration intérieure de la scene dont les ordres ont été retrouvés. On possède en outre quelques fragments des peintures du portique, des arcatures, des corbeaux du velum et de la corniche superieure. Au théatre d'Orange on rencontre les mêmes dispositions et des mesures principals analogues. / ARCATURES AVEUGLES / COMBLE DU PORTIQUE / « ARC DE LA MISERICORDE » / ANTEFIXE EN TERRE CUITE DU PORTIQUE AU VE / MASQUE EN PIERRE DU PORTIQUE AU XE / HAUTEURS INDIQUEES PAR LA · TOUR DE ROLLAND · / VALVA REGIA / [2×] MACHINAE / [8×] CHORAGIUM / [2×] VALVA HOSPITALIUM / [2×] SCALA / CLOACA / BASILICA THESAURI / [2×] SOL ROMAIN / [2×] SOL ACTUEL / BASILICA / MAT / JULES FORMIGÉ /* [architectural measurements]

2000.458b: Ruined facade and restoration details. 28½ × 41 in. (72.4 × 104.1 cm) approx. INSCRIBED [in watercolor] *ARLES THEATRE ROMAIN / FAÇADE MERIDIONALE ETAT ACTUEL / ENTABLEMENT DU REZ DE CHAUSSEE / II ETAGE 1 ETAGE REZDECH IMPOSTES / ENTABLEMENT PREMIER ETAGE / [3×] FACE INTERE / Voir sur la feuille de la façade du postscenium le detail de la corniche superieure de la scène. / IIE ETAGE 1ER ETAGE REZDECH. ARCHIVOLTES / ENTABLEMENT DEUXIEME ETAGE / Voir sur la feuille de la façade du postscenium le detail des corbeaux du velum. / JULES FORMIGÉ /* [architectural measurements]

2000.458c: Original plan over ruined plan. 31 × 42½ in. (78.7 × 107.9 cm) approx. INSCRIBED [in watercolor] *ARLES THEATRE ROMAIN / PLAN ACTUEL / AMBULATIO VIRIDIBUS ADORNATA / PORTICUS / [2×] THESAURI / [2×] BASILICA / PROSCAENIUM / LOGEUM / ORCHESTRA / FRONS / SCAENAE / VALVA REGIA / [2×] POSTSCAENUM / [4×] CHORAGIA / MACHINAE / [2×] SCALA / [2×] VALVA HOSPITALIUM / [2×] PARASCAENIUM / [2×] ADITUS IN SCAENAM A FORO / [3×] SCALA TRABS / [2×] SCALA AD TRIBUNAL / [2×] PROCURATOR A SCAENA / [2×] ADITUS MAXIMUS / [5×] VOMITORIUM / [2×] SCALA AD MAENIANUM I / [2×] SCALA AD MAENIANUM II / [2×] SCALA AD MAENIANUM III / [2×] AMBULACRUM / MURUS PULPITI / GRADUS DECURIONUM / BALTEUS / GRADUS DECURIONUM / COCHLEA / AXIS TYMPANI / AXIS SUCULAE / JULES FORMIGÉ /* [architectural measurements]

2000.458d: Reconstruction of side elevation. 32 × 54½ in. (81.2 × 138.4 cm) INSCRIBED [in ink] *ARLES THEATRE ROMAIN / FAÇADE MERIDIONALE RESTITUTION / JULES FORMIGÉ /* [architectural measurements]

PROVENANCE Alain Cambon, Paris; Marc Dessauce, New York

ARLES
THEATRE ROMAIN

ARLES
THEATRE ROMAIN

FAÇADE MERIDIONALE
ETAT ACTUEL

| ENTABLEMENT PREMIER ETAGE | ENTABLEMENT DU REZ DE CHAVSSEE | ENTABLEMENT DEVXIEME ETAGE |

IMPOSTES — ARCHIVOLTES

ECHELLES | ENSEMBLE 0,°015 | DETAILS 0,°05

JVLES FORMIGÉ

ARLES
THEATRE ROMAIN

FAÇADE MERIDIONALE
RESTITVTION

ECHELLE 0,°015 P.M.

JVLES FORMIGÉ

11.4

ARCHITECTS: GIACOMO BAROZZI
DA VIGNOLA (ITALIAN, 1507–1573)
AND BARTOLOMEO AMMANNATI
(ITALIAN, 1511–1592)
ARTIST: HAROLD CHALTON BRADSHAW
(BRITISH, 1893–1943)

1992.392a–d and 1992.393: Reconstruction drawings for Villa Giulia, Rome, built ca. 1550 for Pope Julius III: views, cross-sections, plan, details, 1914–15

Pencil, ink, watercolor

1992.392a: Perspective view. 63 × 31¼ in. (160 × 79.3 cm)
INSCRIBED [in brown ink] · ROME · / Villa di Papa Giulio III / Vignola Architect / 1550 / A PERSPECTIVE VIEW MADE FROM MEASUREMENTS AND DRAWINGS IN JUNE · 1915 · / [in black ink] H. Chalton Bradshaw

1992.392b: Cross-section. 25 × 40¼ in. (63.5 × 102.2 cm)
INSCRIBED [in brown ink] VILLA DI PAPA GIULIO III ROME One eighth of an inch to one foot / The Cross Section through the Fountain Court / [in black ink] H. Chalton Bradshaw 1914

1992.392c: Cross-section. 22 × 34¼ in. (55.8 × 87 cm)
INSCRIBED [in black ink] · VILLA PAPA GIULIO III · ROME · / Showing the actual state of the Villa as it appeared in June 1914. / The Longitudinal Section drawn to the full scale of eight feet to one inch. / Vestibule & Apartments / Colonnade Court & Garden / [2×] Loggia / The Fountain Court / Garden / H. Chalton Bradshaw Roma '14

1992.392d: Ground floor plan. 31 × 23½ in. (78.7 × 59.6 cm)
INSCRIBED [in black ink] ROME · VILLA DI PAPA GIULIO III / Giacomo Parozzi [sic] da Vignola and Bartolomeo Ammanati / as a Residence for Pope Julius III / GROUND FLOOR PLAN / The Entrance / GREAT COURT / The gardens are recent / The lighter part is recent / Terrace / Loggia & Ante / Colonade for Sculpture / FOUNTAIN COURT / The staircase was formed later to provide further access to the fountain / The position of the Chapel is not in accordance with the original plan / GARDEN / Bird Cages Loggia / Stair to Fountain Loggia / [various measurements] / [in black ink] H. Chalton Bradshaw / Roma '14

1992.393: Restoration drawings of fragments of an Etruscan temple relocated to Villa Giulio. 32 × 23½ in. (81.2 × 56.6 cm) approx.
INSCRIBED [in brown ink] ETRUSCAN TEMPLE OF LO SCASATO AT CIVITA CASTELLANA / THE TERRA COTTA FRAGMENTS QUARTER SIZE / IN THE VILLA DI PAPA GIULIO ROME / FRAGMENT OF THE CENTRAL ACROTERION / TILES / TEMPLA / CANTHERII / THE COLUMN AND MUTULAE WERE CONCEALED BY THIS HANGING FASCIA / THE CORNICE OF THE PEDIMENT SECTION SHOWING RELATIVE PROJECTIONS / UNDER SIDE OF PROJECTING TILE ON SIDES / ALTERNATE ANTERIXAL FIGURES OF THE SIDES / REVETMENT OF TRABES COMPACTILES / [in pencil] line in red / blue ground / [various measurements] / [in black ink] H. Chalton Bradshaw

PROVENANCE Charles Plante, London

🌹 Bradshaw was the first British Rome Prize recipient. The villa is today home to the National Museum of Etruscan Art.

Villa Giulia, Rome

ROME

Villa di Papa Giulio III

Vignola – Architect

1550

A PERSPECTIVE VIEW MADE
FROM MEASUREMENTS AND
DRAWINGS IN JUNE 1915

1992.392b

VILLA DI PAPA GIVLIO III ROME

One eighth of an Inch to one Foot

The Cross Section through the Fountain Court

1992.392c

Vestibule & Apartments · Colonnaded Court & Garden · Loggia · The Fountain Court · Loggia · Garden

VILLA PAPA GIVLIO III ROME

1992.392d

1992.393

Fragments of the Etruscan temple 'Lo Scasato' at the
National Museum of Etruscan Art in Villa Giulio

RECONSTRUCTION DRAWINGS 553

11.5

ARTIST UNKNOWN (FRENCH)

1990.351: Reconstruction drawing of the Temple of Apollo at Delphi (?), ca. 1900

Pencil, ink, watercolor. 23 3/8 × 29 in. (59.3 × 71.1 cm)
INSCRIBED [in watercolor, on entablature] *Δ – ΓΝΩΘΙ ΣΕΑΥΤΟΝ – Φ*
PROVENANCE unknown

11.6

ARTIST UNKNOWN (FRENCH)

1987.32: Composite reconstruction
drawing of a classical temple,
late 19th century

Pencil, ink, watercolor. 24 × 46 in. (60.9 × 116.8 cm)
INSCRIBED [in watercolor, on pediment] *JUSTICE*
PROVENANCE unknown

11.7

JOSEPH-FRÉDÉRIC DEBACQ (FRENCH, 1800–1892), ATTRIBUTED TO

1989.241–242: Reconstruction drawings of the original polychromy on architectural fragments from the ancient Greek Temple of Hera at Metaponto, Italy, in the collection of Honoré d'Albert, duc de Luynes (1802–1867), ca. 1833

Pencil, watercolor

1989.241: Fragment in the Bibliothèque nationale de France (Luynes 780). 14¼ × 18¾ in. (36.2 × 47.6 cm)

1989.242: Fragments in the Bibliothèque nationale de France (Luynes 780, 784.8 and 784.12). 14¼ × 21¾ in. (37 × 55.2 cm)
INSCRIBED [on both, in watercolor] *FRAGMENT EN TERRE CUITE TROUVÉ DANS LES RUINES D'UN TEMPLE DORIQUE GREC A MÉTAPONTE. / MOITIÉ DE L'EXÉCUTION*

PROVENANCE Shepherd Gallery, New York

🍂 The Temple of Hera was discovered in 1828. The duc de Luynes's collection of antiquities was acquired by the Bibliothèque nationale de France in 1862. These renderings were prepared for publication in Le Duc de Luynes and F. J. Debacq, *Métaponte* (Paris, 1833), plates VII and VIII.

Métaponte (Paris, 1833), pl. VII

Métaponte (Paris, 1833), pl. VIII

Lion's head architectural fragment from the Temple of Hera, Luynes 780
(Duc de Luynes Collection, Bibliothèque nationale de France, Paris)

FRAGMENT EN TERRE CUITE TROUVÉ DANS LES RUINES D'UN TEMPLE DORIQUE GREC A MÉTAPONTE.

MOITIÉ DE L'EXÉCUTION

FRAGMENTS EN TERRE CUITE TROUVÉS DANS LES RUINES D'UN TEMPLE DORIQUE GREC A MÉTAPONTE.

MOITIÉ DE L'EXÉCUTION

SALVE

Jules LAFARGUE

11.8

JULES LAFARGE FILS
(FRENCH, DATES UNKNOWN)

1990.303a: Classical interior, ca. 1900

Pencil, ink, watercolor. 37¾ × 29½ in. (95.8 × 74.9 cm)
INSCRIBED [in pencil] *Jules – LAFARGUE (fils)* / [in watercolor, on tiled entrance floor] *SALVE*
LITERATURE: Sotheby's, London, sale cat. 26 April 1990, p. 142, lot 456 (ill.; mislabeled 457)
PROVENANCE Sotheby's, London, 26 April 1990, lot 456

11.9

ARTIST UNKNOWN (FRENCH)

1991.371: Classical interior, ca. 1900

Pencil, ink, watercolor. 13⅞ × 12¼ in. (35.2 × 31.1 cm)
PROVENANCE unknown

11.10

JOHN JAMES JOASS (BRITISH, 1868–1952)

1987.76: A wall in the House of Livia, Rome, 1895

Pencil, ink, watercolor. 19 × 31 in. (48.5 × 79 cm)
INSCRIBED [in black ink] *PALATINE HILL: ROME / DECORATION OF WALL IN THE HOUSE OF LIVIA /* [2×] *J.J. Joass delt 1895 / J.J. Joass June 95*.
PROVENANCE Gallery Lingard, London

The House of Livia was rediscovered in 1596 and excavated in 1839. Recipient of the RIBA Pugin and Owen Jones prizes, Joass was in Rome in 1892 and again in 1895.

Corresponding wall painting from the House of Livia, Palatine Hill, Rome

# 11.11

EMILE JACQUES GILBERT
(FRENCH, 1793–1874)

1990.333a–e: Wall paintings from Herculaneum and Pompeii from an album, 1824

Pencil, gouache

1990.333a: Unidentified fresco. $16\frac{3}{8} \times 11\frac{1}{4}$ in. (41.2 × 28.5 cm) approx.

1990.333b: Unidentified fresco. $10\frac{1}{4} \times 9\frac{1}{2}$ in. (26 × 24.1 cm) approx.

1990.333c: Copy of a fresco in the Villa Pansa, Pompeii. $14\frac{1}{4} \times 15\frac{1}{8}$ in. (36.1 × 38.7 cm) approx.

1990.333d: Unidentified fresco. $11\frac{1}{4} \times 12\frac{7}{8}$ in. (28.5 × 32.3 cm) approx.

1990.333e: Unidentified ruined fresco at Pompeii. $10\frac{1}{4} \times 14$ in. (26 × 35.5 cm) approx.
INSCRIBED [in pencil] *Portici 1824 G / Peinture trouvée a Herculaneum.*

LITERATURE Sotheby's, London, sale cat. 15 Nov. 1990, pp. 26–27, lot 23 (album of 21 sheets) (333a ill.)
PROVENANCE Sotheby's, London, 15 Nov. 1990, lot 23 (an album of 21 drawings); Charles Plante, London

🌶 Gilbert won the Grand Prix in 1822 and was in Rome 1823–26. The Villa Pansa at Pompeii was excavated in stages (1810, 1813, 1827 and 1852). It has been suggested that the unidentified sheets depict wall paintings in the Eumachia in the Forum of Pompeii and the bakery at Herculaneum (Insula Orientalis II). Such watercolors were rendered by other 19th-century Rome Prize winners and appeared in publications like Fausto and Felice Niccolini, *Le case ed i monumenti di Pompei disegnati e descritti* (vol. 1 Naples, 1854).

View of similar surviving wall paintings from the Ixion Room, House of Vettii, Pompei

1990.333a

RECONSTRUCTION DRAWINGS

1990.333c

1990.333d

1990.333b

1990.333c

11.12

GABRIEL AUGUSTE ANCELET
(FRENCH, 1829–1895)

1990.276a,b: *Envois de Rome* assignments [?]: two restoration drawings of ruins in the Roman Forum, 1853

Pencil, ink, watercolor

1990.276a: Elevation detail of the Temple of Jupiter Stator.
23½ × 31½ in. (59.7 × 80 cm) approx.
INSCRIBED [in watercolor] *TEMPLE DE JUPITER · STATOR / DÉTAIL · AU · QUART · DE · L'EXECUTION* / [in red pencil] *A. Ancelet Rome 1853*

1990.276b

1990.276b: Elevation, profile and ornamental details of the Temple of Concord in the Forum, Rome. 15 × 39½ in. (38 × 100.3 cm) approx.
INSCRIBED [in watercolor] *TEMPLE DE LA CONCORDE AU FORUM / DÉTAIL AU QUART* / [in pencil] *Envoi de Louvet* [?] / [in ink] *A. Ancelet Rome 1853*

PROVENANCE unknown

❧ Ancelet won the Grand Prix in 1851 and was in Rome 1852–55.

View of the Roman Forum, photograph ca. 1900

RECONSTRUCTION DRAWINGS 565

DORIC CAPITAL

FROM THE PARTHENON

11.13

LEON KEACH (AMERICAN, 1893–1991)

1996.401f: Study of a Doric column from the Parthenon: elevation, cross-section and two profiles, ca. 1915–16

Pencil, ink, watercolor. 25 × 17½ in. (63.5 × 44.4 cm)
INSCRIBED [in watercolor and ink] *DORIC CAPITAL FROM THE PARTHENON* / [in red crayon] *1st mention* / [in black ink] *L. Keach*
PROVENANCE Gwenda Jay Gallery, Chicago

11.14

ARTIST UNKNOWN

1989.202: Study of a Corinthian column, ca. 1900

Pencil, ink, watercolor. 20¾ × 15⅛ in. (52.7 × 38.4 cm)
PROVENANCE unknown

11.15

R. DE CLERCK (BELGIAN, DATES UNKNOWN)

1989.244: Competition drawing of a Gothic capital, ca. 1900

Pencil, ink, watercolor. 19 × 24¾ in. (48.2 × 62.8 cm)
INSCRIBED [in blue] *CONCOURS de 3ᵐᵉ ANNÉE – ETUDE d'une VOUTE à LIERNE – CHAPITEAUX –* / [cipher] *ESL* [École de Saint Luc] / [on verso] *DeClerck*
PROVENANCE Shepherd Gallery, New York

11.16

CHARLES EDWARD GEORGES
(BRITISH, 1869–1970)

1988.141f: Examination drawing
of an architectural fragment, 1887

Pencil, watercolor. 19 × 27 in. (48.2 × 65.5 cm)
STAMPED [in black, inside crowned hexangonal] [indistinct] /
[embossed] *ESK* [Examined South Kensington]
PROVENANCE unknown

11.17

HAROLD BRAMHILL (BRITISH, 1905–1997), ATTRIBUTED TO

1987.83: Composite drawing of a Venetian wellhead and flagpole against Palladio's Basilica in Vicenza, ca. 1925

Pencil, ink, watercolor. 28 × 19½ in. (71.1 × 49.5 cm)
INSCRIBED [in watercolor] *PALLADIO*
PROVENANCE Gallery Lingard, London

🌹 Possibly conceived for a book cover or frontispiece.

The Basilica, Vicenza

11.18

NOËL MARCEL LAMBERT
(FRENCH, 1847–1917)

1987.17 and 1990.285: Restoration drawings of the Ambassadors' Staircase and Buffet d'Eau at Versailles for publication in Philippe Gille and Noël Marcel Lambert, *Versailles et les deux Trianons* (2 vols., Tours, 1899), ca. 1898–99

Pencil, ink, watercolor

1987.17: The Ambassadors' Staircase at Versailles, constructed between 1672–79 by Francois d'Orbay (1634–1697) and Charles LeBrun (1619-1690) and destroyed in 1752. 13½ × 21¼ in. (34.2 × 53.9 cm)
INSCRIBED [in ink] *MARCEL LAMBERT Del.t et Direx.t / Marcel Lambert /* [architectural measurements]
PROVENANCE unknown

The Ambassador's Staircase, in Philippe Gille and Noël Marcel Lambert, *Versailles et les Deux Trianons* (Tours, 1899), p. 132bis

1990.285

1990.285: Elevation, plan, profile, and cross-section of the Buffet d'Eau, by Jules-Hardouin Mansart (1646–1708), after its restoration in 1892. 39¼ × 55 in. (140 × 100 cm)
INSCRIBED [in ink] *LE BUFFET D'EAU DE TRIANON au dixième. / DESSINÉ PAR MANSART / SCULPTÉ PAR VAN CLEVE. MAZIERE. GARNIER. / POIRIER. LE LORRAIN. LEMOINE. HARDY. LAPIERE / TERMINE EN 1688 / EXECUTÉ EN MARBRE DU LANGUEDOC / ORNEMENTS EN BRONZE DORÉ / STATUES DE NEPTUNE ET D'AMPHETRITE* [sic] */ COUPE AU QUART DE L'ELEVATION / PLAN AU QUART DE L'ELEVATION*
PROVENANCE Maitre Desamais, Avignon, 17 Dec. 1989

🌶 After winning the Grand Prix in 1873 and three years in Rome, 1874–77, Lambert became *architecte en chef du domaine de Versailles et des Trianons* in 1888, a position he held until 1912.

The Buffet d'Eau, in Philippe Gille and Noël Marcel Lambert, *Versailles et les Deux Trianons* (Tours, 1899), p. 240bis

RECONSTRUCTION DRAWINGS

EGYPTIAN.

- 3 From a Wooden Sarcophagus.
- 4 Portion of a Necklace.
- 5 From the Tombs El Kab.
- 6 From Mummy Case in British Museum.
- 1 From the Tombs, Gourna.
- 2 Part of the Wall of a Tomb, Sakhara.

from Owen Jones' Gram. of Orn.t

GREEK.

- Fret.
- Honeysuckle.
- Guilloche.
- Fret.
- Wave Scroll.
- Painted Ornaments. Honeysuckle.
- Laurel.

from Owen Jones' Gram. of Orn.t

Cornice

Frieze

BYZANTINE.

- 3 Monreale Cathedral.
- 1 Stone Sculptured Ornament.
- 4 From St Marks, Venice.
- 2 From an Enamelled Casket.

from Owen Jones' Gram. of Orn.t

GOTHIC.

- 3, 4 Stained Glass. from Owen Jones Gram. of Ornament.
- Cathedral of Troyes.
- Canterbury Cathedral.
- 1 From the Founder's Tomb, Tintern Abbey.
- 2 Stone Ornament from Niche in Westminster Abbey.

from James K. Collings F.R.I.B.A. Examples of Mediæval Foliage.

11.19

CHARLES EDWARD GEORGES
(BRITISH, 1869–1970)

1988.141c–e: Examination studies of historical ornament after Owen Jones (1809–1874), James Kellaway Colling (1816–1905), and William Chambers (1723–1796), and object studies, 1887

Pencil, ink, watercolor, gouache

1988.141c: Historical ornament after Owen Jones, James Kellaway Colling and objects in London museums. 20¾ × 28⅛ in. (52.7 × 71.4 cm)
INSCRIBED [in ink] *ILLUSTRATIONS OF THE ORNAMENTATION OF CONTINUOUS BORDERING. FRIEZES. PILASTERS. MOULDINGS & IN VARIOUS HISTORIC STYLES. / EGYPTIAN. 1. From the Tombs. Courna. 2. Part of the Wall of a Tomb. Sakhara. From Owen Jones Gram. of Orn^t. / 3. From a Wooden Sarcophagus. / 4. Portion of a Necklace. / 5. From the Tombs El Kab / 6. From Mummy Case in British Museum / GREEK. [2×] Honeysuckle. / [2×] Fret. / Wave Scroll. / Laurel. / Painted Ornaments. From Owen Jones Gram^r. Of Orn^t. / ROMAN. / Cornice Moulding. Trajan's Column. Rome. From the Cast / Frieze from the Forum of Trajan Rome. From the Cast. / Acanthus Scroll Rome from the Cast / POMPEIAN. / 1.2.3. Pilasters and Frieze from Houses in Pompeii from Owen Jones Gram. Of Orn^t. / BYZANTINE. 1. Stone Sculptured Ornament. from Owen Jones Gram. of Orn^t. / 2. From an Enamelled Casket. From Owen Jones Gram. of Orn^t. / 3. Monreale Cathedral. From Owen Jones Gram. of Orn^t. / 4. From S^t. Marks. Venice. Owen Jones Gram. of Orn^t. / GOTHIC. / 1. From the Founder's Tomb. Tintern Abbey. / 2. Stone Ornament from Niche in Westminster Abbey. James K. Collings FRIBA Examples of Medieval Foliage / 3.4. Stained Glass from Owen Jones Gram. of Ornament. Cathedral of Troyes. Canterbury Cathedral / RENAISSANCE. Engraved Ornament Book Illustration / From Furniture of the 16th Century. / Engraved Ornament Book Illus. / Majolica O.J. Gram. of Orn^t. / Inlaid Ornament on a Dagger Sheath / Majolica O.J. Gram. of Orn^t. / Pilaster Painted Decoration by (Raphael) O.J. Gram. of Orn^t. / 15/12/87*
STAMPED [in black] *C. GEORGES.* / [inside crowned octagonal, 3×] *EXAMINED* [illegible] *1889 / 1890*

1988.141d: Historical ornament after Owen Jones and after models in the South Kensington Museum (V&A) and other museum collections. 20⅜ × 26¼ in. (51.8 × 66.6 cm)
INSCRIBED [in ink] *ILLUSTRATIONS OF THE ORNAMENT OF FLAT SURFACES AND BORDERS IN VARIOUS HISTORIC STYLES. / ARABIAN. [2×] Ornament on the Mosque of Kalaoon. Owen Jones. Gram. of Orn^t. / Design from Architrave. Mosque of Tooloon. Cairo. O.J. Gram. of Orn^t. / From the Koran in the Mosque El Barkookeyeh. OJ Gram of Orn^t. / INDIAN. Man's Garment. Benares. India Museum. / Jeypore Enamels South Kensington Museum. / Man's Garment. Benares India Museum. / MORESQUE. 1.2. From the Alhambra. O.J. Gram. of Orn^t. / From the Alhambra / PERSIAN. Carpet. South Kensington Museum / Glaized* [sic] *Tiles. Brighton Museum. / JAPANESE. Silk Damask. Audsley. / Cha^s. E. Georges 23/3/88*
STAMPED [inside rectangle and in crowned hexagonal, 2×] *EXAMINED* [illegible] *1889 / 1890 / WORK ACCEPTED FOR CERTIFICATE* / [embossed] *ESK* [Examined South Kensington]

1988.141e: Studies after William Chambers, 1887. 28¼ × 20½ in. (71.7 × 52 cm)
INSCRIBED [in ink] *THE CLASSIC ORDERS / GRECIAN. / DORIC. TEMPLE OF MINERVA (THE PARTHENON) ATHENS. AUTHOR CHAMBERS / IONIC. TEMPLE OF ERECTHEUS. AUTHOR CHAMBERS / CORINTHIAN. CHORAGIC MONUMENT OF LYSIGRATES. AUTHOR CHAMBERS / ROMAN. / DORIC . AUTHOR CHAMBERS / IONIC. AUTHOR CHAMBERS / CORINTHIAN. AUTHOR CHAMBERS / BASE OF COLUMN. FROM THE TEMPLE OF ERECTHEUS. / ENTABLATURE OF ROMAN IONIC / DETAIL OF LEAF BUD MOULDING / C. Georges / 14/2/87*
STAMPED: [inside crowned hexangonal, 3×] *EXAMINED 1887 3RD GR CERT / EXAMINED 1887* [illegible] / *EXAMINED 1888* [illegible] / [punched stamp] *ESK*

PROVENANCE unknown

❧ A blend of direct studies of objects in museums and historic houses and copies of ornament and architecture in James Kellaway Colling, *Examples of British Medieval Foliage and Coloured Decoration* (London, 1874), Owen Jones, *The Grammar of Ornament* (London, 1856) and William Chambers, *A Treatise on Civil Architecture* (London, 1759).

Owen Jones, *Grammar of Ornament* (1856), pl. VII, Egyptian No. 4

Owen Jones, *Grammar of Ornament* (1856), pl. XXII, Greek No. 8

Owen Jones, *Grammar of Ornament* (1856), pl. LXXXII, Renaissance No. 9

James Kellaway Colling, *Examples of British Medieval Foliage and Coloured Decoration* (1874), p. 66

ILLUSTRATIONS OF THE ORNAMENTATION OF CONTINUOUS BORDERING,
FRIEZES, PILASTERS, MOULDINGS, &c IN VARIOUS HISTORIC STYLES.

EGYPTIAN. GREEK. ROMAN. POMPEIAN.

BYZANTINE. GOTHIC. RENAISSANCE.

C. GEORGES.

ILLUSTRATIONS OF THE ORNAMENTATION OF FLAT SURFACES AND BORDERS, IN VARIOUS HISTORIC STYLES.

ARABIAN.

Ornament in the Mosque of Kalaoon.
Owen Jones. Gram. of Ornt.

Ornament in the Mosque of Kalaoon.
Owen Jones. Gram. of Ornt.

Design from Architrave.
Mosque of Tooloon, Cairo.
O.J. Gram of Ornt.

From the Koran in the
Mosque El Barkookeyeh.
O.J. Gram of Ornt.

INDIAN.

Man's Garment. Benares. India Museum.

Jeypore Enamels. South Kensington Museum.

Man's Garment. Benares. India Museum.

MORESQUE.

From the Alhambra

O.J. Gram of Ornt.

From the Alhambra

PERSIAN.

Carpet.
South Kensington Museum.

Glaized Tiles. Brighton Museum.

JAPANESE.

Silk Damask. Audsley.

William Chambers, *Treatise on Civil Architecture* (1759),
'The Ionic Order', p. 22bis

William Chambers, *Treatise on Civil Architecture* (1759),
'The Corinthian Order', p. 28bis

578 PETER MAY COLLECTION II

11.20

G.E. HENDERSON
(BRITISH, DATES UNKNOWN)

1992.394: Restoration drawing or design of a circular mosaic, 1899

Pencil, ink, watercolor. Diam. 25 in. (63.5 cm)
INSCRIBED [in ink] *G.E. Henderson '99*
PROVENANCE Charles Plante, London

RECONSTRUCTION DRAWINGS 579

12
LANDMARKS, MONUMENTS, AND MAUSOLEA

12.1

WILLIAM RAILTON (BRITISH, 1801–1877) AND OTHERS

1987.90a,b: The Charles I and Lord Nelson and monuments in Trafalgar Square, London, mid-19th century

Pencil, ink, watercolor

1987.90a: Equestrian Monument to Charles I, installed ca. 1850. 18 × 12 in. (45.7 × 30.4 cm)

1987.90b: Lord Nelson Monument, 1846. 18½ × 11½ in. (46.9 × 29.2 cm)

LITERATURE Sotheby's, London, *Drawings and Watercolors from the Collection of the late Sir John and Lady Witt*, sale cat. 19 Feb. 1987, p. 147, lot 187 (ill. mislabeled 184); *Capital Buildings* (Gallery Lingard, London, 1987), pp. 15–16, cat. nos. 5 (ill.) and 6 (ill.)

PROVENANCE Sir John and Lady Witt collection; Sotheby's, London 19 Feb. 1987, lot 187; Gallery Lingard, London

🍒 It is likely the watercolors were prepared for publication.

Trafalgar Square, London

1987.90a

582 PETER MAY COLLECTION II

William Railton's Nelson's Column, drawn by G. Hawkins, engraved by J. B. Allen, 1850

LANDMARKS, MONUMENTS & MAUSOLEA 583

12.2

BENJAMIN DEAN WYATT
(BRITISH, 1775–1855)

1990.353a–c: Construction drawings for the Duke of York's Monument, Pall Mall, London: elevation, cross-section and plans, ca. 1830

Pencil, ink, watercolor

1990.353a: Frontal elevation. 11⅝ × 7⅝ in. (29.5 × 19.3 cm)
INSCRIBED: [in black ink] *Duke of York's Monument. No. 23. Elevation of the Column.* / [in red ink] *No.-5 – B:W:* / [architectural measurements]

Duke of York's Monument, Pall Mall, London

584 PETER MAY COLLECTION II

1990.353b: Cross-section. 11 5/8 × 7 5/8 in. (29.5 × 19.3 cm)
INSCRIBED [in black ink] *Duke of York's Monument. General Section thro' the Column.* [in red ink] *No – 5 – B:W:* [in red and black ink] *a – Foundation of Concrete forming a Frustrum of a Pyramid- 19 × 10$^{in.}$ deep below the Ground line, 53 feet square at its base – and 30 feet square at its base – and 30 feet square at the top – lying at the bottom 12$^{in.}$ deep in a solid bed of maiden clay. / b – 6 in. Yorkshire Landings in 9 stones making a square of 30 feet – lying about 1 foot apart – & embedded in the concrete. / c – Do – Do in 9 stones close jointed – lying on top of concrete upon which the structure is built.* / [architectural measurements]

1990.353c: Two cross-sections. 12 7/8 × 9 1/4 in. (32.7 × 23.5 cm)
INSCRIBED [in black ink] *Duke of York's Monument* / [in red ink] *No – 5 – B:W:* / [in black] *No. 14.- Plans of the Courses forming the upper & lower diameters of the Shaft of the Column – lettered N & O in the Sections Nos. 18 & 19. / a. – Bond Stone – with the 5 Steps, and the Newel the whole height of the course cut out of the Solid block. / b. – Copper plugs 2ins Sq. 3ins deep let in half way into the Center of the Newel of the Bond Stone of each course, and run in with Parker's best Cement all round. / c. – Yorkshire Stone keep as shown at (o) in the Sections Nos. 18 & 19 passing through each course of the Shaft at every Joint and going down 2 inches into the course below. – & run in with Parker's best cement all round. / N.B. – the Bond Stone as shown in these Plans at (a) is repeated in each course throughout the shaft of the Column – each successive bond Stone being at right angles with that of the preceding course. –*

PROVENANCE Heim Gallery, London; Charles Plante, London

12.3

SCULPTOR: CHARLES EMILE SEURRE
(FRENCH, 1798–1858)
ARCHITECTS: JACQUES GONOUIN
(FRENCH, 1737–1818) and JEAN-BAPTISTE
LEPÈRE (FRENCH, 1761–1844)
ENGRAVER: EPHRAÏM CONQUY
(FRENCH, 1808–1843)

1989.215: Monument to Napoleon, also known as the Grand Army (Grand Armée), Austerlitz or Victory Column, Place Vendôme, Paris, with figure of Napoleon in military uniform, ca. 1833–43

Engraving and watercolor. 39¾ × 18¼ in. (100.9 × 46.3 cm)
PROVENANCE unknown

🌶 The column was erected between 1806 and 1810, with a statue of Napoleon sculpted by Antoine-Denis Chaudet showing him in Roman armor. In 1833 this statue was replaced with the one represented here, showing him in contemporary uniform, in what is probably a commemorative print. In 1871 this second figure of Napoleon was itself removed and later replaced by a third.

Monument to Napoleon, Place Vendôme, Paris

12.4

LEON JAUSSELY (FRENCH, 1875–1932)

1990.260: Competition drawing for a memorial column, ca. 1895–1900

Pencil, ink, watercolor, gilding. 14 × 11⅜ in. (35.5 × 29 cm)
INSCRIBED [on column] *COURAGE* / [in ink] *Joussely*
PROVENANCE Sotheby's, London, 27 April 1989, lot 661

LANDMARKS, MONUMENTS & MAUSOLEA

12.5

SCULPTOR: ALESSANDRO DE' LEOPARDI
(ITALIAN, 1465–1523)
ARTIST UNKNOWN (FRENCH)

1987.3: Competition drawing of the base of one of Alessandro de' Leopardi's flagpoles of 1505, Piazza San Marco, Venice, late 19th century

Pencil, ink, watercolor. 35½ × 24½ in. (90.1 × 62.2 cm)
INSCRIBED [in watercolor] *PILÔNE SUR LA PLACE SAINT-MARC À VENISE*
STAMPED [in purple] *ECOLE ROYALE DES BEAUX ARTS / CONCOURS D'EMULATION*
PROVENANCE unknown

Alessandro de' Leopardi, flagpole base, Piazza San Marco, Venice

Canaletto, *The Square of Saint Mark's, Venice*, 1742/44
(National Gallery of Art, Washington)

12.6

JEAN-CAMILLE FORMIGÉ
(FRENCH, 1845–1926)

2007.527: Competition drawing for a fountain for Place de Lyon, Lyon: elevation, ca. 1870

Pencil, ink, watercolor. 28⅛ × 39 in. (71.4 × 99 cm)
PROVENANCE Alain Cambon, Paris

1988.136

12.7

ARCHITECT UNKNOWN (FRENCH)

1988.136: Competition drawing for a fountain: elevation, late 19th century

Pencil, ink, watercolor. 24⅝ × 19⅞ in. (62.5 × 50.4 cm)
PROVENANCE unknown

12.8

ARCHITECT UNKNOWN

1989.198: Competition design for a fountain: elevation, 18th century (?)

Pencil, ink, watercolor. 11 × 8½ in. (27.9 × 21.5 cm)
PROVENANCE unknown

REGNANTE · CAROLO · X ·
PRISTINVM · FONTEM · ANGVSTIORI · AREA · JAM · AMPLIFICATA
COMMVNI · VTILITATI · VRBIS · QVE · ORNAMENTO ·
IN · MAIVS · RESTITVERVNT · PRAEFECTVS · ET · AEDILES
ANNO · MDCCCXXVIII ·

12.9

LOUIS TULLIUS JOACHIM VISCONTI
(ITALIAN/FRENCH, 1791–1853)

2000.446 and 2000.515: Elevations of the fountain at Place Gaillon, Paris, 1828

Pencil, ink, watercolor

2000.446: 27½ × 19½ in. (69.8 × 49.5 cm)
INSCRIBED [on pediment above fountain, in watercolor] *REGNANTE · CAROLO · X · PRISTINUM · FONTEM · ANGUSTIORI · AREA · JAM · AMPLIFICATA · COMMUNI · UTILITATI · URBIS · QUE · ORNAMENTO · IN · MAIUS · RESTITUERUNT · PRAEFECTUS · ET · AEDILES · ANNO · MDCCCXXVIII*
PROVENANCE Galerie Martin du Louvre, Paris

2000.515: 26⅜ × 18¼ in. (66.9 × 46.3 cm)
INSCRIBED [in ink] *LVisconti 1838* / [on pediment above fountain, in watercolor] *REGNANTE · CAROLO · X · PRISTINUM · FONTEM · ANGUSTIORI · AREA · JAM · AMPLIFICATA · COMMUNI · UTILITATI · URBIS · QUE · ORNAMENTO · IN · MAIUS · RESTITUERUNT · PRAEFECTUS · ET · AEDILES · ANNO · MDCCCXXVIII*
PROVENANCE D. & R. Blissett, London

Fountain at Place Gaillon, Paris

LANDMARKS, MONUMENTS & MAUSOLEA 593

2000.478a

2000.478b

12.10

GABRIEL PIERRE MARTIN DUMONT
(FRENCH, 1720–1791)

2000.478a,b: Competition drawings for a fountain: elevation and plan, 1743

Pencil, ink, watercolor. 13½ × 10¼ in. (34.2 × 26 cm)
INSCRIBED [2000.478a, on reverse] *Gabriel-Martin Dumont invenit et fecit à Rome au mois de janvier 1743*
LITERATURE *Dessins du XVIe Siecle* (Galerie Daniel Greiner, Paris, 1997), pp. 14–15, cat. 19 (ill.)
PROVENANCE Galerie Daniel Greiner, Paris

❧ Dumont won the Grand Prix in 1737 and remained in Rome until at least 1746.

12.11

ARCHITECT UNKNOWN (FRENCH)

2000.547: Competition drawing
for a triumphal bridge: elevation, ca. 1800

Pencil, ink, watercolor. 7⅝ × 10⅞ in. (19.5 × 27.5 cm)
PROVENANCE Galerie Martin du Louvre, Paris

LANDMARKS, MONUMENTS & MAUSOLEA

| DESIGN FOR A BRIDGE OVER A RIVER WITH COVERED FOOTWAYS | THE SOANE MEDALLION 1915/1920 | AND THE TREATMENT OF THE APPROACHES AND RIVER EMBANKMENTS |

GOVERNMENT OFFICES | ROADWAY | THE CITY HALL | ROADWAY | GOVERNMENT OFFICES

NORTH FACADE TO RIVER

"CITY CENTRE"

| DESIGN FOR A BRIDGE OVER A RIVER WITH COVERED FOOTWAYS | THE SOANE MEDALLION 1915/1920 | AND THE TREATMENT OF THE APPROACHES AND RIVER EMBANKMENTS |

PUBLIC OFFICES | PUBLIC OFFICES

SOUTH FACADE TO RIVER

"CITY CENTRE"

12.12

GEORGE ALFRED ROSE
(BRITISH, DATES UNKNOWN)

1990.297a–c: Competition drawings for the 1915 (1920) Soane Medallion "Two designs for a Bridge over a River, with Covered Footways", 1915–20

Pencil, ink, watercolor

1990.297a: Elevation. 30 × 53 in. (76.2 × 134.6 cm)
INSCRIBED [in black and red] *THE SOANE MEDALLION 1915 (1920) / DESIGN FOR A BRIDGE OVER A RIVER WITH COVERED FOOTWAYS AND THE TREATMENT OF THE APPROACHES AND RIVER EMBANKMENTS / NORTH FAÇADE TO RIVER / [2×] GOVERNMENT OFFICES / THE CITY HALL / [2×] ROADWAY*

1990.297b: Elevation. 30 × 53 in. (76.2 × 134.6 cm)
INSCRIBED [in black and red] *THE SOANE MEDALLION 1915 1920 / DESIGN FOR A BRIDGE OVER A RIVER WITH COVERED FOOTWAYS AND THE TREATMENT OF THE APPROACHES AND RIVER EMBANKMENTS / SOUTH FAÇADE TO RIVER / [2 ×] PUBLIC OFFICES / "CITY CENTRE"*

1990.297c: Perspective. 26 × 30 in. (66 × 76.2 cm)
INSCRIBED [in black and red] *THE SOANE MEDALLION 1915 (1920) / PERSPECTIVE VIEW OF THE BRIDGE / "CITY CENTRE"*

LITERATURE Sotheby's, London, sale cat. 26 April 1990, p. 126, lot 405 (ill., sold with booklet illustrating and discussing the winning design by Arthur Gordon Shoosmith)
PROVENANCE Sotheby's, London, 26 April 1990, lot 405

🍁 Owing to World War I, the 1915 competition was postponed at least twice and finally held in 1920, as reflected in the dating of Rose's drawings. The Medallion winner was awarded £150. A fourth Rose drawing and a preliminary sketch were sold at Sotheby's, London, 22 May 1986, lot 341. See *Journal of the Royal Institute of British Architects* (24 January 1920), p. 134, for more on the Soane Medallion.

Cover to a homemade 6-page booklet with clipping and photographs of the now-lost Shoosmith prizewinning drawings

LANDMARKS, MONUMENTS & MAUSOLEA

12.13

ARCHITECT UNKNOWN (FRENCH)

1990.350: Competition drawing for a city gate: elevation and two plans, ca. 1900

Pencil, ink, watercolor. 38⅝ × 54¾ in. (98.1 × 139 cm)
PROVENANCE unknown

12.14

PAUL BONAMY (FRENCH, 1865–1951)

2000.440: Drawing for a city gate: elevation and plan, 1921

Pencil, ink, watercolor. 18⅞ × 25¾ in. (47.9 × 65.4 cm)
INSCRIBED [in ink] *PB* [cipher] *9 Juin 21 / 9 – 6 – 21 / 2^me*
STAMPED [in black] *PAUL BONAMY ARCHITECT & PAYSAGISTE /* [indistinct] *TOULOUSE*
PROVENANCE unknown

LANDMARKS, MONUMENTS & MAUSOLEA

12.15

ARCHITECT UNKNOWN (BRITISH)

1990.335: Drawing for a city or garden gate: elevation and plan, 19th century

Pencil, ink, watercolor. 9½ × 16 in. (24.1 × 40.6 cm)
INSCRIBED [in ink] *Elevation / Ground Plan /* [architectural measurements]
LITERATURE Sotheby's, London, sale cat. 15 Nov. 1990, p. 26, lot 22 (from a folio of drawings)
PROVENANCE Sir John Summerson collection; Sotheby's, London, 15 Nov. 1990, lot 22; Charles Plante, London

12.16

GABRIEL-JEAN-ANTOINE DAVIOUD
(FRENCH, 1824–1881)

1999.413: Gated entrance to Parc Monceau, Paris, mid-19th century

Pencil, ink, watercolor. 12⅞ × 19¾ in. (32.7 × 50.1 cm)
PROVENANCE Marc Dessauce, New York

Parc Monceau, Paris, photograph ca. 1900

LANDMARKS, MONUMENTS & MAUSOLEA

1987.94

12.17

ARTHUR ROSE (BRITISH, DATES UNKNOWN)

1987.94: The lodge at Grosvenor Gate, Hyde Park, London, early 20th century

Pencil, ink, watercolor. 12¼ × 18 in. (31.1 × 45.7 cm)
INSCRIBED [in ink] *ROSE* / [in pencil] *Grosvenor Gate, Hyde Park*
LITERATURE *Capital Buildings / An Exhibition of Architectural Designs and Topographical Views of London* (Gallery Lingard, London, 1987), p. 24, cat. 18
PROVENANCE Gallery Lingard, London

Lodge at Grosvenor Gate, Hyde Park, London

602 PETER MAY COLLECTION II

2000.438

12.18

ARCHITECT UNKNOWN

2000.438: Drawing of a gateway:
elevation, 19th century

Pencil, watercolor. 10½ × 17 in. (26.6 × 43.1 cm)
PROVENANCE Shepherd Gallery, New York

12.19

ARCHITECT UNKNOWN

1987.66a–f: Six designs for city gates: elevations, early 19th century

Pencil, ink, watercolor. 10½ × 18¼ in. (26.6 × 46.3 cm)
PROVENANCE Garrick C. Stephenson, New York

1987.66a

1987.66b

1987.66c

1987.66d

1987.66e

1987.66f

1988.105a

1988.105b

1987.56

12.20

ARCHITECT UNKNOWN (FRENCH)

1988.105a,b: Competition drawings for the Guichet du Louvre, Paris: elevations, ca. 1900

Pencil, ink, watercolor. 16½ × 22½ in. (41 × 57 cm)
PROVENANCE Shepherd Gallery, New York

12.21

ARCHITECT UNKNOWN (FRENCH)

1987.56: Competition drawing for the Guichet du Louvre, Paris: elevation, early 20th century

Pencil, ink, watercolor. 19½ × 27½ in. (49.5 × 69.8 cm)
PROVENANCE unknown

Guichet du Louvre, Paris

LANDMARKS, MONUMENTS & MAUSOLEA

12.22

JEAN BERAUD (FRENCH, 1882–1954)

1989.236c: Competition drawing for a city gate: elevation, two cross-sections and plan, ca. 1903

Pencil, ink, watercolor. 16¾ × 23⅞ in. (42.5 × 60.6 cm)
INSCRIBED [in ink] *L'ENTRÉE – D'UNE CITÉE / AVEC – UN – PASSAGE – À – VOITURE – ET – 2 – PASSAGES – A – PIÈTONS* /*Jean Béraud* / *atelier Laloux Lemaresquier* / [in pencil] *coupe suivant AB*/ *coupe suivant* [indistinct] / *coupe suivant E F*
PROVENANCE unknown

12.23

J. DE BIEVRE (BELGIAN, DATES UNKNOWN)

2000.520: Competition drawing for a city gate: elevation, plan, cross-section and detail, early 20th century

Pencil, ink, watercolor. 25½ × 37⅜ in. (64.7 × 94.9 cm)
INSCRIBED [in ink] *Portique en bordure d'une place publique.* / *12 / coupe AB / détail* / [in blue crayon] *20/60* / [architectural measurements]
STAMPED [circular, in red ink] *ACADÉMIE ROYALE DES BEAUX-ARTS ET ÉCOLE DES ARTS DECORATIFS*
PROVENANCE Galerie Martin du Louvre, Paris

12.24

ARTIST UNKNOWN (BRITISH)

1987.86: Imaginary cityscape of known buildings such as Manchester Police Court; the Tron Kirk, Edinburgh; St James the Less, London; and other British buildings and churches, late 19th century

Pencil, ink, watercolor. 27 × 51½ in. (68.5 × 130.8 cm)
LITERATURE Sotheby's, London, sale cat. 30 April 1987, pp. 142–43, lot 634 (ill.); *Capital Buildings / An Exhibition of Architectural Designs and Topographical Views of London* (Gallery Lingard, London, 1987), pp. 10 and 17, cat. 8 (ill.)
PROVENANCE Sotheby's, London, 30 April 1987, lot 634; Gallery Lingard, London

🖌 Perhaps influenced by Charles Robert Cockerell's architectural capriccios composed of buildings in assorted historical styles.

12.25

THOMAS BLASHILL (BRITISH, 1831–1905)

1987.75: Village clock tower,
late 19th century

Pencil, ink, watercolor. 18½ × 14½ in. (46.9 × 36.8 cm)
INSCRIBED [in ink] *Thos. Blashill*
LITERATURE *Greeks and Goths. An Exhibition of Architectural Drawings in Revival Styles 1800–1930* (Gallery Lingard, London, 1987), pp. 21 and 32, cat. 27 (ill.)
PROVENANCE Gallery Lingard, London

LANDMARKS, MONUMENTS & MAUSOLEA 611

12.26

JOHN THOMAS ROCHEAD (BRITISH, 1814–1878) AND ROBERT F. SHERAR (BRITISH, DATES UNKNOWN)

1987.72: View of the National Wallace Monument, Abbey Craig, near Stirling, Scotland, 1904

Pencil, ink, watercolor. 28¾ × 16 in. (73 × 40.6 cm)
INSCRIBED [in pencil] *Robt. F. Sherar. Archt. 1904.*
LITERATURE *Greeks and Goths. An Exhibition of Architectural Drawings in Revival Styles 1800–1930* (Gallery Lingard, London, 1987), pp. 21 and 37, cat. 40 (ill.)
PROVENANCE Gallery Lingard, London

National Wallace Monument, Abbey Craig

1987.72

612 PETER MAY COLLECTION II

12.27

CHARLES EDWARD GEORGES
(BRITISH, 1869–1970)

1988.141g: Elevation and plan of Charles Barry's 1830 Corinthian Tower, Queen's Park, Brighton, 1890

Pencil, ink, watercolor. 29⅝ × 15½ in. (75.2 × 39.3 cm)
INSCRIBED [in ink] *CORINTHIAN TOWER QUEENS PARK BRIGHTON / ELEVATION / PLANS / ROOF / LEVEL OF WINDOWS / MEASURED AND DRAWN BY Charles E. Georges 10/3/90* / [architectural measurements]
PROVENANCE unknown

Corinthian Tower, Queen's Park, Brighton

LANDMARKS, MONUMENTS & MAUSOLEA 613

12.28

ARCHITECT UNKNOWN (FRENCH)

1990.257: Competition drawing for a bell tower: elevation, 19th century

Pencil, ink, watercolor. 35⅞ × 22⅛ in. (91.1 × 56.2 cm)
PROVENANCE unknown

12.29

VICTOR BALTARD (FRENCH, 1805–1874)

2000.422: Competition drawing for a belltower: elevation, 1828

Pencil, watercolor. 13⅝ × 7¾ in. (34.61 × 19.69 cm)
INSCRIBED [in pencil] *Baltard 9 fev. 1828*
LITERATURE Peter Fuhring, *Design into Art / Drawings for Architecture and Ornament / The Lodewijk Houthakker Collection*, vol. II (1989), p. 533, no. 822 (ill.)
PROVENANCE P. Leroux, 1974; Lodewijk Houthakker, Amsterdam

Printed assignment for the *concours d'émulation*, 2 March 1881

616 PETER MAY COLLECTION II

12.30

J. VEGUND [?] (FRENCH)

1990.300: Competition drawing for a bell tower: elevation, and two plans, 1881

Pencil, ink, watercolor. 25¼ × 18¼ in. (64.1 × 46.3 cm)
INSCRIBED [in ink] *N°. 32 / 2 Mars 1881 / J Vegund [?] /* [in blue crayon] *2ᵉ mention* / [in red crayon] *9*.
LITERATURE Sotheby's, London, sale cat. 26 April 1990, p. 140, lot 449 (ill.)
PROVENANCE Sotheby's, London, 26 April 1990, lot 449

🌺 The assignment for the *concours d'émulation* dated 2 March 1881, *Un Campanile ou Tour pour les cloches* for a parish church, is also annotated, in pencil, "2ᵉ. Mention".

12.31

ARCHITECT UNKNOWN (FRENCH)

1989.199: Competition drawing for a bell tower: elevation, plan, cross-section and detail, 19th century

Pencil, ink, watercolor. 55¾ × 24¾ in. (141.6 × 62.8 cm)
INSCRIBED [in ink] *PLAN AU NIVEAU DU BALCON / PLAN AU NIVEAU DE LA CORNICHE*
PROVENANCE unknown

1989.237 verso

12.32

JEAN BERAUD (FRENCH, 1882–1954)

1989.237verso: Competition drawing for the roof of a campanile: elevation and plan, ca. 1903

Pencil, watercolor. 18¾ × 24⅝ in. (47.6 × 62.6 cm)
INSCRIBED: [in ink] *UNE – TOITURE SURMONTÉE D'UN CAMPANILE / Jean Béraud d'atelier Laloux* [in red crayon] *10* / [in pencil] *Celui de le Tour Eiffel est fonctienment mieux* / [in red pencil] *il y a des choses bien dans ce campanile mais trop de details le collet notament [illegible] et facilement surplus / ces cartouches ne [illegible] pas / manqué le mention / ombre mal tracée*
PROVENANCE unknown

12.33

JEAN BERAUD (FRENCH, 1882–1954)

1989.236a, d: Competition drawings for admission to the École des Beaux Arts: elevations, cross-sections, plans, and perspective for two pantheons, 1903

1989.236a: A Pantheon: Two cross-sections, elevation, plan.
Pencil, ink, watercolor. 16¾ × 22⅝ in. (48.5 × 57.4 cm)
INSCRIBED [in ink] *PORTIQUE D'UN PANTHEON / Jean Béraud / coupe sur CD / coupe sur AB / Plan / Elevation /* [architectural measurements]

1989.236d: A Pantheon: Elevation, cross-section, plan, perspective
Pencil, ink, watercolor. 16⅝ × 23⅞ in. (42.2 × 60.6 cm)
INSCRIBED [in ink] *UN – MONUMENT – EN – SOUVENIR D'HOMMES ILLUSTRES / Jean Béraud / atelier Laloux Lemaresquier*
STAMPED [in purple] *10 OCT. 1903 / Gaillet / Concours du* [in pencil] *Octobre 1903* [stamped] *A* [in pencil] *Béraud Jean*

PROVENANCE unknown

PORTIQUE D'UN PANTHÉON

UN MONUMENT EN SOUVENIR D'HOMMES ILLUSTRES

ND. DES VICTOIRES

12.34

AMET GEORGES ALEXANDRE PRADELLE
(FRENCH, 1865–1935)

1987.61a,b: Prix de Rome competition drawings for a Monument to Joan of Arc: plan and elevation, 1890

Pencil, ink, watercolor, metallic tape
STAMPED *Vente Georges PRADELLE Mr. P.M. ROGEON G.P.*

1987.61a Plan in the form of a helmeted female face
80 × 63 in. (203.2 × 160 cm)

1987.61b: Elevation. 79 × 64 in. (200.6 × 162.5 cm)
INSCRIBED [in watercolor, below pediment] *ND. DES VICTOIRES* [on pediment atop center staircase] *A – JEHANNE – D'ARC – LA – SAINTE – FILLE – QUI – PAR – SA – FOI – ET – SON – COURAGE – ENTRAINA – LES FRANCAIS – A – LA VICTOIRE – ET – RENDIT – A – CHARLES – VII LA – COURONNE – USURPÉE – PAR – LES – ANGLAIS – COCH.* / [on lowest pediment] *A – JEHANNE – D'ARC – LA – PUCELLE – QUI – DELIVRA – LA FRANCE – DU – JOUG – ODIEUX – DES – ANGLAIS – LA – RECONNAISSANTE* / [over side doors] *BIBLIOTHEQUE / MUSÉE* / [on base of trophies] *ORLEANS / REIMS/* [and other illegible inscriptions]

PROVENANCE unknown

🔖 The prize-winning first and second place drawings by Emmanuel Pontremoli, Louis Charles Marie Varcollier and Emile Pierre Bossis are in the ENSBA (see also vol. 1, pp. 22–23).

Prize-winning plan of a Monument to Joan of Arc by Emile-Pierre Bossis, 1890 (ENSBA, PRA 313-1)

Prize-winning plan of a Monument to Joan of Arc by Louis-Charles-Marie Varcollier, 1890 (ENSBA, PRA 312-1)

Prize-winning elevation of a Monument to Joan of Arc by Louis-Charles-Marie Varcollier, 1890 (ENSBA, PRA 312-2)

Prize-winning cross-section of a Monument to Joan of Arc by Louis-Charles-Marie Varcollier, 1890 (ENSBA, PRA 312-3)

1987.61a

1987.61b

12.35

ARCHITECT UNKNOWN (FRENCH)

2000.435: Five monuments on one sheet: elevations, 1822

Pencil, ink, watercolor. 17¾ × 24¾ in. (45 × 62.8 cm)
INSCRIBED [in ink] 24 9.^bre. 1822 Belvedere ou petit Observatoire. / 28 9.^bre 1822 Chapelle Funèbre particulière. / 4 X^bre. 1822 Temple Funèbre. / 3 X^bre. 1822. Monument Funèbre / 16 X^bre. 1822 Pavillon dans un Parc.
PROVENANCE Shepherd Gallery, New York

12.36

JEAN BAPTISTE PIERRE HONORE FERAUD (FRENCH, 1816–1884), ATTRIBUTED TO

1990.352: Competition drawing for a mausoleum: elevations, cross-sections and plan, mid-19th century

Pencil, ink, watercolor, gilding. 14 × 20 in. (35 × 50.8 cm)
INSCRIBED [in ink] FAÇADE PRINCIPALE / FAÇADE LATERALE / COUPE TRANSVERSALE / COUPE LONGITUDINALE / [in red and black] [indistinct inscriptions]
PROVENANCE Charles Plante, London

12.37

ARCHITECT UNKNOWN (FRENCH)

1991.363a: Competition drawing for a walled cemetery: elevation, late 19th century

Pencil, ink, watercolor. 15¾ × 46 in. (40 × 116 cm)
PROVENANCE unknown

FACADE PRINCIPALE · FACADE LATERALE

COUPE TRANSVERSALE · COUPE LONGITUDINALE

12.38

PROSPER ETIENNE BOBIN
(FRENCH, 1844–1923)

1989.197 (Bobin archive): Drawings for the Monument Richelieu, Richelieu, France, 1914

Blueprint; pencil, ink, watercolor. Various dimensions, variously inscribed
LITERATURE Sotheby's, London, sale cat. 27 April 1989, p. 156, lot 653
PROVENANCE Sotheby's, London, 27 April 1989, lot 653

MONUMENT RICHELIEU

VILLE DE RICHELIEU (I&L)

ECHELLE DE 0,05 P.M.

Dressé par l'Architecte Soussigné
Paris le 25 Octobre 1913

Prosper Bobin

13
LANDSCAPE DESIGN AND GARDEN ARCHITECTURE

13.1

JOSEPH MARIE COUPPÉ
(FRENCH, DATES UNKNOWN)

1989.234: Plan of the city and park
of Châteauneuf, France, 18th century

Pencil, ink, watercolor. 16⅛ × 17 in. (40.9 × 73.1 cm)
INSCRIBED [in ink] *Plan Géometrique de la VILLE ET PARC DE CHATEAUNEUF fait par Joseph marie Couppé géomtre. du cadastra*
PROVENANCE unknown

13.2

MICHEL (GERMAN?, DATES UNKNOWN)

1987.23f: Plan and cross-section of the Ducal Orangerie in the English Garden at Meiningen, Germany, late 18th century

Pencil, ink, watercolor. 10½ × 7¼ in. (26.6 × 18.4 cm)
INSCRIBED [in ink] *Plan der Herzogl. S. Meiningischen Orangerie / Perspectivischer Lange-Durchschnitt nach der Linie AB / Michel del.*
PROVENANCE Niall Hobhouse, London

🌿 Prepared for publication in *Allgemeines Teutsches Garten-Magazin…*, no. 3, Weimar, 1806 (plate 3). The orangerie situated in the English garden commissioned by Duke Georg I of Saxon-Meiningen in the 1780s was open-air in summer (plate 2) and in winter was enclosed and heated to keep the orange trees and other tropical plants alive.

Allgemeines Teutsches Garten-Magazin…, no. 3, Weimar, 1806 (plate 3)

Allgemeines Teutsches Garten-Magazin…, no. 3, Weimar, 1806 (plate 2)

LANDSCAPE DESIGN

13.3

LOUIS-ADAM LORIOT (FRENCH, 1700–1767), ATTRIBUTED TO

1988.137: Plan of the mid-17th century Tuileries Palace Garden designed by André Le Nôtre (1613–1700), mid-18th century

Pencil, ink, watercolor. 79½ × 28¾ in. (201.9 × 73 cm)
PROVENANCE Galerie de Bayser, Paris

🍂 Largely conforming to Israel Silvestre's printed plan of the garden dated 1671.

Plan of the Tuileries Garden, 1671, engraving by Israel Silvestre

13.4

ARTIST UNKNOWN (FRENCH)

1987.23d: Bird's-eye view of a French château and formal garden, 18th century

Pencil, ink. 11¾ × 7½ in. (19 × 29.8 cm)
PROVENANCE Niall Hobhouse, London

1987.23c

13.5

ARTIST UNKNOWN (GERMAN)

1987.23c: Perspective view of a formal garden with visitors, 18th century

Pencil, ink, watercolor. 7½ × 11¾ in. (19 × 29.8 cm)
INSCRIBED [in ink] *Ingenieur Lieutenant* [indistinct] *Baumeister L. Rettÿ Leli:* [?]
PROVENANCE Niall Hobhouse, London

13.6

ARTIST UNKNOWN (GERMAN?)

1987.23e: Perspective view of a water garden with visitors, 18th century

Pencil, ink, watercolor. 12 × 18 in. (30 × 45.7 cm) approx.
PROVENANCE Niall Hobhouse, London

13.7

ARCHITECT UNKNOWN (FRENCH)

1987.23a: Design for a picturesque garden in the chinoiserie style, 1788

Pencil, ink, watercolor. 23¼ × 36½ in. (59 × 92.7 cm)
INSCRIBED [in ink] *1788* / [architectural measurements] / [corresponding to red letters on plan]

A. Un Chateau
B. Un Moulin Chinoie
C. Un Pavillon Chinoie
D. Un rochér avec un Cattafal deçus
E. Un pont Chinoie
F. Un pont Levie
G. Un rochér
H. Un Chemin Creusé de la profondeur de Six piedes
I. Deux petites Bergerices en palissade
J. Un Bers

PROVENANCE Niall Hobhouse, London

13.8

LUIZET PERE & FILS: MARC ANTOINE II LUIZET (FRENCH, 1820–1897) AND GABRIEL II LUIZET (FRENCH, 1846–1922)

1987.50: Plan for a garden for Mr. Charles Mossant, Bourg de Péage, France, 1884–85

Pencil, ink, watercolor. 35¾ × 26½ in. (90.8 × 67.3 cm)
INSCRIBED [in ink] *Monsieur Chles. Mossant, Propre a Bourg-de-Péage (Drôme) / Projet de Jardin, exécuté en 1884-85 par Luizet Père et fils, Archtes. de Jardins à Ecully. (Rhône) / Habitation / Cour / Bts. de Service /Bts. de Service /* [architectural measurements]
PROVENANCE unknown

🍎 Casimir Mossant founded a hat manufactory in Bourg de Péage in 1833 and was succeeded by his sons Charles and Casimir in the 1880s.

Monsieur Ch.**les** Mossant,
Propte à Bourg-de-Péage. (Drôme)

Projet de Jardin, exécuté en 1884-85
par Luizet Père et fils, Arch.tes de Jardins
à Ecully. (Rhône)

1987.19

1989.247

1989.194a

1989.194b

13.9

PAUL FOUCHÉ (FRENCH, DATES UNKNOWN)

1987.19 and 1989.247: Two views of public gardens, ca. 1900

Pencil, ink, watercolor

1987.19: View of a public garden. 19 × 27 in. (48.2 × 65.5 cm)
INSCRIBED [in ink] : *Paul Fouché aquarelliste*

1989.247: View of a conservatory garden, kitchen garden and farmyard. 26⅜ × 39⅝ in. (66.9 × 100.6 cm)
INSCRIBED [in ink] *Paul Fouché pinxit*.

PROVENANCE unknown

13.10

ETIENNE THEODORE DOMMEY
(FRENCH, 1801–1872)

1989.194a,b: Two competition designs for a garden with a terraced conservatory and a folly: perspective, plans and elevation, ca. 1820

Pencil, ink, watercolor
INSCRIBED [both, on verso] *Dommey*

1989.194a: Perspective and plan of a terraced conservatory. 18 × 10⅜ in. (45.7 × 26.3 cm)

1989.194b: Elevation and plan of a garden folly in the form of a tempietto. 18 × 10½ in. (45.7 × 26.6 cm)

LITERATURE Sotheby's, London, sale cat. 27 April 1989, p. 155, lot 643
PROVENANCE Sotheby's, London, 27 April 1989, lot 643

LANDSCAPE DESIGN

1987.26a

1987.26b
1987.26c

1989.161

13.11

ARCHITECT UNKNOWN (FRENCH)

1987.26a–c: Competition drawings for formal gardens with belvederes: elevation and two plans, late 19th century

Pencil, ink, watercolor

 1987.26a: Elevation of belvedere. 19 × 36 in. (48.3 × 91.4 cm) approx.

 1987.26b: Plan of garden and belvedere. 33 × 28 in. (83.8 × 71.1 cm) approx.

 1987.26c: Plan of garden and belvedere. 37 × 28 in. (94 × 71.1 cm) approx.

PROVENANCE unknown

13.12

CHARLES PROSPER ANCELET (1874–1956), ATTRIBUTED TO

1989.161: Competition drawing for a garden pavilion and fountain: elevation, ca. 1890

Pencil, ink, watercolor, gouache, foil tape. 15¾ × 49 in. (40 × 124.4 cm)

PROVENANCE unknown

LANDSCAPE DESIGN

1989.230a

1989.230b

13.13

ARTIST UNKNOWN (FRENCH)

1989.230a,b: Drawings of a park gate and garden folly, ca. 1900

Pencil, ink, watercolor. 11⅜ × 24 in. (28.8 × 60.9 cm)
 1989.230a: Park gate
 1989.230b: Garden folly
PROVENANCE unknown

13.14

LOUIS PERIN (FRENCH, 1871–1938)

1987.1: Competition drawing for an orangerie: elevation, plan, and cross-section, 1894

Pencil, ink, watercolor, metallic tape. 26 × 58½ in. (66 × 148.6 cm)
INSCRIBED [in ink] *Louis Périn / Eleve de M^r. Guadet*
PROVENANCE Dinan & Chighine, London

13.15

NEUMANN (FRENCH?, DATES UNKNOWN)

1989.195: Competition drawing for a belvedere: elevation, plan and cross-section, ca. 1900

Pencil, ink, watercolor. 17½ × 24¾ in. (44.4 × 62.8 cm)
INSCRIBED [in blue crayon] *3*. [obscure] *2 Prix Neumann* / [in ink] *Neumann*
LITERATURE Sotheby's, London, sale cat. 27 April 1989, p. 160, lot 670
PROVENANCE Sotheby's, London, 27 April 1989, lot 670

13.16

ARCHITECT UNKNOWN (FRENCH)

1989.156a,b: Competition drawings for garden pavilions: frontal elevations, ca. 1900

Pencil, ink, watercolor

 1989.156a: Garden pavilion. 8⅝ × 10¼ in. (21.9 × 26 cm)

 1989.156a: Garden pavilion. 7 × 12 in. (17.7 × 32.3 cm)

PROVENANCE unknown

1989.156a

1989.156b

13.17

JEAN MICHEL FAULTE
(BELGIAN, 1726–1766)

1989.193a–d: Four designs for a banqueting house: elevation, cross-section, and two plans, 1765

Pencil, ink, watercolor. 19¾ × 13¾ in. (50.1 × 34.9 cm)

1989.193a: Elevation
INSCRIBED [in ink] *Elevation Du Refectoire ou sale à manger*

1989.193b: Cross-section
INSCRIBED [in ink] *Coupe Du Refectoire ou sale à manger*

1989.193c: Plan
INSCRIBED [in ink] *Plan de la souterrin du refectoire ou sale à manger*

1989.193d: Presentation view
INSCRIBED [in ink] *Projet d'un Refectoire ou sale à manger composé par M͏ʳ. Faulte. Architecte de s.a.r. duc charles de Lorraine et de bar&&& à Bruxelles. 1765.*

PROVENANCE Shepherd Gallery, New York

❧ Faulte was architect to Prince Charles de Lorraine (1712–1780), who governed the Austrian Netherlands, now Belgium. The neo-classical banqueting house was designed for an unknown client a year before the architect's death.

Plan
De la souterrin du refectoire ou sale
à manger &c.

Projet d'un Refectoire ou sale à manger
Composé par M.ʳ saulte
Architecte de S.A.R. duc charles de Lorraine et de bar &c
à bruxelles. 1763 &c.

1989.193c 1989.193d

13.18

ARTIST UNKNOWN (ITALIAN)

1987.41: Drawing of the Caffetteria della Gloriet in Trieste: frontal elevation, 19th century

Pencil, ink, watercolor. 24 × 37½ in. (60.9 × 95.2 cm)
INSCRIBED [in ink] *Prospetto principale della Caffetteria detta Gloriet fuori del passeggio all'Aquidotto di Trieste eretta nel 1819* / [architectural measurements in Italian and Austrian feet]
PROVENANCE unknown

Ruins of Caffetteria della Gloriet, Trieste

13.19

HENRI FRANCOIS GABRIEL VIOLLIER
(SWISS-RUSSIAN, 1750–1829)

2000.512: Design for a pleasure palace on Kamenny Ostrov (Stone Island) in the Neva delta, St. Petersburg: facade, ca. 1770

Pencil, ink, watercolor. 10¾ × 16⅞ in. (27.3 × 42.8 cm)
INSCRIBED [in ink] *Pavillon bati en bois dans L'Ile de Kaminostrof: pour Mr. De Pletcheijef Capitain de flote.* / *Виоллер* [Viollier] / [architectural measurements]
PROVENANCE D. & R. Blissett, London

❧ An inscription now hidden on the reverse apparently reads 'collection of Her Royal Highness the Duchesse of Wurtemburg 1778.'

1988.112

13.20

ARCHITECT UNKNOWN
(FRENCH, 19TH CENTURY)

1988.112: Competition drawing for a pleasure palace or belvedere: cross-section and plan

Pencil, ink, watercolor. 21⅛ × 18⅞ in. (68.9 × 48 cm)
PROVENANCE Shepherd Gallery, New York

13.21

ERNEST CHARDON DE THERMEAU
(FRENCH, 1836–1896)

1989.226–227: Competition drawings for a pleasure palace in a garden: elevation and cross-section, 1861

Pencil, ink, watercolor. Both 14 × 16¼ in. (35.5 × 41.2 cm)

1989.226: Elevation

1989.227: Cross-section

INSCRIBED [both, in pencil] *E. Chardon 1861*
PROVENANCE Blain Brieux, Paris

1989.226

1989.227

1988.84a

1988.84b

13.22

AMET GEORGES ALEXANDRE PRADELLE
(FRENCH, 1865–1935)

1988.84a,b: Competition drawings for a pleasure palace in a garden: frontal elevations

Pencil, ink, watercolor. 7½ × 9½ in. (19 × 24.1 cm)
STAMPED [both, in ink] *Vente Georges PRADELLE Mr. P.M. ROGEON C.P.*
PROVENANCE Gallery Lingard, London

13.23

ERNEST CHARDON DE THERMEAU
(FRENCH, 1836–1896)

1989.224–225: Competition drawings for a pleasure palace and classical pagoda: elevations, plans, and cross-sections, 1861–62

Pencil, ink, watercolor. 18⅞ × 12½ in. (47.9 × 31.7 cm)

1989.224: Frontal elevation, two plans and cross-section, 1862
INSCRIBED [in ink] 12 *Mars 1862 / Duvivier*
STAMPED [in blue] *ECOLE DES BEAUS-ARTS / CONCOURS D'EMULATION*

1989.225: Frontal elevation, two plans and cross-section, 1861
INSCRIBED [in ink] *le 9^{bre} 1861 Duvivier / le 23 9^{bre} 1861*
STAMPED [in blue] *ECOLE DES BEAUS ARTS / CONCOURS D'EMULATION*

PROVENANCE Blain Brieux, Paris

LANDSCAPE DESIGN

13.24

LOUIS ALFRED PERROT
(FRENCH, 1828–1870)

1987.23g: Competition drawing for a garden folly: elevation, plan, and cross-section, 1846

Pencil, ink, watercolor, gouache. 17¾ × 13¾ in. (45 × 34.9 cm)
INSCRIBED [in watercolor over pencil] *Perrot Alfred eleve de M^r. Bonneau* / *.86.* / *7* [indistinct] *1846.* / [indistinct]
STAMPED [in black] *ECOLE ROYALE DES BEAUX ARTS / CONCOURS D'EMULATION*
PROVENANCE Niall Hobhouse, London

13.25

ARCHITECT UNKNOWN (FRENCH)

2000.474: Competition drawing for a garden pavilion, late 19th century

Pencil, ink, watercolor. 21 5/8 × 13 in. (54.9 × 33 cm)
PROVENANCE Alain Cambon, Paris

112.
4 9bre 1846.

CLARA POMARÉ MARINA MOCADOR MARIA

café
salle de bal
portique

de Juilly élève de M. Boltard

13.26

HENRY GUILLOT DE JUILLY
(FRENCH, 1822–before 1906)

1990.311: Competition drawing for a garden ballroom, 1846

Pencil, ink, watercolor. 17 × 15¼ in. (43.1 × 38.7 cm)
INSCRIBED [in ink] *CLARA / POMARE / MARINA / MOCADUR / MARIA / salle de bal / parterre / office / café / 112. 4 9bre. 1846.* [indistinct] / *de Juilly élève de Mr. Baltard*
STAMPED [in black] *ECOLE ROYALE DES BEAUX ARTS / CONCOURS D'EMULATION*
PROVENANCE unknown

13.27

GEORGES ASSELINE (FRENCH, b. 1878)

1991.358: Competition drawing for a garden pavilion: elevation, cross-section, plan, 1896

Pencil, ink, watercolor. 18¾ × 14¾ in. (47.6 × 37.4 cm)
INSCRIBED [in ink] *Georges Asseline* / *Elève de M.M. Ginain et Scellier de Gisors*
PROVENANCE unknown

1991.358

LANDSCAPE DESIGN 659

13.28

ARCHITECT UNKNOWN (BRITISH)

2000.439: Drawings for a conservatory, ca. 1900

Pencil, ink, watercolor. 13 3/8 × 20 1/8 in. (33.9 × 51.1 cm)
INSCRIBED [in ink] *PLAN / FRONT ELEVATION / END ELEVATION / SECTION THROUGH CENTRE / SECTION TOWARDS DRAWING ROOM / END OF DRAWING ROOM /* [architectural measurements]
PROVENANCE Shepherd Gallery, New York

13.29

JACQUES MAURICE PREVOT
(FRENCH, 1874–1950)

1991.369a–c: Competition drawings for a trellised garden pavilion: elevation detail, pediment detail, cross-section and plan, 1893

Pencil, ink, watercolor

1991.369a: Frontal elevation detail. 19 1/2 × 18 in. (49.5 × 45.7 cm) approx.
INSCRIBED [in ink] *M. Prevot Eve. de MM. Gaudet et Paulin*

1991.369b: Pediment detail. 18 × 9 1/2 in. (45.7 × 24.1 cm) approx.

1991.369c: Cross-section and plan of entrance pavilion. 10 × 18 in. (25.4 × 45.7 cm) approx.
INSCRIBED [in ink] *M. Prevot Eve. de MM. Gaudet et Paulin*

PROVENANCE unknown

1991.369a

1991.369b

1991.369c

1988.146a

1988.146b

A. TARDIF
Architecte - Décorateur

A. TARDIF
Architecte - Décorateur

13.30

ALFRED TARDIF (FRENCH, DATES UNKNOWN)

1988.146a–d: Designs for a trelliswork pavilion: elevations, details, and ceiling, ca. 1890

Pencil, ink, watercolor
STAMPED [in ink] *A. TARDIF Architecte – Décorateur*

1988.146a: Elevation with fountain. 12¾ × 17 in. (32.3 × 443.1 cm) approx.

1988.146b: Elevation with stove. 12⅜ × 17¼ in. (31.1 × 43.1 cm) approx.

1988.146c: Ceiling detail. 17⅛ × 18 in. (43.8 × 45.7 cm) approx.
INSCRIBED [in pencil] *Ciel / Ciel / Lustre*

1988.146d: Elevation details. 19⅜ × 25¾ in. (48.9 × 65.4 cm) approx.
INSCRIBED [in pencil] [architectural measurements]

PROVENANCE unknown

1988.146c

1988.146d

1988.115

13.31

ARCHITECT UNKNOWN
(SOUTH AMERICAN?)

1988.115–118: Designs for a small garden pavilion or 'Glorieta': elevations and furnishings, 20th century

Pencil, ink, watercolor

1988.115: Two elevations for a trellised pavilion. $17\frac{1}{2} \times 22\frac{1}{2}$ in. (44.4 × 57.1 cm)

1988.116: Elevation of the table for inside the pavilion. $19 \times 14\frac{1}{4}$ in. (48.2 × 36.1 cm)
INSCRIBED [in pencil and watercolor] *MESA DE LA GLORIETA*

1988.117: Two sconces for the garden. $15\frac{1}{2} \times 12\frac{3}{4}$ in. (39.3 × 32.3 cm)

1988.118: Armchair and bench for the garden. $13\frac{1}{2} \times 15\frac{3}{4}$ in. (34.2 × 34.9 cm)

PROVENANCE unknown

🌹 This set may be related to the presentation drawing for Emilio P. Furt, Sarmiento, Buenos Aires (see cat. 14.14).

1988.116

1988.117

1988.118

1989.213a

COUPE A 0.01

PLAN A 0.01

ECHELLE DES DETAILS 0.05

1989.213b

13.32

ARCHITECT UNKNOWN (FRENCH)

1989.213a,b: Competition drawings for a trellised garden pavilion: elevations, cross-sections, and plans, 20th century

Pencil, ink, watercolor

1989.213a: Frontal elevation. 14½ × 22 in. (36.8 × 55.8 cm)

1989.213b: Elevation detail, two cross-section details, two plans. 23 × 26½ in. (58.4 × 67.3 cm)
INSCRIBED [in ink] *COUPE / PLAN /* [architectural measurements]

PROVENANCE unknown

13.33

ALFRED HATTEN SIMS
(BRITISH, DATES UNNOWN)

2000.461: Examination drawings for a Palm Court, 1929: elevation and plan, 1929

Pencil, ink, watercolor. 19 × 28 in. (48.2 × 71.1 cm)
INSCRIBED [in ink] *A PALM COURT / Alfred Hatten Sims – 29 – / KEY PLAN 32ND SCALE. / FINAL EXAMINATION SUBJECT NO CIV.*
PROVENANCE Charles Plante, London

LANDSCAPE DESIGN

1987.23h

1991-377

13.34

PERIGNON (FRENCH, DATES UNKNOWN)

1987.23h: Trellised gate and garden, 19th century

Pencil, ink, watercolor. $4\frac{1}{4} \times 9$ in. (10.8 × 22.8 cm)
INSCRIBED [in ink] *Perignon Fecit*
PROVENANCE Niall Hobhouse, London

13.35

ARCHITECT UNKNOWN (FRENCH?)

1991.377: Trellised gate to a garden folly, 19th century

Pencil, ink, watercolor. $19 \times 13\frac{3}{4}$ in. (48.2 × 34.9 cm)
PROVENANCE unknown

13.36

JEAN COURNIER
(FRENCH, DATES UNKNOWN)

1989.203: Elevation of a garden urn, 1879

Pencil, ink, watercolor. $17\frac{3}{4} \times 14\frac{5}{8}$ in. (45 × 37.1 cm)
INSCRIBED [in ink] *Cournier Jean 1879*
PROVENANCE unknown

1989.203

LANDSCAPE DESIGN

1988.138

13.37

ARTIST UNKNOWN

1988.138: Picturesque garden folly and fountain, ca. 1900

Pencil, watercolor. 7¼ × 9¼ in. (18.4 × 23.4 cm)
PROVENANCE unknown

13.38

ARTIST UNKNOWN (FRENCH)

2005.408: Roman banquet stage set in a French urban garden, ca. 1900

Pencil, ink, watercolor. 12½ × 18 in. (31.7 × 45.7 cm)
INSCRIBED [in ink] [signature indistinct]
PROVENANCE unknown

1990.296

13.39

M. VANDERSON (BRITISH?, DATES UNKNOWN)

1990.296: View of Mr. Jackson's Hermitage at Hammersmith, Middlesex, UK, 1802

Pencil, watercolor. 11 3/8 × 17 3/4 in. (28.8 × 45 cm)
INSCRIBED (in watercolor) *hermitage de Hammersmith a Londres 1802 construit par Mr. Jackson*
LITERATURE Sotheby's, London, sale cat. 26 April 1990, p. 123, lot 400 (ill.)
PROVENANCE Sotheby's, London, 26 April 1990, lot 400

13.40

MELVILLE ALLEN (BRITISH, 1863–1952)

1990.250a,b: Two views of a country house and its gardens, 1932

Pencil, watercolor. 14 1/4 × 22 in. (35.8 × 55.8 cm)
INSCRIBED [in watercolor] *Melville Allan*
PROVENANCE unknown

1990.250a

1990.250b

13.41

ENRIQUE MARIN HIGUERO
(SPANISH, 1876–1940)

1989.249: Courtyard of the Generalife in the Alhambra, Granada, Spain, early 20th century

Pencil, watercolor. 22 × 15¼ in. (55.8 × 38.7 cm)
INSCRIBED [in watercolor] *Enrique Marin*, *Granada*
PROVENANCE unknown

1989.249

13.42

FRANK MYERS BOGGS
(AMERICAN, 1855–1926)

1990.262b: Courtyard of the Generalife in the Alhambra, Granada, Spain, 1892

Pencil, ink, watercolor. 21½ × 17 in. (54.6 × 43.1 cm)
INSCRIBED [in ink] *PATIO DE LA ACEQUIA. GENERALIFE. GRANADA 92*
PROVENANCE unknown

Generalife in the Alhambra, Granada, Spain

1990.262b

LANDSCAPE DESIGN 675

13.43

GEORGE ANTON MERCIE (1882–1957) and
CLAUDE FRANCOIS BERNARD (1884–1930)

1990.253: Perspective view of a decorative well for Mme L.P., Chennevières-sur-Marne, France, early 20th century

Pencil, ink, watercolor. 24 3/8 × 21 1/8 in. (61.9 × 53.6 cm)
INSCRIBED [in red ink] *PROPRIÉTÉ DE MADAME L.P. A CHENNEVIÈRES PROJET DE PUITS DÉCORATIF – VUE PERSPECTIVE / G.A. MERCIÉ – F.C. BERNARD ARCHITECTES. D.P.L.G.*
PROVENANCE unknown

13.44

ARCHITECT UNKNOWN
(PROBABLY GERMAN)

1987.57: Competition drawing for a well: elevation and plan, 1866

Pencil, ink, watercolor. 17¾ × 11 in. (45 × 27.9 cm.)
INSCRIBED [in pencil] *FReust[_?_] 13 Juni 1866*
PROVENANCE unknown

LANDSCAPE DESIGN 677

13.45

EDWIN LUTYENS (BRITISH, 1869–1944)

1990.274: Drawings for the Garden House at Abbotswood, Stow-on-the-Wold, ca. 1902

Pencil, ink, watercolor. 21 × 27 in. (53.3 × 68.5 cm)
INSCRIBED [in ink] *"ABBOTSWOOD" GARDEN HOUSE.¼" SCALE – DRAWING N⁰. 64. / PLAN / GRASS LAWN / GARDEN HOUSE / BUTTRESS CUT DOWN / GROUND PLAN. / EXISTING BUTTRESS CUT DOWN TO STEP LEVEL / MILL STONE / STONE SLATES ON EDGE / GARDEN / WALL STEPPED BACK WITH TOOTHINGS LEFT / BATTERED WALL / NORTH ELEVATION. / TOOL HOUSE / LOWER LEVEL PLAN. / SECTION A.B. / SECTION C. / TOOLED TEMPLATES UNDER ENDS OF [?] / OAK DOOR / SECTION AB / OAK EGGS / COPPER PIN / OAK / ELM / RAFTERS / LEAD CAP / STONE SLATES / ELM SOFFIT / STONE PAVING / CEMENT CONCRETE / DRY STONE RUBBISH / DAMP COURSE / FOOTERS AT APPROVED DEPTH / FLOOR TO BE RT AT LEAST 6" ABOVE GROUND LEVEL / SECTION C / FOOTING AT [?] DEPTH /* [and various notations in pencil]
PROVENANCE Stubbs Books & Prints, New York

Abbotswood, Stow-on-the-Wold, Gloucestershire, UK

13.46

J. DE BIEVRE (BELGIAN, DATES UNKNOWN), ATTRIBUTED TO

2000.449: Competition drawing for a garden pavilion: two exterior elevations, two cross-sections, plan, and detail of entrance, 1st half 20th century

Pencil, ink, watercolor. 22½ × 35½ in. (57.1 × 90.1 cm)
INSCRIBED [in ink] *Project d'un Pavillon de repos dans un Parc / Façade Principale / Coupe Longitudinale / Façade Postérieure / Coupe Transversale / Détail de la porte.* / *VESTIAIRE* / *HALL* / *BUFFET* / [2×] *W.C.* / [architectural measurements] / [in blue crayon] 24.3
STAMPED [within circle, in purple] *ECOLE DES BEAUX-ARTS ET ECOLE DES ARTS DECORATIFS* [indistinct]
PROVENANCE Galerie Martin du Louvre, Paris

LANDSCAPE DESIGN

14
CAST-IRON ARCHITECTURE AND DESIGN

14.1

ARCHITECT UNKNOWN

1987.78: View of a cast-iron and glass pavilion or arena, ca. 1900

Pencil, ink, watercolor. 22½ × 36 in. (57.2 × 91.4 cm)
PROVENANCE unknown

1987.78

14.2

HENRI ALPHONSE ALEXANDRE DEFRASSE
(FRENCH, 1860–1939), ATTRIBUTED TO

1998.406: Competition drawing for a heated conservatory: frontal elevation, cross-section and plan, ca. 1880

Pencil, ink, watercolor. 29 × 45 in. (73.7 × 114.3 cm)
INSCRIBED [in watercolor] [2×] *Soules de Charbon / Chaufferte*
PROVENANCE Lucy B. Campbell, London

14.3

EUGÈNE LUCIEN BOURDAIN
(FRENCH, b. 1873)

1988.158a,b: Competition drawings for a conservatory: elevation and cross-section, ca. 1895

Pencil, ink, watercolor. [Bourdain's signature on reverse according to invoice]

1988.158a: Frontal elevation detail. 27¼ × 20½ in. (69.22 × 52.07 cm)
INSCRIBED [above entrance, in watercolor] *PLANTES TROPICALES*

1988.158b: Cross-section detail. 27⅜ × 25½ in. (27.37 × 64.77 cm.)

PROVENANCE Archiform, Paris

1988.158a

686 PETER MAY COLLECTION II

1988.158b

14.4

JEAN CAMILLE FORMIGÉ
(FRENCH, 1845–1926)

2000.457: Presentation drawing: frontal elevation detail of Paris Universal Exposition entrance on avenue Rapp, 1899

Pencil, ink, watercolor. 38⅝ × 25¾ in. (98.1 × 65.4 cm)
INSCRIBED [in red ink] *PORTE RAPP* / *1899* [on reverse] *C. Formigé*
LITERATURE *Dessins d'Architecture A. Ballu (1849–1939): C. Formigé (1845–1926)* (Paris, Librairie Galerie Alain Cambon, n.d.), cat. 19
PROVENANCE Galerie Alain Cambon, Paris

Paris Universal Exposition, entrance, photograph ca. 1899

688 PETER MAY COLLECTION II

14.5

ARCHITECT UNKNOWN (FRENCH)

1988.135: Competition drawing for a bank: cross-section, ca. 1900

Pencil, ink, watercolor. 22⅞ × 42½ in. (58.1 × 108 cm)
INSCRIBED: [in watercolor, cipher] *BF* (Banque de France)
PROVENANCE unknown

CAST-IRON ARCHITECTURE

1990.267

14.6

ARCHITECT UNKNOWN (FRENCH)

1990.267: Competition drawing for a public building: cross-section, late 19th century

Pencil, ink, watercolor. 22⅞ × 23⅞ in. (58.1 × 60.6 cm)
PROVENANCE unknown

14.7

ARCHITECT UNKNOWN (FRENCH)

1989.232a–c: Competition drawings for a public gymnasium: frontal elevation and two cross-sections, late 19th century

Pencil, ink, watercolor

1989.232a: Frontal elevation. 24½ × 29⅞ in. (62.2 × 75.8 cm)
INSCRIBED [over entrance, in watercolor] *GYMNASE MUNICIPAL*

1989.232b,c: Cross-sections, 25⅜ × 39⅜ in. (64.4 × 100 cm)

PROVENANCE unknown

1989.232a

1989.232b

1989.232c

CAST-IRON ARCHITECTURE 691

14.8

ARCHITECT UNKNOWN (FRENCH)

1990.256: Design for a greenhouse (?): frontal elevation detail, ca. 1900

Blue ink. 27½ × 34½ in. (56.5 × 73.6 cm)
INSCRIBED [in ink, cipher] *VR*
PROVENANCE unknown

14.9

ARCHITECT UNKNOWN (CONTINENTAL)

1991.378: Competition drawing for a market hall: frontal elevation, late 19th century

Pencil, ink, watercolor. 16 × 34½ in. (40.6 × 87.6 cm)
INSCRIBED [in watercolor] *JOB* / [2×] *P*
PROVENANCE unknown

CAST-IRON ARCHITECTURE

14.10

GUILLAUME LICHTENFELDER
(1857–1938), FIRM OF, PARIS

1990.255a,b: Presentation drawings for market halls: two elevations and plan, mid- to late 19th century

Pencil, ink, watercolor

1990.255a: Elevation and plan for a market in Ile d'Olerton. 24 × 33 in. (61 × 83.8 cm)
INSCRIBED [in black] *Planche 1 MARCHÉ DU CHATEAU ILE D'OLERON / FAÇADE PRINCIPALE / PLANS DE LA TOITURE & DE LA CHARPENTE /* [in red] *G. Lichtenfelder succr. / Echelle de 0 m. 01. p. met pour le plan / Echelle de 0m. 02. p. met. Pour la façade.*
STAMPED [in blue] *CHARPENTES EN FER HALLES & MARCHÉS / USINE CARRÉ / USINE CARRÉ Avenue de la GRANDE ARMÉE PARIS*

1990.255b: Elevation for a market in Oran. 16 × 37⅜ in. (40.6 × 94.9 cm)
INSCRIBED [in black] *MARCHE D'ORAN. / Façade Laterale. / Feuille No 4. /* [cipher in red and black] *HL*

PROVENANCE unknown

🌶 The metalwork manufacturer La Maison Carré, established in the 19th century at 41, Avenue de la Grande Armée, was resurrected in the aftermath of the Franco-Prussian War by German refugee Guillaume Lichtenfelder.

Planche I — MARCHÉ DU CHATEAU ÎLE D'OLÉRON

FAÇADE PRINCIPALE

PLANS
DE LA TOITURE & DE LA CHARPENTE

CHARPENTES EN FER
HALLES & MARCHÉS
USINE CARRÉ

Échelle de 0,02 p.m.t pour la façade

Échelle de 0,01 p.m.t pour le plan

ELEVATION TRANSVERSALE.

ELEVATION LONGITUDINALE.

1989.222a

COUPE TRANSVERSALE
suivant AB.

COUPE LONGITUDINALE.

1989.222b

1989.222c

14.11

ARCHITECT UNKNOWN (FRENCH)

1989.222a–c: Competition drawings for a market: elevations, cross-sections and plan, ca. 1900

Pencil, ink, watercolor. 24 × 39¼ in. (61 cm × 99.7 cm)

1989.222a: Two elevations
INSCRIBED [in black] *ELEVATION TRANSVERSALE.* / *ELEVATION LONGITUDINALE* / *Devise: Me, me adsum qui feci.* / [architectural measurements]

1989.222b: Two cross-sections
INSCRIBED [in black] *COUPE TRANSVERALE suivant AB.* / *COUPE LONGITUDINALE* / *l'aqueduc est coupé sur l'axe transversal du bâtiment* / *Devise: Me, me adsum qui feci.* / [architectural measurements]

1989.222c: Plan
INSCRIBED [in black] *PLAN D'ENSEMBLE* / *LEGENDE* / *a. Bureau de l'Inspecteur du marché.* / *b.c.d.e. Stalles pur marchands divers.* / *f.g. Stalles pour les bouchers.* / *h.i. Stalles pour les poissonniers.* / *k.l.m.n. Bornes fontaine.* / *o. Urinoir.* / *p. Cabinets d'aisances pour hommes.* / *q. id. Pour dames.* / *r. Stalle réservée.* / *s.t.u.v. Allées desservant les stalles.* / *x. Voirie longitudinale et transversal.* / *y.z. Caniveaux d'écoulement.* / *w. Prise d'eau.* / *Devise: Me, me adsum qui feci.* / [architectural measurements and other markings]

PROVENANCE unknown

CAST-IRON ARCHITECTURE 697

1990.279a

1990.279b

14.12

ANDREEV [?] (RUSSIAN)

1990.279a,b: Drawings for a market: elevation, plan and construction details, 1874

Pencil, ink, watercolor

1990.279a: Frontal elevation and plan. 10½ × 11½ in. (26.6 × 29.2 cm)
INSCRIBED [in red] *попытка* [popytka] / [in black] *андреев* [Andreev] *1874* / N1 *книжная торговля* [knizhnaja torgovlja] / *орлова* [orlova] / N2 *менялная лавка* [menjalnaja lavka] / *план* [plan] / *шкаф* [shkaf] / *стол* [stol] / *скамейка* [skamejka]/ [architectural measurements and other markings]

1990.279b: Three construction details. 10 × 15¼ in. (25.4 × 40.0 cm)
INSCRIBED [in red] *попытка* [popytka/ [in black] *андреев* [Andreev] 1874 / *детали в 1/10 натуры* [detail v 1/10 natury: 1/10 scale]

PROVENANCE unknown

14.13

ARCHITECT UNKNOWN (CONTINENTAL)

1987.43: Design for an arched entrance: elevation, early 20th century

Pencil, ink, watercolor, gilding. 38 × 23 in. (96.5 × 58.4 cm)
PROVENANCE unknown

14.14

ARCHITECT UNKNOWN
(SOUTH AMERICAN?)

1988.114: Presentation drawing: entrance to the home of Emilio P. Furt, Sarmiento, Buenos Aires, Argentina, 20th century

Pencil, ink, watercolor. 20¼ × 25 in. (51.4 × 63.5 cm)
INSCRIBED [in watercolor] *PROPIEDAD DEL SEÑOR EMILIO P. FURT / SARMIENTO 2478 / NIVEL DEL PISO /* [architectural measurements]
PROVENANCE unknown

14.15

RICHARD D. F. CLARKE
(BRITISH, DATES UNKNOWN)

1990.277: Design for a railing and gate: frontal elevation, ca. 1869–89

Pencil, ink, watercolor. 17 3/8 × 30 in. (44.1 × 76.2 cm)
INSCRIBED [in pencil] 72 / [architectural measurements]
LITERATURE Sotheby's, London, sale cat. 19 Dec. 1989, p. 43, lot 76
PROVENANCE Sotheby's, 19 Dec. 1989, lot 76

❧ From a large collection of drawings, some dated 1869–89 and executed in the Government School of Art, Belfast.

DESIGN FOR WROUGHT IRON RAILING.
⅔ full size

1988.141a

1988.141b

14.16

CHARLES EDWARD GEORGES
(BRITISH, 1869–1970)

1988.141a,b: Examination drawings: designs for iron railings, 1888–90

Pencil, ink, watercolor

1988.141a: Detail of a railing. 17⅝ × 28 in. (44.7 × 71.1 cm)
INSCRIBED [in ink] *DESIGN FOR WROUGHT IRON RAILING 2/3 full size* / [in pencil] *Charles E. Georges, April 1890*
STAMPED *PRIZE WORK* / [in crowned hexagonal] *EXAMINED N.A.T.5. 1890*

1988.141b: Elevations and details of a railing. 10¾ × 18¼ in. (27.3 × 46.3 cm)
INSCRIBED [in pencil] *C. Georges 5/7/88*
STAMPED [in rectangle] *EXAMINED FOR CERTIFICATE* / [embossed] *ESK*

PROVENANCE unknown

14.17

ARCHITECT UNKNOWN (CONTINENTAL)

2000.447: Designs for a railing and gate, ca. 1900

Pencil, ink. 11¾ × 18⅞ in. (29.8 × 47.9 cm)
PROVENANCE Galerie Martin du Louvre, Paris

15
A PLANTAR ARCHIVE

1990.308a detail

15.1

JEAN-BAPTISTE PLANTAR
(FRENCH, 1790–1879)

1990.308a–v and 1991.355a–d: Archive of architectural designs and details, mid-19th century

Pencil, ink, watercolor. Various sizes

1990.308a: Design for a fountain

1990.308b: Design for a fountain
INSCRIBED [in pencil] *Plantar*

1990.308c: Design for a fountain

1990.308d: Design for a candlestick

1990.308e: Design for a torchere for the Pantheon
INSCRIBED [in ink] *pour le Panthéon Plantar*

1990.308f: Design for a pediment
INSCRIBED [in pencil] *hotel de Villes du* [obscured] *restauration de la campanile.*
(A similar drawing is preserved at the Musée des Arts Décoratifs in Paris, CD 4211)

1990.308g: Design for a panel with a trophy for the south wall of the Escalier des Princes in Versailles
INSCRIBED [in ink] *Pour Versailles Plantar* / [in pencil] [architectural measurements]

1990.308h: Design for a pediment
INSCRIBED [in pencil] *mai 1848 Plantar*

1990.308i: Design for a pediment

1990.308j: Design for a pediment
INSCRIBED [in pencil] *Plantar*

1990.308k: Design for a pediment
INSCRIBED [in pencil] *mai 1848 Plantar*

1990.308l: Design for a pediment

INSCRIBED [in pencil] *Plantar 29 mai 1848*

1990.308m: Design for a pediment
INSCRIBED [on beehive, in watercolor] *TRAVAIL* / [in pencil] *Plantar 27 mai 1848*

1990.308n: Design for a pediment
INSCRIBED [in pencil] *Plantar 28 mai 1848*

1990.308o: Design for a pediment
INSCRIBED [in watercolor] *VILLE DE PARIS* / [in pencil] *Plantar 27 mai 1848*

1990.308p: Two designs for pediments
INSCRIBED [in pencil] *le 21 mai 1848 Plantar*

1990.308q: Two designs for pediments
INSCRIBED [in pencil] *fait 19 mai 1848* / *Plantar*

1990.308r: Two designs for pediments
INSCRIBED [on beehive, in watercolor] *TRAVAIL* / [in pencil] *le 21 mai 1848 Plantar*

1990.308s: Two designs for pediments
INSCRIBED [in pencil] *mai 1848 Plantar*

1990.308t: Design for an overdoor
INSCRIBED [in pencil] *december 1847 Plantar*

1990.308u: Design for an overdoor
INSCRIBED [in pencil] *december 1847 Plantar*

1990.308v: Design for an overdoor
INSCRIBED [in pencil] *December 1847 Plantar*

1990.355a: Design for an overdoor

1990.355b: Design for an overdoor

1990.355c: Design for an overdoor
INSCRIBED [in pencil] *hotel du Ville*

1990.355d: Design for an overdoor
INSCRIBED [in pencil] [architectural measurements]

LITERATURE Sophie Derrot, *Michel Liénard (1810–1870) : luxuriance et modestie de l'ornement au XIXe siècle*, PhD thesis, École Pratique des Hautes Études (Paris, 2014); Alexandre Gady, 'De l'acanthe a l'ogive. Monsieur Plantar, sculpteur et ornemaniste', in Alexandre Gady (ed.), *"Fort docte aux lettres et en l'architecture": Mélanges en l'honneur de Claude Mignot* (Paris, 2018), pp. 435-55; Justine Gain, *Jean-Baptiste Plantar, la sculpture d'ornement dans les Galeries Historiques de Versailles*, MA thesis, École du Louvre (Paris, 2018)
PROVENANCE unknown

🌶 Plantar, from 1818 until around 1848, was the last head of architectural ornament and sculpture at the French royal building department, with the title *Sculpteur des Bâtiments du roi*. Accordingly, he and his atelier produced numerous designs on paper for a variety of royal palaces, government buildings, churches and monuments. An archive of designs by this obscure artist was offered by Galerie Fischer-Kiener in Paris in 1989, and was possibly the source for the May drawings. Further selections were acquired by the Château de Versailles, Musée Carnavalet, Musée des Arts Décoratifs, Château de Fontainebleau and Getty Research Institute.
In 2003, over 500 drawings were auctioned at Piasa, Paris, and acquired by the Bibliothèque de l'Institute national de l'histoire de l'art, collections Jacques Doucet. Some of the sheets without Plantar's signature might represent the work of other members of his atelier.

1990.308a

1990.308b

1990.308c

1990.308d

0005027/36

1990.308e

pour le Panthéon Plantar

hotel de Villed[e]...
restauration de
la campanile

1990.308f

1990.308g

Pour Versailles Plantar

1990.308h

1990.308j

1990.308i

1990.308k

710 PETER MAY COLLECTION II

1990.308l

1990.308o

1990.308m

1990.308p

1990.308n

1990.308q

PLANTAR ARCHIVE

1990.308r

1990.308t

1990.308s

1990.308u

1990.308v

712 PETER MAY COLLECTION II

1990.355a

1990.355b

1990.355c

1990.355d

ARCHITECTURAL MODELS

1989.209 detail

M1

UNKNOWN (BRITISH)

1990.10505: Model of a temple, early to mid-18th century, altered and fitted with theater and stand, 19th century

Wood (walnut on later mahogany stand), glass, paper, metalwork. 59 × 20½ × 20½ in. (149.8 × 52 × 52 cm)
PROVENANCE Charles James Robinson, London; Mallett, London
LABEL [inside drawer, printed in black] *C.J. RICHARDSON, 34 Kensington Square*

🌹 The interior is fitted with a Victorian-era theater which, given the paper label, was owned by prominent London architect Charles James Robinson (1806–1871), Sir John Soane's student and assistant and an avid collector of design drawings. It is possible Robinson is responsible for converting the temple into a theater and adding the stand. Some of the paper and decoupage stage sets are constructed from George Baxter's 1852 printed views of the Great Exhibition of 1851. Accompanied by various printed and hand-colored theater booklets.

M2

UNKNOWN (FRENCH)

1989.220: Model of a temple

Wood (oak, amboyna), bronze. 18 × 15¾ × 22 in. (45.7 × 40 × 55.8 cm)
PROVENANCE Galerie B.J.F., Paris

M3

UNKNOWN (BRITISH)

1989.216: Model of the East Parade Chapel, Leeds, UK, with fitted interior to function as a desk, mid- to late 19th century

Wood (mahogany, pine), paper. 27¾ × 24½ × 20⅝ in. (70.5 × 61.6 × 52.4 cm)
INSCRIBED [on print adhered to inside] *East Parade Chapel / Agent S. Brown Jr. Engr. By Briggate / Engr. Pub. By T. H. Ellis 2 Jerwin St. London* / [in ink] *Greek St. / Russell St. / Mr. Hare Surgeon / Infirmary St.*
PROVENANCE Cliff Leonard, New York

🌿 East Parade Street Chapel, located at the intersections of Greek, Russell and Infirmary Streets, opened in 1841, closed in 1899 and was demolished shortly thereafter. The handwritten name 'Mr. Hare Surgeon' might indicate the owner of this model, which perhaps functioned as a storage unit and desk in his office.

M4

UNKNOWN (FRENCH)

1989.209: Model of a City Hall, late 19th century

Wood (anigre, walnut, maple, ash), glass; clock
45 × 27½ in. (114.3 × 69.9 cm)
PROVENANCE Galerie Acteon, Paris

M5

UNKNOWN

2014a : Model of the Paris Opéra,
late 19th century

Wood (cherry). 7 × 12 × 13¾ in (17.7 × 30.4 × 34.9 cm)
INSCRIBED [on underside, in pencil] *Grand Opera Paris*
PROVENANCE D. & R. Blissett, Hampshire, UK

2014a from above

Elevation of the west lateral facade of the Paris Opéra (Palais Garnier),
from *Le Nouvel Opéra* (1876–80), folio I, plates 3–4

201a

M6

UNKNOWN (FRENCH)

1989.218: Model of an imperial staircase, 19th century

Wood (walnut). 18 × 24 × 18 in. (45.7 × 60.9 × 45.7 cm)
PROVENANCE Galerie Acteon, Paris

734 PETER MAY COLLECTION II

M7

HONORÉ TOURANJOU
(FRENCH, DATES UNKNOWN)

1989.201: Model of a spiral staircase, 1839

Wood (various), ivory, glass, paper, ink. 17⅜ × diam. 6⅞ in. (44.1 × 17.5 cm)
INSCRIBED [on paper label framed on underside beneath glass] *Fait à Marseille par Honoré-Touranjou aspirant du devoir le dix march 1839.*
PROVENANCE Galerie Acteon, Paris

ARCHITECTURAL MODELS 735

M8

WILLIAM HAYWARD BRAKSPEAR
(BRITISH, 1819–1898) and
WILLIAM SIDNEY BRAKSPEAR
(BRITISH, DATES UNKNOWN)

1991.374: Model for a chicken house for Bow Manor, Sale, Cheshire, UK, ca. 1860

Wood, cardboard, paint and sand. 13 × 9½ × 18¾ in. (33 × 24 × 48 cm)
LITERATURE Sotheby's, London, sale cat. 1 April 1991, p. 115, lot 105
PROVENANCE Sotheby's, London, 11 April 1991, lot 105

1991.374

M9

UNKNOWN

1990.287: Model of a mantelpiece, late 18th–19th century

Plaster inside a glazed wooden (maple?) frame.
9½ × 10½ × 5 in. (24.1 × 26.7 × 12.7 cm)
PROVENANCE unknown

M10

UNKNOWN

1993.10684: Model of a classical façade, late 18th–19th century, within modern frame

Plaster, cardboard, wood. 27 × 24 in. (68.5 × 60.9 cm) approx.
PROVENANCE unknown

M11

UNKNOWN

1991.365: Model of a corner entrance

Plaster, paint. 10 × 8 × 4¼ in. (25.5 × 20 × 11 cm)
PROVENANCE Galerie Acteon, Paris

M12

UNKNOWN (ITALIAN)

1990.263: Model of the Baptistry at Pisa, ca. 1900

Alabaster, marble, glass. Height 7 in. (17.8 cm)
PROVENANCE unknown

Baptistry, Pisa

1990.263

740 PETER MAY COLLECTION II

M13

UNKNOWN (ITALIAN)

2018a: Models of the ruins of the Temple of Castor and Pollux and of the Temple of Vespasian, Rome, mid-19th century

Marble (Giallo Antico). 30¾ × 10 × 9¾ in. (78.1 × 25.4 × 24.7 cm)
LITERATURE Christie's, New York, sale cat. 23 October 2018, p. 219, lot 333 (ill.)
PROVENANCE Christie's, New York, 23 October 2018, lot 333

M14

UNKNOWN (ITALIAN)

1990.269: Model of a Roman ruin

Bronze, marble. Height 5½ in. (14 cm)
PROVENANCE unknown

1990.269

M15

UNKNOWN (FRENCH)

1990.270: Model of the monument to Napoleon, Place Vendôme, Paris, ca. 1833

Bronze, stone. Height 15¾ in. (40 cm)
PROVENANCE unknown

🌺 A miniature version of what is variously known as the Napoleon Column, Austerlitz Column, Victory Column and Grand Army (Grande Armée) Column; also called the Vendôme Column. See cat. 12.3.

The Column of the Grande Armée (Monument to Napoleon), Place Vendôme, Paris

ARCHITECTURAL MODELS

M16

UNKNOWN

1990.321: Model of a city gate

Bronze. 10 × 9 x 2½ in. (25.4 × 22.9 × 6.4 cm)
PROVENANCE unknown

M17

UNKNOWN

1989.10258a–c: Three models of stage sets, 19th century

Watercolor

1989.10258a: 11½ × 16 in. (29.2 × 40.6 cm), framed

1989.10258b: 12½ × 18¾ in. (31.8 × 47.6 cm), framed

1989.10258c: 12 × 15½ in. (30.5 × 39.4 cm), framed

PROVENANCE unknown

1989.10258a

1989.10258b

1989.10258c

2. Mod. e Par.

5.
7.
2. Mod.
17½.
4½.
4.
5.
1. Mod ½.
1. Mod ½.
3.
3½.
7.
4½.
5.

BOOKLETS OF DRAWINGS

B1

JOHAN FREDRIK ABOM
(SWEDISH, 1817–1900)

1989.210: Book of architectural orders: 35 pages of drawings, 1834, and a printed title plate pasted to the cardboard cover

Pencil, ink and wash. 10¼ × 8¼ in. (26 × 21 cm)

INSCRIBED [in ink] Les Ordre [sic] D'Architecture. [illegible] J. F. Abom / J Nordstedt [illegible] J. F. Abom, 1841.

❦ Practice drawings after Charles Pierre Joseph Norman, Moritz Hermann von Jacobi and Johann Matthäus von Mauch, *Vergleichende Darstellung der architectonischen Ordnungen der Griechen und Römer und der neueren Baumeister* (Potsdam, 1830) or a subsequent volume of von Mauch. The printed bookplate adhered to the cover of the bound drawings, perhaps the precise inspiration or model for them, is titled GRIECHISCHE UND RÖMISCHE BAU-ORDNUNGEN. A copy of this publication, however, has not been located.

Norman, von Jacobi and von Mauch, *Vergleichende Darstellung der architectonischen Ordnungen der Griechen und Römer und der neueren Baumeister*, 1830, pl. 45, 46 and 49

748 PETER MAY COLLECTION II

GRIECHISCHE UND RÖMISCHE BAU-ORDNUNGEN.

Les Ordres D'Architecture

| Toscan | Dorique | Ionique | Corinthien | Composite |

B2

UNKNOWN (FRENCH)

1990.313a–i: Booklet entitled *Projets Desroches, projets 4*.: nine sheets of drawings for private residences, mid-19th century

Pencil, ink, watercolor. 8 × 13 in./ 13 × 8 in. (20 × 32 cm/ 32 × 20 cm) approx.
INSCRIBED [in ink, on cover pages] *Projets Desroches. / projets. 4.*

1990.313a: INSCRIBED [in ink] *Elévation sur la rüé./* [architectural measurements]

1990.313b: INSCRIBED [in ink] *Elévation sur le coté.* [architectural measurements]

1990.313c: INSCRIBED [in ink] *Plan au rez de chaussée. / Cour. / Vestibule. / Salle L'italienne. / Serre / Salle a manger. / [2×] Antichambre / [3×] Cabinet. / Gallerie. / jardin. / Chambre à coucher. / Antichambre. /* [architectural measurements]

1990.313d: INSCRIBED [in ink] *Plan du premier étage. / Cour / Vestibule / Sallon* [sic] */ [2×] paysage / [4×] cabinet / [2×] chambre à coucher / gallerie / cabinette toilette / Jardin /* [architectural measurements]

1990.313e: INSCRIBED [in ink] *Plan des combres. /* [architectural measurements]

1990.313f: INSCRIBED [in ink] *COUPE SUR LA LIGNE A.B. / ELÉVATION SUR LA RUÉ. / PLAN DU REZ DE CHAUSSÉE / cour / antichambre / [2×] cabinet / cuisine / [4×] chambre / PLAN DU PREMIER ÉTAGE / Terrasse / [2×] chambre / [2×] antichambre / cabinet /* [architectural measurements and other notations]

1990.313g: INSCRIBED [in ink] *COUPE SUR LA LIGNE A.B. / ÉLÉVATION SUR LA RUÉ / PLAN DU REZ DE CHAUSSÉE / passage / cabinet / chambre / Boutique / office / cuisine / cour / Remise / grange / Ecurie / PLAN DU PREMIER ÉTAGE / Salle / [4×] chambre / [2×] cabinet /* [architectural measurements and other notations]

1990.313h: INSCRIBED [in ink] *Coupe sur la ligne ab. /* [architectural measurements]

1990.313i: INSCRIBED [in ink] *A B*

Plan au rez de chaussée.

jardin

Cabinet · Gallerie · Cabinet
Chambre à coucher · Salle à manger
Salle à l'italienne
Cabinet · Serr. · antichambre
Antichambre · Vestibule

Cour

Plan du premier étage.

Jardin

Cabinet · gallerie · Cabinet
chambre à coucher · chambre à coucher
Sallon
Cabinet de toilette · cabinet
cabinet · vestibule

cour

Plan du premier étage.

Jardin

Cabinet · gallerie · Cabinet
chambre à coucher · chambre à coucher
Sallon
Cabinet de toilette · cabinet
cabinet · vestibule

cour

Plan des combles.

Plate 1

COUPE SUR LA LIGNE. A. B.

PLAN DU REZ DE CHAUSSÉE.

ÉLÉVATION SUR LA RUE.

PLAN DU PREMIER ÉTAGE.

Plate 2

COUPE SUR LA LIGNE A.B.

ÉLÉVATION SUR LA RUE.

PLAN DU REZ DE CHAUSSÉE.

PLAN DU PREMIER ÉTAGE.

A B

AFTERWORDS, CONCORDANCE & INDEXES

AFTERWORD I

MARK FERGUSON
FEBRUARY 2020

I REMEMBER LEARNING TO DRAW AS A CHILD and discovering the power of shade and shadow to make flat shapes into round objects. I also remember discovering the power of axonometric projection, although I did not know what it was at the time, to create the illusion of space. These discoveries unlocked the power of drawing to record things I could observe as well as things I might imagine in my mind's eye. Gradually, I became aware that buildings shape the way we live. Inspired by this understanding, I began to experiment with re-shaping my immediate environment and committing these ideas to paper. Later in college and now in professional life, architectural drawings retain their allure through their capacity to record ideas and curate what we see with a few strokes of a pen.

I imagine Peter May's fascination with architecture and architects began with similar childhood discoveries and a curiosity about the rich diversity of old and new building forms. He cultivated that interest by becoming a patron of architecture and a collector of drawings. I now realize, after collaborating with him on a succession of building projects over many years, that commissioning an architect with sympathetic tastes is the single most rewarding way to become immersed in the discipline of architecture. Patrons, like their architects, turn visions into reality.

Peter and Leni hold a special place in my career. They were our firm's first clients and have returned over a dozen times with commissions, ten of which they built. In addition to being our most active clients, their contrasting perspectives on how to live with buildings captures an essential and productive tension in our practice. Peter is a dreamer—he imagines grand plans for new places. Leni is a realist—she respects the way things are. To embrace the tension between dreams and reality is essential to making poetry in architecture.

At Ferguson & Shamamian Architects, we collaborate with our clients. We design houses for them, not for us. Sharing ideas, completing each other's sentences, accommodating differences, resolving conflicts, and incrementally agreeing to a way forward is the essence of the creative process. Most projects begin with a site and a concept that is communicated in a few short words, a reference image, and a sketch.

The sketch is where the architect's ideas begin. They are impressions drawn at the size of a napkin, envelope or sketchbook, unencumbered by dimensions and details, yet conveying the essential features of a room, building or landscape. The architect develops these sketches in stages at increasingly larger scales and greater degrees of precision, considering alternate avenues of inquiry, discarding weak ideas, retaining strong ones, and resolving conflicts until every important detail has been considered, engineered, coordinated, documented and annotated for the builder.

NORTH ELEVATION
1/8" = 1'-0"

THE OFFICE OF
FERGUSON & SHAMAMIAN
ARCHITECTS, LLP

0 2 4 8 16 24 FEET

PALM BEACH, FLORIDA

Historically, as now, the essential medium of the architectural design process is the orthographic drawing, most importantly the plan. The plan implies elevations and sections. All three projections are necessary to describe a three-dimensional object (fig. 1). Initially, two-dimensional representations can be conceived independently of each other before being locked together to represent an object or space. Drawn to scale, these drawings are the way we study the underlying order of a design and accurately map buildings and landscapes without the distorting interference of perspective vision or the vagaries of memory that characterize an actual experience with a building.

Orthographic drawings greatly simplify the designer's task by flattening three dimensions into two, but they also complicate the viewer's task. The small scale of architectural drawings (they are rarely drawn at the actual size of the building) can also frustrate a client trying to imagine inhabiting the spaces they represent. Happily, Peter May has a well-trained eye for reading design drawings and intuiting the three-dimensional spaces they represent. We often turn to physical models to make a building or a particular architectural feature more comprehensible, but small replicas also present experiential challenges. We have found that perspective drawings are most successful at overcoming these shortcomings by depicting the look and feel of a building in its surroundings with furnished interiors (fig. 2).

The drawings Peter has chosen to collect were created at a time when the artistry of hand-drafted and painted architectural drawings rivaled fine art. Architects today continue to make spectacular drawings, but they are rarely made by hand. Digital rendering has become the tool of choice for most design presentations in schools and offices, especially now with the advent of the three-dimensional digital model. The

FIG. 1
Ferguson & Shamamian Architects, North Elevation, May Residence, Palm Beach

digital model surpasses all other drawings and physical models by consolidating all the information necessary to visualize a building from any vantage point, within or without, from afar and close up. The mystery of plan, elevation and section is replaced by visualizations that require no abstract thinking or leap of imagination. By looking through goggles or at a large fixed screen, and moving one's head or toggling a mouse, a viewer enters a cinematic experience of a place at its actual size in real time. The viewer can walk, fly, and pause at any place in the model to study details and vistas. With enough data to describe materials and lighting, the model's verisimilitude rivals reality.

Many of the buildings and details in Peter's collection illustrate magnificent structures on a civic scale. The drawings are impressive for their large size, illusionistic rendering techniques and pictorial interest. Some drawings depict actual structures; others depict imaginary buildings conceived in a course of study. Also, there are renderings of extant masterpieces as well as speculative reconstructions of buildings that exist in ruin. By rendering buildings in color, under sunlight, these artists/architects transformed technical descriptions into beautiful illustrations accessible to the expert and lay person alike.

We all want to be surrounded by beauty. Living with beautiful drawings of exquisite architecture is one way that Peter and Leni fulfill their need. I suspect the drawings also inspire Peter to regularly imagine new projects. It is possible that particular drawings had a direct influence on designs we developed together, although there is no doubt that they influenced Peter's preference for classic architectural languages embodying ornament and color and enriched his appreciation for how gardens and interiors complete an architectural composition.

While working with Peter and Leni I have had the privilege of collaborating with others to design landscapes and interiors for the buildings. These collaborations with gifted designers broadened the team's expertise, deepened its point of view, and energized the creative spirit aroused by Peter and Leni's vision for each new place.

I write this essay with abundant gratitude for Peter and Leni's support over thirty years and for the vicarious pleasure I have enjoyed while imagining, elaborating, refining, and editing their unfolding visions for new houses in beautiful places. My practice has offered me no greater reward.

FIG. 2
Ferguson & Shamamian Architects,
Pool House perspective drawing,
May Residence, Palm Beach

AFTERWORD II

BUNNY WILLIAMS
JANUARY 2020

PETER MAY IS A VERY RARE CLIENT. HE HAS A passion for architecture and reads plans as though he were a trained architect. He loves the entire process of design and building. So many years ago, when I first began working with the Mays, I was having dinner with Stephanie Hoppen, a renowned print dealer in London, and she told me of a collection of original architectural drawings that she had assembled for her gallery. I immediately connected her with Peter and thus was the beginning of this amazing collection, made stronger by the curatorial eye and expertise of Steve Andrews.

What is so exciting for an interior designer is to have a collection of art to hang at the completion of a project. This is when a room comes alive. Over the years of working on so many projects for the Mays, I have had the pleasure of moving and rehanging the many they own. They have looked perfect whether in Florida, Colorado, Connecticut, or New York as the quality of the drawings and the various subjects lend themselves to any interior and more than anything it is the personal collection of a man who loves to build.

FIG. 1
Interior detail, Maywood

FIG. 2
Interior detail, May residence, New York

CONCORDANCE

INV. NO.	CAT. NO.	INV. NO.	CAT. NO.	INV. NO.	CAT. NO.	INV. NO.	CAT. NO.	INV. NO.	CAT. NO.	INV. NO.	CAT. NO.
1987.1	13.14	1987.87	8.31	1989.167	9.13	1990.221	2.11	1990.353a–c	12.2	2000.434	2.12
1987.2a,b	2.5	1987.88	8.38	1989.168	8.49	1990.233a–c	3.6	1990.354	3.4	2000.435	12.35
1987.3	12.5	1987.89	7.16	1989.170	9.33	1990.250a,b	13.40	1990.10505	M1	2000.436	9.24
1987.4	8.9	1987.90a,b	12.1	1989.171	9.44	1990.251a,b	9.30	1991.324	2.13	2000.437	1.39
1987.5	8.10	1987.92	2.9	1989.172a,b	9.1	1990.252	9.46	1991.325	7.12	2000.438	12.18
1987.6	8.77	1987.93	4.12	1989.173	5.7	1990.253	13.43	1991.355a–d	15.1	2000.439	13.28
1987.7	1.1	1987.94	12.17	1989.174a,b	2.21	1990.254	9.31	1991.356	8.54	2000.440	12.14
1987.8	5.3	1987.95	8.71	1989.176a,b	8.30	1990.255a,b	14.10	1991.358	13.27	2000.441	1.27
1987.9	8.8	1987.96	8.36	1989.177	9.25	1990.256	14.8	1991.362	8.19	2000.442	8.52
1987.12	8.77	1987.147	5.9	1989.178a–k	8.34(I)	1990.257	12.28	1991.363a	12.37	2000.444	9.14
1987.14	2.15	1987.219	7.6	1989.179	8.34(II)	1990.258a,b	8.53	1991.363b	10.7	2000.445	9.4
1987.15	8.5	1988.84a,b	13.22	1989.180	8.34(II)	1990.259	3.10	1991.364a–f	7.18	2000.446	12.9
1987.16	9.26	1988.85	1.28	1989.181	8.35	1990.260	12.4	1991.365	M11	2000.447	14.17
1987.17	11.18	1988.99	8.28	1989.182	8.35	1990.261a,b	9.51	1991.366	10.2	2000.448	8.67
1987.18	2.2	1988.100a–c	7.3	1989.183	8.34(II)	1990.262a	4.13	1991.367	3.11	2000.449	13.46
1987.19	13.9	1998.101a–c	2.17	1989.184	8.34(II)	1990.262b	13.42	1991.368a–o	10.1	2000.450	7.11
1987.20	1.5	1988.102a–c	1.15	1989.185	8.34(II)	1990.263	M12	1991.369a–c	13.29	2000.451	8.68
1987.21a–f	2.6	1988.103a,b	6.1	1989.186	8.34(II)	1990.264	2.24	1991.370	2.16	2000.452	8.82
1987.23a	13.7	1988.104a–f	5.4	1989.187	8.34(II)	1990.266	11.2	1991.371	11.9	2000.453	8.82
1987.23b	8.3	1988.105a,b	12.20	1989.188	8.23	1990.267	14.6	1991.372	8.6	2000.454	8.82
1987.23c	13.5	1988.106a,b	8.14	1989.189a,b	8.46	1990.269	M14	1991.373	8.63	2000.455	8.82
1987.23d	13.4	1988.107a,b	5.2	1989.190	9.49	1990.270	M15	1991.374	M8	2000.456	2.20
1987.23e	13.6	1988.109a,b	9.50	1989.192a,b	9.12	1990.271	8.79	1991.375a,b	8.80	2000.457	14.4
1987.23f	13.2	1988.110	8.47	1989.193a–d	13.17	1990.272	8.79	1991.376a,b	2.1	2000.458a–d	11.3
1987.23g	13.24	1988.111a,b	7.10	1989.194a,b	13.10	1990.273	8.76	1991.377	13.35	2000.459	5.5
1987.23h	13.34	1988.112	13.20	1989.195	13.15	1990.274	13.45	1991.378	14.9	2000.461	13.33
1987.25a–c	1.29	1988.113	9.34	1989.196a–h	8.69	1990.275	8.75	1991.379a–d	8.29	2000.462	8.66
1987.26a–c	13.11	1988.114	14.14	1989.197	4.11	1990.276a,b	11.12	1991.380	5.6	2000.463	8.66
1987.28	8.21	1988.115	13.31	1989.197	8.81	1990.277	14.15	1991.381	7.14	2000.464	8.66
1987.29	6.3	1988.116	13.31	1989.197	12.38	1990.278	9.48	1991.382	7.14	2000.465	7.15
1987.30	8.73	1988.117	13.31	1989.198	12.8	1990.279a,b	14.12	1991.383	8.12	2000.466	8.40
1987.31	9.29	1988.118	13.31	1989.199	12.31	1990.280	9.53	1991.384	6.7	2000.467	8.40
1987.32	11.6	1988.119a–c	7.2	1989.200	3.22	1990.281a–c	4.4	1991.385a–c	3.16	2000.468	1.11
1987.33a–h	7.1	1988.120a–d	8.17	1989.201	M7	1990.282	2.14	1991.386	3.18	2000.469a,b	1.40
1987.34	9.49	1988.121a–d	3.7	1989.202	11.14	1990.283	8.72	1991.388a–c	6.5	2000.470a–c	1.41
1987.35	9.49	1988.122	7.13	1989.203	13.36	1990.285	11.18	1991.389	9.5	2000.471a,b	1.25
1987.36	9.49	1988.123	1.7	1989.205	8.4	1990.286a,b	8.58	1991.390	9.5	2000.472	1.17
1987.37	9.49	1988.124	8.83	1989.206	9.49	1990.287	M9	1992.392a–d	11.4	2000.473	8.16
1987.38	9.11	1988.125	8.83	1989.207	9.49	1990.291a,b	8.1	1992.393	11.4	2000.474	13.25
1987.39	9.45	1988.126	5.8	1989.208	9.49	1990.292	9.35	1992.394	11.20	2000.475	3.9
1987.40	8.62	1988.127	1.20	1989.209	M4	1990.293	9.36	1992.395	1.36	2000.476	3.20
1987.41	13.18	1988.128	2.8	1989.210	B1	1990.294	8.26	1993.396	3.25	2000.477	3.1
1987.42	9.55	1988.129	1.16	1989.211a,b	8.43	1990.295a–f	2.25(I)	1993.10684	M10	2000.478a,b	12.10
1987.43	14.13	1988.130	8.19	1989.212	7.9	1990.296	13.39	1994.397	9.15	2000.479a,b	8.7
1987.44	8.24	1988.131a,b	8.33	1989.213a,b	13.32	1990.297a–c	12.12	1994.398	10.4	2000.480	8.50
1987.45	3.2	1988.133	8.75	1989.214	6.4	1990.298	3.15	1994.416	2.10	2000.481	9.2
1987.46	3.24	1988.134	9.28	1989.215	12.3	1990.299	8.39	1995.399	1.4	2000.482a,b	9.10
1987.47a,b–c	7.8	1988.135	14.5	1989.216	M3	1990.300	12.30	1995.400a–e	8.18	2000.483	9.32
1987.48a,b	7.4	1988.136	12.7	1989.217a,b	10.6	1990.302	2.4	1996.401a, d–e	1.22	2000.484	9.9
1987.49a–c	1.19	1988.137	13.3	1989.218	M6	1990.303a	11.8	1996.401b	3.23	2000.513	8.27
1987.50	13.8	1988.138	13.37	1989.220	M2	1990.303b	8.37	1996.401c, h	1.37	2000.512	13.19
1987.51	5.1	1988.140	4.6	1989.222a–c	14.11	1990.304	1.21	1996.401f	11.13	2000.514a,b	8.41
1987.53	8.2	1988.141a,b	14.16	1989.223	3.13	1990.305	6.2	1996.401g	2.27	2000.515	12.9
1987.54a–e	8.57	1988.141c–e	11.19	1989.224	13.23	1990.306a–c	4.1	1996.401i–j	3.26	2000.516	1.35
1987.55	8.51	1988.141f	11.16	1989.225	13.23	1990.307	1.8	1996.402	4.2	2000.517a–d	5.10
1987.56	12.21	1988.141g	12.27	1989.226	13.21	1990.308a–v	15.1	1997.403a–i	6.6	2000.518	1.18
1987.57	13.44	1988.141h	9.54	1989.227	13.21	1990.309a–i	8.56	1998.405	1.34	2000.519	9.40
1987.58	8.15	1988.142	9.47	1989.228a–c	1.32	1990.310	4.3	1998.406	14.2	2000.520	12.23
1987.60	8.55	1988.143	3.12	1989.229	1.31	1990.311	13.26	1999.361	2.19	2000.521	2.26
1987.61a,b	12.34	1988.144a–d	8.20	1989.230a,b	13.13	1990.312	2.3	1999.409	9.38	2000.522	4.10
1987.62a–d	1.14	1988.145	9.20	1989.231	1.30	1990.313a–i	B2	1999.410	3.3	2000.528	1.24
1987.64	9.41	1988.146a–d	13.30	1989.232a–c	14.7	1990.314	9.8	1999.411	3.3	2000.542	4.9
1987.65a,b	9.42	1988.150	3.14	1989.234	13.1	1990.319a–d	8.59	1999.412	3.3	2000.543	2.22
1987.66a–f	12.19	1988.158a,b	14.3	1989.235a,b	9.16	1990.320	9.23	1999.413	12.16	2000.544	4.5
1987.67	8.45	1988.404	8.22	1989.236b	4.7	1990.321	M16	1999.414	1.33	2000.545a–c	1.26
1987.68	8.65	1989.148	1.3	1989.236c	12.22	1990.322	2.25(II)	1999.415a,b	8.32	2000.547	12.11
1987.69	1.23	1989.149	8.13	1989.237recto	1.6	1990.323a–l	9.6	1999.417	8.42	2003.524a,b	10.3
1987.70	3.27	1989.151	8.74	1989.237verso	12.32	1990.326	1.9	1999.418	9.39	2005.408	13.38
1987.71	3.19	1989.152	1.12	1989.238	3.8	1990.327a–d	9.18	1999.419	9.7	2007.527	12.6
1987.72	12.26	1989.153a–c	9.21	1989.239a–h	5.11	1990.328	9.22	1999.420a–d	8.60	2010.538	2.7
1987.73a,b	8.64	1989.154	9.43	1989.240	8.11	1990.333a–e	11.11	2000.421	11.1	2010.539	7.17
1987.74	3.21	1989.155	8.78	1989.241	11.7	1990.334	8.48	2000.422	12.29	2014a	M5
1987.75	12.25	1989.156a,b	13.16	1989.242	11.7	1990.335	12.15	2000.423	9.3	2016.540	4.8
1987.76	11.10	1989.159a,b	8.70	1989.244	11.15	1990.336	8.25	2000.425	10.5	2018a	M13
1987.77	1.38	1989.160	9.19	1989.245	10.5	1990.337	3.28	2000.427	10.5	2020.548	7.19
1987.78	14.1	1989.161	13.12	1989.246	10.5	1990.345	9.52	2000.428	3.17		
1987.80	2.23	1989.162	1.10	1989.247	13.9	1990.346	9.27	2000.429	3.17		
1987.81	8.61	1989.163a,b	7.5	1989.248	2.18	1990.347	9.17	2000.430	8.44		
1987.82	9.37	1989.164a–d	1.2	1989.249	13.41	1990.350	12.13	2000.431	8.44		
1987.83	11.17	1989.165	3.5	1989.288	7.7	1990.351	11.5	2000.432	8.44		
1987.86	12.24	1989.166	1.13	1989.10258a	M17	1990.352	12.36	2000.433	8.44		

768 PETER MAY COLLECTION II

INDEXES

INDEX OF ARCHITECTS AND ARTISTS OF ARCHITECTURAL DRAWINGS

This index is in alphabetical, word by word order. It does not cover the Foreword, Acknowledgements or Editor's Acknowledgements. Location references are to page number, page and figure number (in italics), and catalogue number (in bold) and are given in that order. Where the spelling/attribution of a name is uncertain, it is followed by [?].
Abbreviations: attr. = attribution; fig. = figure.

Abom, Johan Fredrik, **B1**
Adam, Robert, 15, 50, 55, 63, 88, *50 fig. 7, 88 fig. 23*, **8.47, 9.5**
Adler, Dankmar, 14, *15 figs. 23–24*
Adshead, Stanley, 56
Alberti, Leon Battista, 88
Allen, Melville, **13.40**
Ammannati, Bartolomeo, 54, **11.4**
Ancelet, Gabriel Auguste, 36, *36 fig. 33*, **1.2, 7.5** (attr.), **11.12, 13.12**
André, Louis Jules (attr.), **8.19**
Andreev, **14.11**
Asseline, Georges, **13.27**
Atkinson, William, **8.41**
Bailey, Henry, **8.42**
Baltard, Victor, **12.29**
Barragan, Luis, 72
Barry, Sir Charles, 50, 87
Bérard, André-Denis, 65
Bérard, Charles-Eugène, 65
Bérard, Édouard, **1.15**
Béraud, Jean, 24, *24 figs.10–11*, **1.6, 3.8, 4.7, 12.22, 12.32, 12.33**
Bernard, Claude François, **13.43**
Berteau, Elie (attr.), **8.49**
Bibiena, Ferdinando Galli (attr.), **1.9**
Bickerstaffe, Ellen S., **9.36**
Bievre, J. de, **8.52, 8.67, 12.23, 13.46**
Blashill, Thomas, **12.25**
Blondel, Jacques-François, 80–81
Blore, John, 55, *56 fig. 16*
Bobin, Prosper Étienne, 15, 38, 40–41, *39–41 figs. 37–42, 77 fig. 1*, **2.17, 4.11, 5.2, 5.4, 7.3, 8.81, 12.38**
Boggs, Frank Myers, **4.13, 13.42**
Bolton, Arthur Thomas, 57, *47 fig. 1*, **7.16**
Bonamy, Paul, **12.14**
Bossis, Émile-Pierre, 621
Boullée, Étienne-Louis, 65, *65 fig. 5*
Bourdain, Eugène Lucien, **8.75, 14.3**
Boussin, Claude, **9.49**
Boussois, Charles-Louis, 185
Bovet, C., **8.35**
Boyle, Richard, 3rd Earl of Burlington, 47–8, 61, 63–64, *49 fig. 4*
Bradshaw, Harold Chalton, 6, 54, *54 fig. 13*, **11.4**
Brakspear, William Hayward, 50, 89–90, *51 fig. 8, 89 fig. 25*, **8.39, M8**
Brakspear, William Sidney, 90, *89 fig. 25*, **M8**
Bramhill, Harold, 51, *51 fig. 9*, **1.24, 2.26, 4.10, 11.17** (attr.)
Brandon, David, 56, *56 fig. 17*, **1.38, 8.63**
Briault, Emmanuel-Georges, **8.20**
Brongniart, Alexandre-Théodore, 38
Broughton, Eric, **1.25**
Brown, Edward, **8.71**
Brunelleschi, Filippo, *79 fig. 5*
Bryson, John A., **1.23**
Burton, G., **3.24**
Buzas, Stefan, *68 fig. 9*
Cambon, Charles-Antoine, **9.32**
Camut, Émile, 6, 29–30, *29 fig. 22*, **6.6**
Caristie, Jean Antoine (attr.), **4.4**
Carteron, Jean Marcel, 26, *26 fig. 14*, **2.14**
Cavaillé-Coll, Emmanuel, 29
César, Fernand Valère Marie Alexandre, **2.2**

Chaikin, Benjamin, **3.19**
Chambers, Sir William, 48, 50, 55, 66, 575
Champneys, Basil, **8.72**
Chapuis, E., **1.8**
Chatron, Jules, **3.22, 7.6**
Chipiez, Charles, 84, **11.1**
Clarke, Dr. George, 64
Clarke, Richard, D. F., **14.15**
Clerck, R. de., **10.5, 11.15**
Clerget, Jacques Jean, **8.54**
Cockerell, Charles Robert, 610
Cogez, Alexandre-Frédéric, **9.25**
Coquart, Ernest, 38
Couppé, Joseph Marie, **13.1**
Couray, A. [?], **4.6**
Cournier, Jean, **13.36**
Courtonne, Jean, 81, *81 fig. 11*
Courtonne, Jean-Baptiste, *81 fig. 11*
Crace, John Dibblee, **1.39**
Cubitt, Thomas (attr.), 15, **8.43**
Cuinat, L., **8.56–8.57**
Dance Jr., George, 53
Dance Sr., George., 53
Daviould, Gabriel Jean Antoine, **12.16**
Davison, Thomas Raffles, 57, *59 fig. 20*, **8.38**
Dawber, Edward Guy, *58 fig. 19*, **8.65**
Debacq, Joseph-Frédéric, **11.7**
Dedeban, Jean-Baptiste (attr.), **9.10**
Defoiss, [Thomas?], **7.18**
Defrasse, Alphonse-Alexandre, xvi, 36, *37 figs. 35–6*, **6.5, 8.1, 14.2**
Del Rossi, Domenico, **8.23**
Delannoy, Marie Antoine, **1.33**
Delmas, Fernand, **1.15**
Deslandes, Édouard-Julien, 185
Desmaison, Louis Saint-Ange, **9.12**
Despradelles, Constant Désiré, 42
Destailleur, Gabriel Hippolyte, 65, 482
Devey, George, 89
Dommey, Étienne Theodore, **13.10**
Duban, Félix, 19
Dufay-Lamy, Émile, **9.19**
Dumont, Gabriel-Pierre-Martin, 21, *22 fig. 6*, **12.10**
Durand, André, **8.26**
Eiffel, Gustave, 40, 263
Erben, [Ludwig?], **3.11**
English, Charles William, 57, *47 fig. 1*, **7.16**
Esmer, Juel, **8.69**
Falcino, Mariano, **4.2**
Farey, Cyril Arthur, 15, 57, *58 fig. 18*, **7.15, 8.40, 8.66**
Fatio, Edmond, 66, *66 fig. 6*
Faulte, Jean-Michel, **13.17**
Feraud, Jean-Baptiste Pierre Honoré, **12.36**
Ferguson, Mark, x, xi, xiii, xv, 1, 762–64
Ferguson and Shamamian, 78, 762–64, *763 fig. 1, 765 fig. 2*
Ferret, Pierre, 35, *35 fig. 32*, **10.1**
Fletcher, Banister, 84
de Fleury, Charles Rohault, **1.4**
Florence, Henry Louis, 52
Formigé, Jean-Camille, 22, 208, **8.18, 12.6, 14.4**
Formigé, Jules, 6, **11.3**
Fortier, Laurent, **8.9**
Foster, Norman, 72–3
Foster, Thomas Oliphant, **3.27**
Fouché, Paul, **13.9**
de Fournier, Jean-Baptiste Fourtuné, **8.33**
Fowke, Francis, **1.35**
Francq, M., **8.10**

Gandy, Joseph Michael, vi, 15, 380, **8.32**
Gardelle, Camille, 42, *44–45 figs. 45–46*, **8.83**
Gehry, Frank, 73
George, P., **2.3**
Georges, Charles Edward, 6, **9.54, 11.16, 11.19, 12.27, 14.16**
Gibbs, James, 66
Gilbert, Émile Jacques, 6, 36, *36 Fig 34*, **11.11**
Godwin, Edward William, 54
Goldfinger, Ernö, 73
Gonquin, Jacques, **1.3**
Goureau, Charles Ulysse, 91, *91 fig. 28*, **10.6**
Gours, Charles, **1.5**

Guadet, Julien, 22, 35
Guillonnet, Émile Octave Denis Victor, **9.42**
Hadid, Zaha, 73
Hardouin-Mansart, Jules, **9.1**
Hardwick Jr., Thomas, 50, *50 fig. 6*, **2.10**
Harvey, John Dean Monroe, 57, *58 fig. 19*, **8.65**
Hawksmoor, Nicholas, 48, 64, 66, *66 fig. 7*
Hébrard, Jean, 35, **10.1**
Henderson, G. E., **11.20**
Heurtier, Jean-François, **8.27**
Higuero, Enrique Marin, **13.41**
Hittorff, Jacob-Ignaz, 40
Holford, Sir William C., **7.17**
Holl, Steven, 72
Hostein, Édouard Jean Marie, **8.51**
Hugon, G., **8.55**
Hunt, Richard Morris, 41
Irvine, Alan, *68 fig. 9*
Jacobsz, Caspar Philip, *17 fig. 26*
Janssenz, A. R., **8.82**
Jaussely, Léon, **12.4**
Joass, John James, **11.10**
Jones, Inigo, 47–8, 63, *48 fig. 3*
Jones, Owen, 87, 575
Jorgensen, Alexander Eugen, **7.12**
de Juilly, Henry Guillot, **4.1, 13.26**
Juvarra, Filippo, *68 fig. 8*
Kaldor, Andras, 10, *14 fig. 21*
Kámáluddin, **2.25a–b**
Keach, Leon, 15, 42, *42–3 figs. 43–4*, **1.22, 1.37, 2.27, 3.23, 3.26, 11.13**
Kent, William, 48, 55
Kimball, Herbert S., **8.11**
Koolhaas, Rem, 74
Korovine, O., **9.38**
Kühn, Josef, **7.11**
Ladewig, Franz Wilhelm, **9.14**
Lafarge fils, Jules, **11.8**
Laloux, Victor, 24, *24 figs. 11–12*, **5.5**
Lambert, Noël Marcel, **11.18**
Lang, Adolf, **8.80**
Lasdun, Sir Denys, 73
Latrobe, Benjamin Henry, 55, *55 fig. 15*
Le Vau, Louis, 80
Lebret, Paul Joseph, **2.4, 3.15**
Ledoux, Claude-Nicolas, 81
Lemaresquier, Charles, 24
Lepère, Jean-Baptiste, **12.3**
Lewis, J. Whitfield, **1.41**
Liberton, C., **8.68**
Lichtenfelder, Guillaume, **14.10**
Linke & Cie, Paris, **9.50**
Lobre, Maurice, **9.43**
Loriot, Louis-Adam (attr.), **13.3**
Lucchi, Pietro, **9.17**
Luizet, Gabriel II, **13.8**
Luizet, Marc-Antoine II, **13.8**
Lutyens, Sir Edwin Landseer, 15, 52, 57, **13.45**
Mancini/Marini [?], Mario/Marco [?], **4.9**
Martin, Paul, **8.77**
Martin, Sir Leslie, 73
Massé, Emmanuel Auguste, **9.39**
May, Hugh, 48
Mayernick, David, 10, *10 fig. 15*
Menouvrier, Félix, **8.4**
Mercie, George Anton, **13.43**
Mewès, Charles-Édouard, 65
Mewès, Charles-Frédéric, 67
Michel, **13.2**
Michelangelo, 62
Micheli, Vicenzo, **4.2**
Millington-Drake, Teddy, 8, *10 fig. 16*
Munnings, G., **9.15**
Mylne, Robert, 71
Nash, John, 421
Nénot, Henri-Paul, 38
Neumann, **13.15**
Newman, John, **2.9**
Nicod, Charles-Henri, 185
Paccard, Alexis, 38
Palladio, Andrea, 47–8, 62–3, *63 fig. 3*, **8.21–8.22**
Parry, Eric, 72

Pearce, Edward, 71, *63 fig. 4*
Pei, I. M., 73–4
Percier, Charles, *69 fig. 10*, **8.30**
Perignon, **13.34**
Perin, Louis, **8.53, 13.14**
Perrault, Claude, 80
Perronet, Jean-Rodolphe, 80–81, *81 fig. 10*
Perrot, Louis-Alfred, 27, *27 figs. 16–17*, **3.17, 13.24**
Peschel, Hans, **9.14**
Piccardo, P., **9.20**
Pinho, Philippe Fereira d'Aranjo, **9.51**
Plantar, Jean-Baptiste, 15, **15.1**
Plucknett, James, & Co, **8.37**
Pontremoli, Emmanuel, 22, 621
Pradelle, Amet Georges Alexandre, 22, *23 fig. 7*, **12.34, 13.22**
Pratt, Sir Roger, 48, 64
Prévost, Jacques-Maurice, 33, 35, *34 figs. 29–31*, **3.16, 8.29, 10.1, 13.29**
Price, Cedric, 74
Proctor, Albert, **9.40**
Proy, Achille-Laurent, *1 fig. 1, 20 fig. 4*, **1.32, 2.11, 6.4**
Quarenghi, Giacomo, 65, *69 fig. 11*
Railton, William, **12.1**
Rajkovich, Thomas Norman, 10
Raney, Vincent, 70
Rasmussen, Hans, **8.70**
dal Rée, Vincenzo, *66 fig. 6*
Reilly, Sir Charles, 51
Remon, George, **9.26**
Richardson, C. J., 49, *49 fig. 5*, **10.3**
Richardson, George (attr.), **9.3**
Richardson, Sir Albert, 65, 68–9, 71, *69 fig. 11*
Rigault, T., **8.61**
Rochead, John Thomas, **12.26**
Rohard, Leon, **1.11, 3.1**
Rose, Arthur, **12.17**
Rose, George Alfred, 52, *53 fig. 12*, **12.12**
Rossi, Aldo, 72
Rostaing, Léon-Philibert, **1.18**
Salvin, Anthony, 89
Sandby, Thomas, 54, *55 fig. 14*, **7.14**
da Sangallo, Antonio, 62
da Sangallo, Giovanni Battista, *73 fig. 15*
da Sangallo, Giuliano, 78, *79 fig. 7*
Saulnier, Jules, 38
Scamozzi, Vincenzo, 62–63
Sehnal, Eugene, **3.20**
Sherar, Robert F., **12.26**
Shoosmith, Arthur, 52, 597
Sims, Alfred Hatten, **13.33**
Smirke, Sydney, 87
Smith, Alex F., **5.11**
Soane, Sir John, 14–15, 48–9, 61, 63, 88, *49 fig. 5*, **10.3**
 Portrait of Sir John Soane amid his Public and Private Buildings (Joseph Michel Gandy), vi
 Soane Medallion, 52, 54, 275, *53 figs. 11–12*, **12.12**
Sortais, Louis, 22
Spence, Sir Basil, 56
Stanses, Louis, **3.10**
Steel, Kenneth, **8.36**
Steinhard, Antal, **8.80**
Stirling, James, 74
Stock, Henry, 57, *47 fig. 1*, **7.16**
Stoecklin, Henri, 24
Stoecklin, Jules, 24
Stupenengo [?], **7.13**
Sullivan, Louis 14, *15 figs. 23–4*
Tabuteau, Bernard, 21, *21 fig. 5*, **5.3**
Talbert, Bruce James, **3.21**
Talman, John, 63–64, 71
Talman, William, 48, 61, 63–4, 71
Tardif, Alfred, **9.21, 13.30**
Tasker, John, **8.48**
Taylor, Sir Robert, 49
Tessin Jr., Nicodemus, 64
Tessin Sr., Nicodemus, 64
de Thermeau, Ernest Chardon, **3.13, 13.21, 13.23**
Thomas, Paul, **9.41**
Tonnau, Roger, **1.13**
Touranjou, Honoré, 91, *91 fig. 27*, **M7**
Tracy, Samuel William, **8.61**

CONCORDANCE & INDEXES

Treves, Marco, 4.2
Triggs, Henry Inigo, 8.66
Trowbridge, Alexander Buel, 35
Unsworth and Goulder, 57, 58 fig. 18
Unsworth, William Frederick, 8.66
Uren, Reginald, 52, 52 fig. 10, 1.26, 1.40
Urtin, Paul François, Marie, 9.44
Valentin, André-Jules, 24
Valentin, Jehan, 24, 26, 25 fig. 13, 6.2
Vanbrugh, Sir John, 48, 64, 66
Van der Rohe, Mies, 72, 88
Vanderson, M., 13.39
Van Dijk, Henri, 1.27
Van Seben, Henri, 9.34
Varcollier, Louis, 22, 621, 23 figs. 8–9
Vaudoyer, Léon, 38
Vegund, J., 28 fig. 18, 12.30
Vertue, George, 8.31
Vickers, Squire Joseph, 3.25
Videlou, R., 8.58
Vieulet, Yves, 11.2
da Vignola, Giacomo Barozzi, 54, 11.4
Viloin, P. [?], 6.3
Viollier, Henri François, Gabriel, 13.19
Visconti, Louis Tullius Joachim, 12.9
Walcot, William, 57
Ware, William Robert, 42
Warman, William, 3.19, 8.45
Waterhouse, Alfred, 55, 61 fig. 1
Webb, John, 63–64
Webb, Sir Aston, 57, 59, 59 fig. 20, 8.38
Wieland, Albert, 8.44, 10.4
Willey, Émile, 8.78
Williams, Bunny x, xi–xiii, xv, 1, 767
Wilson, James, 2.7
Wilson, Sir Colin St, 73
Wilson, Willcox & Wilson, 1.36
Winter, D. H., 3.19
Woog, Lucien-Léon, 1.3, 2.6, 5.9
Wren, Sir Christopher, 48, 64, 66, 66 fig. 7, 4.12
Wright, Frank Lloyd, 14, 69, 14 fig. 22, 7.19
Wyatt, Benjamin Dean, 12.2
Wyatt, James, 48
Wyatville, Sir Jeffry, 68, 71, 8.32, 8.60
Zumthor, Peter, 82, 82 fig. 13

INDEX OF PLACES DEPICTED IN DRAWINGS

Arles, France, the Arena, 11.3
Athens, Greece, study of a Doric column from the Parthenon, 11.13
Baroda, India, interiors for Maharaja Gaekwad, 9.50
Bartlesville, Oklahoma, Price Tower, 7.19
Bath, UK
 Octagon Assembly Room, 1.36
 Royal School, 2.7
Berndorf, Austria, Berndorf School, 9.14
Bois le Roi, France, villa, 8.56
Bourg de Péage, France, garden plan, 13.8
Brighton, UK
 Corinthian Tower, Queen's Park, 12.27
 Royal Pavilion, 8.37
Brussels, Belgium, town houses, 8.82
Budapest, Hungary, New York apartment building, 8.80
Buenos Aires, Argentina
 dining room, 9.51
 entrance to home of Emilio P. Furt, Sarmiento, 14.14
Cannes, Hotel Gallia, 24 fig. 13, 6.2
Châteauneuf, France, plan of the city and park, 13.1
Chennevières-sur-Marne, France, decorative well, 13.43
Cheshire, UK, Statham Lodge, 8.41
Colesborne House, Gloucestershire, UK, 8.63
Copenhagen, facade of Christian IX's Gade, 7.12
Dijon
 residence for M. Valliere, Boulevard Garnot, 8.55
 tram station, 40 figs. 39–40, 5.2
Dublin, Ireland, Royal Exchange, 55 fig. 14, 7.14
East Liss, Petersfield, UK, Rake Holt House, 58 fig. 18, 8.66
Elton, Berry Leas house, Huntingdonshire, UK, 58 fig. 19, 8.65
Fermo, Italy, Chiesa della Pietà, 9.17
Florence, Italy
 Great Synagogue, 4.2
 Uffizi Tribuna Gallery, 1.28
 Villa Poggio Imperiale, 8.26
Grenada, Spain, courtyard of the Generalife in the Alhambra, 13.41, 13.42
Hammersmith, UK, Hermitage, 13.39
Hammerwood Lodge, Sussex, UK, 55 fig. 15
Hampton Court Palace, 8.40
Herculaneum, Italy, reconstruction drawings of wall paintings, 11.11
Jerusalem
 St. John Opthalmic Hospital, 3.19
 Temple of Jerusalem, reconstruction drawing, 11.1
Kimbolton Castle, Huntingdonshire, UK 50 fig. 7, 8.47
Labrouguière, France, school, 2.1
Lille, France, art museum, 1.15
Liverpool, UK, medical office, 9.36
London, UK
 Athanaeum Club, Pall Mall, 1.39
 boudoir, 49 Belgrave Square, 9.21
 Buckingham Palace, 59 fig. 20, 8.38, 9.15
 Charles I monument, Trafalgar Square, 12.1
 Chestnut Avenue, Forest Gate, Spitalfields, 8.71
 Duke of York's monument, Pall Mall, 12.2
 Hamburg-Amerika Line building, Cockspur St, 47 fig. 1, 7.16
 Hyde Park, lodge at Grosvenor Gate, 12.17
 Lord Nelson monument, Trafalgar Square, 12.1
 Marlborough Club, Pall Mall, 56 fig. 17, 1.38
 Queen's House, Greenwich, 48 fig. 3
 Royal Horticultural Society, 1.35
 School for the Indigent Blind, 2.9
 St. Augustine's, Watling St, 66 fig. 7
 St. Bride's Vicarage, Fleet Street, 8.72
 St. James's Palace, 8.36
 St. Paul's Cathedral, 4.12
 train station, 5.10
Lucknow, India, Canning College, 2.25a–2.25b
Lyon
 Place de Lyon, fountain, 12.6
 post office, 3.22
Mamiano, Italy, Villa Magnani, 9.9
Manchester, UK, Town Hall, 61 fig. 1, 3.21
Maser, Italy, Villa Barbaro, 8.21
Maxeville, France, boys' school, 2.2
Meiningen, Germany, Ducal Orangerie, 13.2
Metaponto, Italy, Greek Temple of Hera, 11.7
Milan, Italy, Credito Italiano bank, Piazza Cardusio, 7.13
Moccas Court, Herefordshire, UK, 88 fig. 23, 9.5
Le Mont-Dore, Dordogne, France, Thermal Baths, 6.6
Montevideo, Uruguay, private residences, 8.83
Moulins, France, rental buildings with apartments and shops, 8.77
Naples, Italy, Strada Aragona Pignatelli Palace, 8.24
Newcastle upon Tyne, UK, cultural center, 1.23
Nice, train station, 41 fig. 41, 5.4
Oxford, UK, Woolworth's building on Cornmarket, 7.17
Paris, France
 apartment buildings, frontal elevations, 8.79
 building in 5th arrondissement, 8.75
 Carnavalet, Museé, 11.13
 Dunod publishing house and bookshop, rue Bonaparte, 7.9
 Gare d'Orsay, 5.5
 Guichet du Louvre, 12.20–12.21
 Les Invalides, 9.1
 Opera House, 1.4–1.5
 Plan-Relief Gallery, 80 fig. 9
 Parc Monceau, gated entrance, 12.16
 Place Gaillon, fountain, 12.9
 Place Vendôme, Monument to Napoleon, 12.3
 residence and gardens of Louis-Nicolas d'Avoust (Davout), Duke of Auerstädt and Prince of Eckmühl, rue St. Dominique, 8.30
 Sainte Anne de la Butte aux Cailles, 4.11
 Sainte Geneviève, 31 fig. 25, 8.73
 Sorbonne, 39 fig. 38, 77 Fig 1, 2.17
 Tuileries Palace
 garden plan, 13.3
 interior views, 8.33
Pompeii, Italy, reconstruction drawings of wall paintings, 11.11
Portsmouth, UK, art gallery, 1.25
Reading, Pennsylvania, USA, train station, 5.11
Rethel, France, City Hall, 3.3
Richelieu, France, Monument Richelieu, 12.38
Richmond, UK, royal palace, 8.31
Rigny-Usse, France, view of Château d'Ussé, 8.2
Rome, Italy
 Forum, restoration drawings of ruins, 11.12
 House of Livia, reconstruction drawing of a wall, 11.10
 Temple of Minerva, 73 fig. 15
 Temple of Vesta, reconstruction drawing, 11.2
 Villa Giulia, 54 fig. 13, 11.4
Sagan (Zagań), Poland, 6
 views of the Castle and Estate of Royal Duchy of Sagan, 8.34(II)
 views of the village, 8.34(I)
Sankt Pölten, Austria, Franz-Joseph Hospital, 3.20
Sarthe, France, Château de Préval (La Matrassière), 8.7
St Petersburg, Russia, pleasure palace on Kamenny Ostrov (Stone Island), Neva delta, 13.19
Stirling, Scotland, National Wallace Monument, 12.26
Stow-on-the-Wold, UK, Garden House at Abbotswood, 13.45
Syam, France, Château de Syam, 9.6
Toulon, France, Villa Dupuy de Lôme, 8.51
Tourcoing, France, City Hall, 3.1
Trieste, Italy, Caffetteria della Gloriet, 13.18
Vaux-le-Vicomte, Château de 9.19
Venice, Italy
 Ca' d'Oro facade, xvii, 37 figs. 35–6, 8.1
 Piazza San Marco, flagpole base, 12.5
Versailles, France, Château de Versailles, 8.27–8.28
 Ambassador's Staircase, restoration drawing, 11.18
 Buffet d'Eau, restoration drawing, 11.18
 Chapel, imagined interior elevations, 9.16
Vicenza, Italy
 composite drawing of a Venetian wellhead and flagpole against Palladio's Basilica, 11.17
 Palazzo Porto Festa, 63 fig. 3
 Villa Almerico-Capra (Villa Rotonda), 8.22
Vienna, Austria, commercial buildings, 7.11
Vincennes, France, 21 Avenue de Paris, 8.78
Winchester, UK, Bishop Fox's Chantry Chapel, Winchester Cathedral, 48 fig. 2
Windsor Castle, UK 8.32
Yangon, Myanmar, Magistrates Court, 3.27
York, UK, Assembly Rooms, 49 fig. 4
Zatorie, Poland, Palace of Günthersdorf, 8.35

GENERAL INDEX

Accademia del Disegno, Florence, 19
Accademia di San Luca, Rome, 19, 61
Académie Royale d'Architecture, 47–48
Aedes: Galerie für Architektur und Raum, Berlin 72
Alain Cambon Gallery, 5 fig. 8
Allen, Armin B., 68, 70 fig. 13
Allgemeines Teutsches Garten-Magazin, 633
American Society of Architectural Historians, 68
Andrews, Stephen Boone, 5–6, 17, 70
Archigram Archive, 74
Architect and Building News, 426
Architectural Illustrations of Windsor Castle, (Michael Gandy and Benjamin Baud), 380
architectural models, 77–82, 85–86, 92
 Ancient Egyptian porch and garden, 78 fig. 3
 architect's cabinet, 4 fig. 7
 Baptistry, Pisa, 86, 86 fig. 19, M12
 chicken house, 89 fig. 25, M8
 City gate, M16
 City Hall, M4
 classical façades, 89 fig. 24, M10
 collection of, 82–5
 compagnonnage system, 90–92
 corner entrance, M11
 display of in English country houses, 86, 87 fig. 20
 East Parade Chapel, Leeds, UK, M3
 function, 86
 mantelpieces, 88 fig. 22, M9
 materials, 86–8, 90
 model-makers, 87–8
 Napoleon's Monument, Place Vendôme, Paris, M15
 Paris Opera House, M5
 pattern books, 90, 90 fig. 26
 Roman ruins, M14
 ruins of Temple of Castor and Pollux and Temple of Vespasian, Rome, M13
 Seagram Building, model, 82 fig. 12
 stage sets, M17
 staircases, 90–91, 91 figs. 27–9, M6–M7
 temples, 77 Fig 1, M1–M2
 Zinc Mine Museum, Allmannajuvet, Norway, 82 fig. 13
Architects (Registration) Act (1931), 51
Artis Group Ltd, 68
Arundel, Thomas Howard, Earl of 63
ateliers, 21–2, 54
Atkinson, J. J., 3.21
Bartlett School of Architecture, London, 51
Beaver Creek, Colorado, Vilar Center, xi, 1, 3, 3 fig. 4, 10, 14 fig. 21
Beit, Sir Otto, 9.21
Belgrave Square (no. 49), London, 485
Bell, Edward, 1.36
Beviere, Leopold, 6.6
Bieder, Jean, 516
Blass, Bill, 71
Blondel, Merry-Joseph, 464
Bonnier de la Mosson, Joseph, 81
Bordeaux, FRAC Aquitaine, 73
Boston, Brigham and Women's Hospital, 70
Boys, Thomas Shotter, 55
British School at Rome, scholarships, 52, 54
Brosen, Frederick, 10
Builder, The, 54, 57, 326
Building News, The, 434
Cambon, Alain, Gallery, 5 fig. 8
Campbell, John, 2nd Duke of Argyll, 66
Canadian Centre for Architecture, Montreal, 67, 73–74, 84
Capriccio of an Architect's Studio (by David Connell), 10, 11 fig. 17
Carmichael, John Wilson, 55
Carnegie Museum of Art, Pittsburgh, PA, 83
Cassas, Louis François, 87, 87 fig. 21
Centre Pompidou, Paris, 73
Chambers, William, *A Treatise on Civil Architecture*, 575
Champonnois l'aîné, 464
Charles de Lorraine, 648
Chicago, Stock Exchange, 14, 15 figs. 23–4
Christie's auction house, 68, 70, 69 fig. 11
Clarendon Gallery, The, London, 69
Colbert, Édouard, Marquis de Villacerf, 452
Colling, James Kellaway 575
Columbia University, Avery Library, New York 65, 85
Colvin, Sir Howard, 70
Cooper Hewitt Smithsonian Design Museum, New York 65–67, 91
Confraternity of Carpenters, *compagnon* masterpiece, 92, 92 fig. 30
Connell, David, *Capriccio of an Architect's Studio*, 10, 11 fig. 17

Conrad, Theodore (model-maker), 82, 85, *82 fig. 12*
Conquy, Ephraïm (engraver), 12.3
Contarini, Giacomo, 62–3
Cooper, Jeremy, 69
Cornewall, Sir George Amyand, 458
Coutts, Howard, 456
Day family (model-makers), 87
Delouvrier, Alfred, 5.1
Deutsches Architekturmuseum, Frankfurt-am-Main, 69–70, 73, 84
Drummond, William, 67
Drummond-Stewart, Sir John, 65
École Nationale Supérieure des Beaux-Arts (ENSBA) (formerly École des Beaux-Arts), 19, 21–22, 61, *18–20 figs. 1–3*
 Beaux-Arts tradition, 41–43
 Château de Gaillon, portico, 19, *20 fig. 4*, 2.11
 concours, 26–28, 365, *28 fig. 19*
 diploma, 33
 effect on US institutions, 41–43
 envois de Rome, 36–37
 Prix de Rome competition, *see* Prix de Rome competition
 prizes, 29–33
Edward VII, King of Great Britain and Northern Ireland, 391
Elwes, J. N., 423
Ferguson, Mark, 1, 762–65
ffrench, Yvonne, 67
Fischer Fine Art, London, 69
Fischli, Peter, 84
Flitcroft, Henry, 48
Fouquet, Jean-Pierre and François (model-makers), 87, *87 fig. 21*
Fuhring, Peter, 70, 456, *70 fig. 13*
Gahlin, Sven, 67
Gaillon, Château de, Normandy
 portico, 19, *20 fig. 4*, 2.11
 View of the Château de Gaillon in Normandy (by Israel Silvestre), 168
Galerie Knoedler, Zurich, 70
Galerie van Rooy, 72
Galerie Wurthle, Vienna, 70
Galleria Antonia Jannone, Milan, 72
Gallery Lingard, London, 69
Gandy, Michael, vii
 and Benjamin Baud, *Architectural Illustrations of Windsor Castle*, 380
Gay, Walter, 509
Georg I of Saxon-Meiningen, 633
Gerdes, Ludger, 84
Getty Research Institute, Los Angeles, 70, 73–4
Gille, Philippe, *Versailles et les deux Trianons*, 572
Goddard, R. W., 8.72
Godeboeuf competition, 29–30, *30 fig. 23*, 9.53
Government School of Art, Belfast, 701
Griggio, Nadale, 8.21
Grinke, Paul, 67
Gwenda Jay Gallery, Chicago 1.22, 1.37, 2.27, 3.23, 3.26, 11.13
Gwynn, John, 4.12
Hanks, David, 70
Hanson, Glen, *The San Remo, New York City*, 10, *11 fig. 18*
Harding, James Duffield, 55
Harris, John (Curator of Drawings, RIBA), 66–68, 70
Harvard Art Museums, Fogg Art Museum, Cambridge, MA, 67
Hazlitt, Gooden & Fox, London, 69, *70 fig. 13*
Herodotus, 77
History of the Royal Residences, The, (W. H. Pyne), 14
Hobhouse, Niall, 70–72
Hoppen, Stephanie, 1, 5–6, 70, 767
Hotel Drouot, Paris, 68
Hottinger, D., 3.27
Houthakker, Lodewijk, 67, 70
Hyatt Mayor, A., 67–8
Jannone, Antonia, Galleria, Milan, 72
Jeudwine, Wynne, 67
Jobez, Jean-Emmanuel, 464
Julius III (Pope), 54
King's College London, 50–51
Klotz, Heinrich, 84
Krah, E., 8.22
Kunstgewerbe Museum, Berlin 65
Lafitte, Louis, 464
Lambert, Phyllis, 67, 70, 73
Le Brun, Pierre, 83–84
Lefuel, Oliver, 372
Le Mercier, Jacques, *79 fig. 6*
Lenepveu, Jules, 22
Le Nôtre, André, 634
Leopardi, Alessandro de' (sculptor), 12.5
Leslie Hindman Auctioneers, Chicago, 68

Linley, David (David Armstrong-Jones, 2nd Earl of Snowdon), 10, *11 fig. 19*
Liverpool School of Architecture, 51
Long and Kentish, London, 73
Ludwig, I, King of Bavaria, 84
Luynes, Honoré, d'Albert, Duc de 556
M+, Hong Kong, 74
Mabey family (model-makers), 87
Maisonnier, Élisabeth, *Versailles, Architecture Rêvées 1660-1815*, 372
Maître de Rieux, *Jean Tissendier, Bishop of Rieux-Volvestre*, *79 fig. 4*
Mason, Howard, 7.17
May, Peter
 Beaver Creek, Colorado, former residence, *3 fig. 4*
 Bridgewater, Connecticut, residence, x
 New York City, former office, 5, *4 fig. 6*
 New York City, office, *1 fig. 2*, *3 fig. 5*, 6.4
 Palm Beach, Florida, residences, xiii–ix, *7–8 figs. 11–2, 16 fig. 25*, *78 fig. 2*
 portrait, xii
 San Remo, New York City, *2 fig. 3*, *8 fig. 14*, *12–13 fig. 20*
 specialty framing for collection, *6 figs. 9–10*, *8 fig. 12*
Mellon, Paul, 67, 70
Metropolitan Museum of Art, New York, 65, 67–8, 83–4, *84 fig. 16*
Middlebury College, Vermont, 68
Morgan, Agnes, 67
Mossant, Casimir, 638
Mossant, Charles, 638
Mouquin, Sophie, *Versailles en ses marbres*, 452
Musée des Arts Decoratif, Paris, 65
Myers, Mary L., 68, *68 fig. 8*
Napoleon III, 381
Netherlands Architecture Institute (Het Nieuwe Institute), Rotterdam, 74
New Zealand Institute of Arts, 51
Oenslager, Donald, 67
Office of the King's Works, 47–48
Oliver, John, 64
Onslow's Auction House, London, 68
Perronet, Jean-Rodolphe, with his Wife (by Alexander Roslin), 80, *81 fig. 10*
Perrot, Georges, 544
Piancastelli, Giovanni, 66
Pingeron, M., 81
Polytechnische Schule, Munich, 84
Ponce, Nicolas, 456
Potts, Henry, 69
Powney, Christopher, 67
Prix de Rome competition, 21–2, 28–9, *29 figs. 20–21*
 envois de Rome, 36–7, *36–7 figs. 33–6*
 drawings, xv
 Joan of Arc monument, *23 figs. 7–9*, 12.34
 medical school, 2.19–2.20
 National Botanical Institute, 2.24
 observatory, 2.23
 spa, 6.5
 spa/casino, 6.4
Projets Desroches, projets 4, B2
Protetch, Max, 72
Pyne, Barbara, 72
Pyne, W. H., *The History of the Royal Residences*, 14
Rockstroh, Heinrich, *90 fig. 26*
Rodriques, Eugène, 66
Romano, Giulio, 62
Rooker, Edward, 4.12
Roslin, Alexander, 80, *81 fig. 10*
Royal Academy of Arts, London, 47, 49, 56–7, 61
Royal Institute of British Architects (RIBA), London, 50–51, 63–65, 68, 71, 275
 Heinz Gallery, 68, *68 fig. 9*
 prize drawing competitions, 52
de Sachy, Alexandre, 83
San Remo (by Glen Hanson), 10, *11 fig. 18*
Sandtner, Jakob, 79, *80 fig. 8*
Schacre, Alfred, 464
Schütte, Thomas, 84
Scotin, Gérard Jan-Baptiste I, 452
Serlio, Sebastiano, 62
Seurre, Charles Émile, 12.3
Sharf, Frederick A., 70, *70 fig. 14*
Shepherd Gallery, New York 68
Silvestre, Israel, 634
 View of the Château de Gaillon in Normandy, 168
Sir John Soane's Museum, London, 82, *83 fig. 14*
Soane Medallion, 52, 54, 275, *53 figs. 11–12*, 12.12
Society of Architectural Historians in Great Britain, 68
Sommier, Alfred, 482
Sotheby's auction house, 68, 70–71, *69 fig. 10*

South Kensington Museum, *see* Victoria and Albert Museum
Spenser, Edward, *The Faerie Queen*, 520
Stieglitz Museum, St Petersburg, 65
Strada, Jacopo, 61–62
Stuart, John, 3rd Earl of Bute, 66
Stubbs, Jane and John,10
Summerson, Sir John, 405
Surveyor of the King's Works, 47–48
Tchoban, Sergei, 71–72
Thaw, Eugene, 70, 91
Thomas, George Housman, *Queen Victoria and Prince Albert inspecting wounded Grenadier Guardsmen at Buckingham Palace 20 February 1855*, 47
Thorp, John, Thorp Modelmakers Archive, 85, *85 fig. 18*
Tissendier, Jean, Bishop of Rieux-Volvestre (Maître de Rieux), *79 fig. 4*
Toher, Jennifer, 70
Vasari, Giorgio, 61–62, *62 fig. 2*
Venturi Scott Brown Associates, Philadelphia, PA, 73
Versailles, Architecture Rêvées 1660-1815 (by Élisabeth Maisonnier), 372
Versailles en ses marbres (by Sophie Mouquin), 452
Versailles et les deux Trianons (Philippe Gille), 572
Vertue, William (King's Master Mason), 47, *48 fig. 2*
Victoria, Queen 9.15
Victoria and Albert Museum, London, 64–65, 68–85, 83 *fig. 15*
von Biron, Dorothea, Duchess of Talleyrand-Périgord, 388–89
von Biron, Peter, Duke of Courland, 388
von Stosch, Philipp, *73 fig. 15*
Wallace, Sir William 12.26
Weinardt, Carl J. 67
Weinreb, Ben, 67, 69
Weiss, David, 84
Wellesley, Arthur, 1st Duke of Wellington, 68, 71
Willard, Levi Hale, 83
Williams, Bunny, 1, 767
Wood, Christopher, 69
Wotton, Sir Henry, 62–63
Wunder, Richard, 67–68
Yale Center for British Art, New Haven, Connecticut, 67
Yu-Chee Chong Fine Art, 69, *69 fig. 12*

CONCORDANCE & INDEXES

PHOTOGRAPHIC CREDITS

All images © Peter May 2020
unless otherwise stated below

Page vi ©Sir John Soane's Museum, London

INTRODUCTION

Fig. 6 Chawleigh, Tia Digital Ltd. Fritz von der Schulenburg/The Interior Archive

Fig. 24 ©Two Red Roses Foundation Collection, IF1216001

THE BEAUX-ARTS TRADITION

Fig. 1 ENSBA inv. PH14; ENSBA/ARTRES, ART583605 © Beaux-Arts de Paris, Dist. RMN-Grand Palais / Art Resource, NY

Fig. 2 Livre Grande Masse des Beaux-Arts 1937, Paris

Fig. 12 ENSBA inv. Ph8686; ENSBA/ARTRES, ART584256
© Beaux-Arts de Paris, Dist. RMN-Grand Palais / Art Resource, NY

Fig. 20 Rendu Projets Melpomène, Livre Grande Masse des Beaux-Arts 1937, Paris

Fig. 21 Inv. 1910.152.1, Réunion des Musées Nationaux/Artres, ART582763 © RMN-Grand Palais / Art Resource, NY

ARCHITECTURAL EDUCATION AND THE ART OF DRAWING IN BRITAIN

Fig. 2 RIBA36183. ©RIBA Collections

Fig. 3 RIBA30693. ©RIBA Collections

Fig. 4 RIBA29052. ©RIBA Collections

Fig. 15 RIBA13248. ©RIBA Collections

Fig. 16 RIBA126490. ©RIBA Collections

THE ARCHITECTURAL DRAWINGS MARKET

Fig. 1 © Royal Academy of Arts, London; photographer: Prudence Cuming Associates Ltd

Fig. 2 Inv. 1991.190.1, Woodner Collection, Patrons' Permanent Fund, Courtesy of The National Gallery of Art, Washington

Fig. 3 RIBA3082-37. ©RIBA Collections

Fig. 4 RIBA37402. ©RIBA Collections

Fig. 5 RIBA3079-37. ©RIBA Collections

Fig. 6 New York, The Metropolitan Museum of Art, 69.59. Courtesy of The Elisha Whittelsey Collection, The Elisha Whittelsey Fund, 1969

Fig. 7 RIBA12082. ©RIBA Collections

Fig. 8 © 1975 The Metropolitan Museum of Art, New York. Reprinted by permission.

Fig. 9 RIBA51218. ©RIBA Collections

Fig. 10 Photo Camerarts.

Fig. 11 ©2020 Christie's Images Limited

Fig. 14 Courtesy Jean S. Sharf

Fig. 15 RIBA36390. ©RIBA Collections

CARPENTERS AND CRAFTSMEN, ARCHITECTS AND COLLECTORS

Fig. 3 New York, Metropolitan Museum of Art, 20.3.13. Rogers Fund and Edward S. Harkness Gift, 1920

Fig. 4 Photo Daniel Martin

Fig. 5 Foto A. Quattrone

Fig. 6 BnF AA-1 (LE MERCIER, JACQUES)

Fig. 7 Gabinetto Fotografico delle Gallerie degli Uffizi, 614693

Fig. 8 Inv. D168335. © Bayerisches Nationalmuseum München. Foto: Krack, Bastian

Fig. 9 État des ingénieurs, Tome IV. 1749 : Fol. 2, Vue de la Galerie des plan-reliefs au Louvre. Paris, Bibliothèque nationale de France, Bibliothèque de l'Arsenal, ms. 4426, fol. 2.

Fig. 10 Inv. WL85, Göteborgs Konstmuseum

Fig. 11 Pl.8 [Cabinet de physique et de mécanique (ou des machines)] Paris, Bibliothèque de l'Institut National d'Histoire de l'Art, NUM OA 720 (1-8).

Fig. 14 Photo provided by courtesy of the British Library/ C.190.b.22

Fig. 15 London, V&A, 33728. © Victoria and Albert Museum, London

Fig. 16 New York, The MET/Artes, ART473073. © The Metropolitan Museum of Art. Image source: Art Resource, NY

Fig 17 Sign. thie_f-79-4

Fig. 20 London, Country Life Archive, 9775

Fig. 21 'Galerie d'Architecture de M. Cassas', *Gazette de l'Amateur des Arts*, no.10 (October 1806), insert before p. 402

Fig. 26 By courtesy of the Staatsbibliothek Augsburg

Fig. 30 Roger Viollet, Parisienne HRL-507379. © Albert Harlingue / Roger-Viollet

CATALOGUE

Listed by Peter May inventory no.
The credits refer to the accompanying figure(s).

1987.3 Washington DC, The National Gallery of Art, 1945.15.3. Gift of Mrs. Barbara Hutton

1987.16 STC190634, The Stapleton Collection / Bridgeman Images

1987.17 The Hague, Koninklijke Bibliotheek, KW 1311 B 7 [1] KB

1987.20 Washington DC, Library of Congress/Flickr, LOT 13512, no. 05

1987.20 Washington DC, Library of Congress (no known restrictions)

1987.23f Munich, Bayerische Staatsbibliothek, Res/4 Oecon. 150-3/ 7587253

1987.28 Florence, Alinari Archives, DEA-S-00A301-2300

1987.39 Bequest of Hélène Irwin Fagan, 1975.5.1. Image courtesy The Fine Arts Museums of San Francisco

1987.41 Wikimedia Commons, Photo by Tiesse / CC0 1.0

1987.49a-c MR2075. Photo: Christian Jean. New York, artres, ART168176 © RMN-Grand Palais / Art Resource, NY; New York, Réunion des Musées Nationaux-Grand Palais/ Artres, ART582761 © RMN-Grand Palais / Art Resource, NY

1987.53 Los Angeles, Getty Images, 528778822, James Leynse / Contributor via Getty ImagesCorbis Historical

1987.56 Wikimedia Commons, Photo by Thesupermat / CC BY-SA 3.0

1987.61 PRA312-3, PRA312-2, PRA312-1, PRA313-1: New York, ENSBA/ARTRES, ART583578; ART583580; ART583581 © Beaux-Arts de Paris, Dist. RMN-Grand Palais / Art Resource, NY

1987.68 RIBA100479. ©RIBA Collections

1987.70 Photo by Ken Marshall via flickr

1987.71 Washington DC, The Library of Congress, LC-M32- 50086-x, Prints & Photographs Division, LC-DIG-matpc-08085. Source: G. Eric and Edith Matson Photograph Collection

1987.72 Wikimedia Commons, Photo by BusterBrownBB / CC BY-SA 3.0

1987.76 New York, Scala Archives/artres, ART6832 Scala / Art Resource, NY

1987.77 London, Country Life Archive, 12935

1987.80 PRA373-3; PRA373-2: New York, ENSBA/ARTRES, ART583588 © Beaux-Arts de Paris, Dist. RMN-Grand Palais / Art Resource, NY

1987.87 New York, Scala Archives/artres, AR9105740 © British Library Board / Robana / Art Resource, NY

1987.88 Wikimedia Commons, Photo by DAVID ILIFF. License / CC BY-SA 3.0

1987.89 Princeton, Princeton University Library, PH-08134-00. Reproduced by kind permission of P&O Heritage Collection www.poheritage.com. Bedford Lemere & Co. (Photographer)

1987.89 Photo by Roberto Ivens by courtesy of the Embassy of Brazil

1987.90 London, Westminister Archives, City of Westminster Archives Centre; RIBA28629 © Edwin Smith / RIBA Collections

1987.92 RIBA68869. © RIBA Collections

1987.94 Hastings Museum & Art Gallery, HASMG: 1997.46.101.5

1988.137 Bibliothèque nationale de France GED-5563

1988.83 Photo: Mark E. Smith. New York, Scala Archives/artres, ART582760 Scala / Art Resource, NY

1988.85 Florence, Alinari Archives, FVQ-F-045332-0000 Archivi Alinari, Firenze

1988.96 Milton Park, Alamy, A6YCKR Robert Harding / Alamy Stock Photo

1988.99 Wikimedia Commons, Photo by ToucanWings / CC BY-SA 3.0

1988.101a-c Photo Kim Youngtae, Paris. London, Bridgeman Images, YOU4420113

1988.102a-c, 1988.107a-d © Bibliothèque d'art et d'archéologie des Musées d'art et d'histoire Ville de Genève, BAA PER Q 251

1988.104a-g None Photographie Ville de Nice, Véran, septembre 2015

1988.105a,b Wikimedia Commons, Photo by Thesupermat /CC BY-SA 3.0

1988.110 ©Sir John Soane's Museum, London. Photograph by Ardon Bar Hama

1988.111a,b Bordeaux, Bibliotheque de Bordeaux, CP 407

1988.124 Montevideo, Biblioteca Nacional d'Uruguay, Photo by Testasecca y Cia

1988.131a,b © Archives Gallimard and permission by Diego Sanchez-Ramon

1988.141c Jones: Washington DC, Smithsonian Institution Libraries, via archive.org; Colling, BAA AG Q 207 © Bibliothèque d'art et d'archéologie des Musées d'art et d'histoire Ville de Genève

1988.141e Getty Research Institute via Hathi Trust Digital Library

1989.171 Milton Park, Alamy, MBT9GH Artefact / Alamy Stock Photo; Paris, Artcurial, Photo by Claude Germaine; Paris, Sothebys, Nicolas Dubois / Art Digital Studio © Sotheby's 2006; Villefranche-sur-Saône, Richard Gerald, Photo by Maxime Brochier

1989.172a,b Paris, Bibliothèque nationale de France, ark:/12148/btv1b53037717r; ark:/12148/btv1b84452754

1989.173 Wikimedia Commons, Photo by I, Sanchezn / CC BY-SA 3.0

1989.178, 179-187a-k Herder Institute Marburg - Image archive: 237575

1989.181, 182 Wikimedia Commons, Photo by Skarabeusz / CC BY-SA 3.0/2.5/2.0/1.0; Gartenseite von Schloss Gunthersdorf. Marburg, Herder Institute, 72506 Herder Institute Marburg – Image archive:72506

1989.210 Munich, Bayerische Staatsbibliothek, aus 2 A.civ. 117 n: pl. 15, 16, 49

1989.212 Institut hongrois, 92 rue Bonaparte, Paris 6e. Wikimedia Commons, Photo by Celette / CC BY-SA 4.0

1989.215 Florence, Alinari Archives, DEA-S-00A000-5102

1989.221 Wikimedia Commons, Photo by Pline / CC BY-SA 3.0; Wikimedia Commons, Photo by Selbymay / CC BY-SA 3.0; Inv. PH8486. New York, ENSBA/ARTRES, ART583582 © Beaux-Arts de Paris, Dist. RMN-Grand Palais / Art Resource, NY; Wikimedia Commons, Vue du château de Gaillon en Normandie by Silvestre, Israël . Source: Paris Musée / Musée Carnavalet / CC0 1.0

1989.235 New York, Réunion des Musées Nationaux-Grand Palais/ Artres, ART583583 © RMN-Grand Palais / Art Resource, NY; New York, Scala Archives/artres, ART582758 Scala / Art Resource, NY

1989.241, 242 Munich, Bayerische Staatsbibliothek, aus 2 Arch. 145 m

1989.241, 242 Paris, Bibliothèque nationale de France, (Luynes.780 0)

1990.262b RIBA61145 ©RIBA Collections; Wikimedia Commons, Photo by Daniel Villafruela / CC BY-SA 3.0

1990.263 Wikimedia Commons, Photo by NotFromUtrecht / CC BY-SA 3.0

1990.266 Wikimedia Commons, Photo by Wknight94 / CC BY-SA 3.0

1990.270 Florence, Alinari Archives, DEA-S-00A000-5102

1990.274 London, SWNS.

1990.276a,b London, Bridgeman Images, LLM2802390 © Look and Learn/Bridgeman Images; Wikimedia commons, Photo by Dcastor / CC0 1.0

1990.282 Wikimedia Commons, Photo by user:Benh / CC BY-SA 3.0

1990.283 Courtesy Eric Chaim Kline Bookseller (39691); London, Historic England Archive, BL05922 Historic England Archive, bl05922

1990.285 Source: Getty Research Institute via archive.org

1990.291a,b London, Bridgeman Images, GLH3040869. Circa Images / Bridgeman Images

1990.294 Florence, Alinari Archives, ACA-F-017018-0000

1990.305 Paris, Ministère de la Culture, IVN00_2007001703 © Ministère de la Culture

1990.323a-l Vincent Bidault, www.vincentbidault.com

1990.325 Photo by Patrick Nouhailler; Photographer Fritz Theodor Benzen, Copenhagen Museum

1990.325 Wikimedia Commons, Photo by Patrick Nouhailler's / CC BY-SA 3.0; Wikimedia Commons, Photo by Fritz Theodor Benzen, Copenhagen Museum / CC0 1.0

1990.333a-e Fotografica Foglia. New York, Scala Archives/artres, ART180937 Scala / Art Resource, NY

1990.347 London, Bridgeman Images, CH5978839 Photo © Christie's Images / Bridgeman Images

1990.353a-c Wikimedia Commons, Photo by besopha / CC BY-SA 3.0

1991.360 Kim Youngtae, Paris. London, Bridgeman Images, YOU4420113 Photo © Kim Young Tae / Bridgeman Images

1991.373 Photo by Dennis Moss of Cirencester, by courtesy of Sir Henry Elwes and Diane Marcus-Page

1991.380 Wikimedia Commons, Photo by I, Sanchezn / CC BY-SA 3.0

1991.389, 390, 391 ©Sir John Soane's Museum, London. Photograph by Ardon Bar Hama

1991.392, 393a–d Photo by Jean-Pierre Dalbéra via Flickr, permission granted by the Beni Culturali; photo by Rjdeadly, permission granted by the Beni Culturali

1991.392, Flickr, photo by Jean-Pierre Dalbéra / CC BY-SA 2.0 (https://creativecommons.org/licenses/by-sa/2.0)], via Flickr, permission granted by the Beni Culturali; Wikimedia Commons, photo by Rjdeadly / CC BY-SA 4.0

1991.392, 393a–d Milan, Guido Alberto Rossi, 006GAR06627, permission granted by the Beni Culturali

1992.395 Bath, Bath in Time, 27217 and 38814 © Bath and North East Somerset Council

1994.397 London, Royal Collections Trust, RCIN 916782 Royal Collection Trust / © Her Majesty Queen Elizabeth II 2020

1996.402 Florence, Alinari Archives, DEA-S-001042-5032

1997.403a-l Wikimedia Commons, Photo by Père Igor / CC BY-SA 3.0

1998.404 Wikimedia Commons, Photo by Massimo Maria Canevarolo / CC BY-SA 3.0

1998.410 Wikimedia Commons, Photo by François GOGLINS / CC BY-SA 4.0

1999.413 EParis, Roger Viollet, 276-3 © Neurdein/Roger-Viollet

1999.414 PRA187-2; New York, ENSBA/ARTRES, ART583584

2000.415 Munich, Bayerische Staatsbibliothek, 644480242 Bayerische Staatsbibliothek München, Res/2 A.civ. 29 l, pl. XXXIII (View of King Henry the Third's Tower); pl. XXXIV (View in the upper ward)

2000.421 Munich, Bayerische Staatsbibliothek, aus 4 Arch. 252 r–4:Tafel V

2000.437 Wikimedia Commons, Photo by CVB / CC BY-SA 4.0

2000.444 Los Angeles, Getty Images, 56465792: Imagno/Contributor, Hulton Archive via Getty Images

2000.446 Wikimedia Commons, Photo by Sammyday / CC BY-SA 3.0

2000.457 London, Bridgeman Images, DGA5196118 © Icas94 / De Agostini / Bridgeman Images

2000.458a-d London, Bridgeman Images, XIR223694

2000.459 Wikimedia Commons, Photo by I, Sanchezn / CC BY-SA 3.0

2000.462 Sir Edward Guy Dawber. London, RIBA100479 RIBA Collections

2000.466/ 467 London, Bridgeman Images, JB24512 © John Bethell/Bridgeman Images

2000.477 Wikimedia Commons, Photo by I, Bangin / CC BY-SA 3.0

2000.479 5162. Carte postale Adol [Auguste Dolbeau], Archives départementales de la Sarthe, 2 Fi 10500

2000.513 MV8928;invDessins1113. Photo: Christophe Fouin. New York, The Chateau de Versailles Museum/Artres, ART582762 © RMN-Grand Palais / Art Resource, NY

2000.516 London, Royal Horticultural Society, LIB0050494; Charles Thurston Thompson / RHS Lindley Collections; RHS_Kensington plans_F47 and F57. Francis Fowkes / RHS Lindley Collections

2000.539 Photo provided by woolworthsmuseum.co.uk

2020.548 Milton Park, Alamy, W2CH7G Jon Arnold Images Ltd / Alamy Stock Photo